35mm Camera Handbook

David Daye

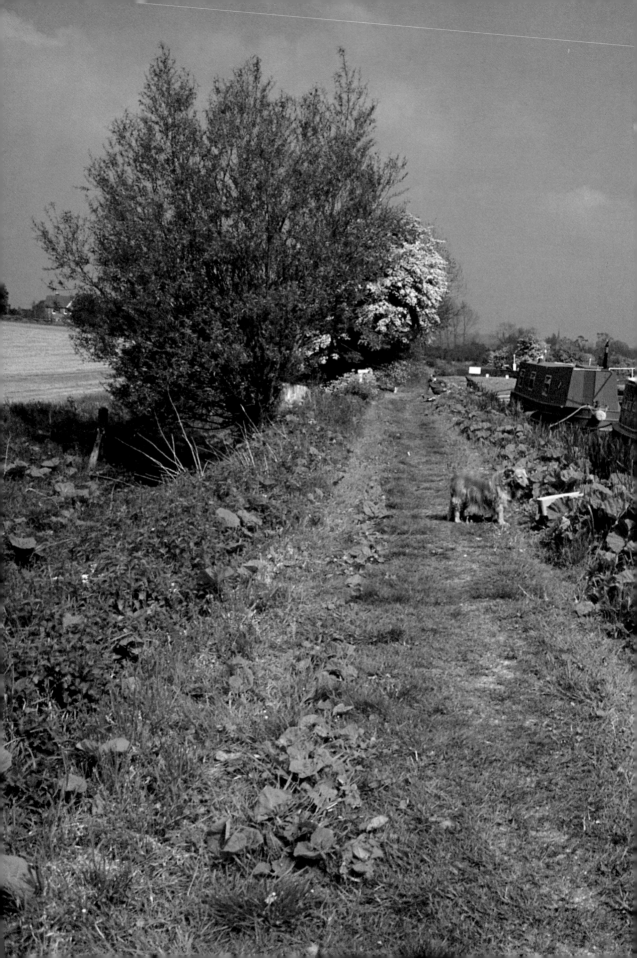

35mm Camera Handbook

David Daye

CHARTWELL
BOOKS, INC.

Published by
BOOK SALES, INC.
114 Northfield Avenue
Raritan Center
Edison, N.J. 08818

produced by
Brompton Books Corp.
15 Sherwood Place
Greenwich, CT 06830

ISBN 0-7858-0019-0

Printed in Great Britain

Foreword
This photographic primer is aimed at those who want to take
their hobby beyond the snapshot level. Only the most essential
information has been included to enable the reader to take
photographs of a range of subjects with the minimum of fuss. I
hope these first steps will be the start of an enjoyable journey
into the world of 35mm photography. David Daye

For Nicola, Kim and Michael.

Acknowledgments
Ace Camera Shop (Bath), AICO, Canon, Cobra, Cullmann UK,
C.Z. Scientific, f-Stop gallery, Fuji UK, Hasselblad/Metz, Hama,
Introphoto, Johnsons-Photopia, Kodak UK, London Camera
Exchange (Bath), Minolta UK, Nikon UK, Olympus UK, Paterson-
Photax, Pentax UK, Polaroid UK.

Special thanks to the following individuals for their help:
Ray Karam, John Wade, Stuart Watt, Mark Turnbull, Graham
Armitage, Keith Ruffell, Mike Shailes, Peter Frankland, Peter
Sutherst, Elaine Swift, Maxine May, Simon Ferguson, Adriana
Casali, Maria Bowers, and Tim Felser.

Contents

35mm Cameras – The Basics

Photography is a very simple process: rays of light reflected from a subject pass through a hole in a box (a camera) to form an image on light-sensitive material (film). But, because light never stays the same and the film may not have the right amount of sensitivity, the camera needs special controls so that it can be adjusted to allow in the correct amount of light.

These controls don't make the camera more difficult to use, just more flexible. This flexibility means that the photographer can shoot many different subjects in different lighting conditions with just one camera. A camera, such as a 35mm manual focus or autofocus SLR with a range of controls, will enable a photographer to take anything from happy snaps to breathtaking landscapes, action sequences, nature subjects, special-effects pictures and, who knows, along the way perhaps some stunning and even inspiring images.

Even high-end 35mm automatic snapshot cameras, while not as versatile as an SLR, enable you to do much more than just point the camera and press the button.

Both of these camera types are widely available today and both have their pros and cons. A closer look at their features, plus a grounding in camera basics, will help you to make better use of them and improve your photography as a whole.

The Camera

There are two features which control the amount of light that is transferred on to the film. The first is the *aperture*, which is a hole with a variable size. Most SLR camera lenses have eight or nine variations of aperture size, known as f-stops. They are shown like this: f/2, f/2.8, f/4, f/5.6, f/8, f/11, f/16, f/22 and f/32. The widest aperture opening in this range is f/2, while the smallest is f/32.

Apertures control the amount of light entering the camera and getting on to the film. They are adjusted manually via an aperture ring, or electronically on an automatic camera.

The length of time that the light is allowed into the camera is controlled by the *shutter*. Because today's films are so sensitive to light, shutter speeds are mostly in fractions of a second, with only a few shutter speeds lasting for one second or longer. A typical shutter speed range on an SLR is shown as fractions of a second and full seconds like this: 1/1000, 1/500,

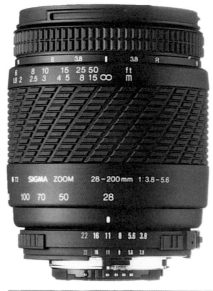

Left: A typical range of apertures, as found on a zoom lens. The lower the figure (ie 3.8), the larger is the aperture opening the higher the figure (ie 22), the smaller the aperture.

Below: Using a slow shutter speed (1/15sec) has blurred the water's movement.

Bottom: A fast shutter speed (1/125sec) has frozen the water's movement.

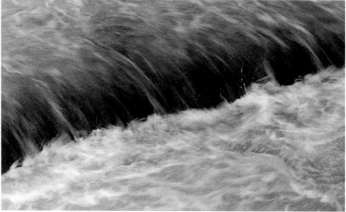

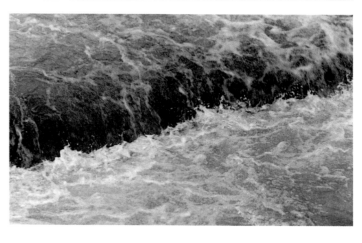

1/250, 1/125, 1/60, 1/30, 1/15, 1/8, 1/4, 1/2, 1, 2, 4, 8, and B. The letter B refers to "bulb" or "brief" time. At this setting, commonly known as the "B setting," the shutter stays open for as long as the camera's shutter button is pressed in. When you lift your finger off the shutter button, the shutter closes.

So, in order to get a correctly exposed image, the aperture and shutter speed work together to allow a fixed amount of light for a fixed amount of time into the camera and then on to the film, to produce the image. The whole procedure is called the *exposure*. A correct exposure setting is when the aperture and shutter speed chosen produce an image that is not too dark and not too light.

Different combinations of aperture and shutter speed will give the same exposure. For example, a setting of f/8 at 1/60 second will give the same exposure as f/5.6 at 1/125 second. Also, the shutter speed in use will depend on whether the photographer wants to freeze the action, or wants a moving subject to record as a blur, or simply wants an in-between shutter speed for a subject that's not moving.

Fast shutter speeds like 1/125, 1/250, 1/500, 1/1000sec or higher will sharply record moving subjects. Slow shutter speeds of 1/60, 1/30, 1/15, 1/8sec or below won't be able to record moving subjects sharply.

Exposure Modes

All exposure modes come from two basic types: *manual* exposure and *aperture-priority auto* exposure. (A less popular variation of the latter system, known as *shutter-priority auto*, is included as an option on more advanced models.)

Manual exposure enables the photographer to choose the aperture and the shutter speed that will give a correct exposure.

Aperture-priority auto exposure is a system in which the photographer chooses an aperture and the camera automatically selects the correct shutter speed.

These two exposure modes are found in most 35mm SLRs. Some basic SLRs only have the manual exposure mode, while higher level SLRs have these two modes plus many more.

One of these advanced exposure modes is called *program*. This is a fully automatic exposure mode that chooses and sets the correct aperture *and* shutter speed. Program's fully-automatic approach is ideal for compact cameras, almost all of which have this mode. It is also included on SLRs as a snapshot mode, used for general picture-taking.

There are versions of program mode that favor shutter speeds or apertures (as with aperture-priority auto exposure). A further refinement of program mode is something

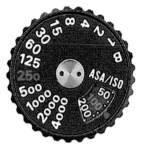

Above: All shutter speeds are shown as fractions of a second except for the figure 1 (1 sec). The B (bulb, or brief) setting is for shutter speeds longer than 1 sec.

Below: Programmed exposure is calculated to provide accurate exposure of a scene which has a good *balance* of bright, dark, and medium tones.

called program *shift*. This feature enables the user to freely adjust the aperture or shutter speed as needed. The camera's exposure system will then automatically choose the corresponding shutter speed or aperture that will give a correct exposure. Think of it as a combination of aperture-priority auto and shutter-priority auto exposure.

For the SLR user, the automatic exposure modes save time in setting apertures or shutter speeds, or both together. Many SLRs of this type also have an auto exposure (AE) lock feature which enables you to lock the exposure for one part of a scene or subject. This is useful if there's a risk of the camera's exposure system being "confused" by tricky lighting (it does happen!). In this case use the AE lock to take an auto-exposure reading of your main subject. Lock it, then compose your shot and take the picture.

The extra exposure modes are very convenient and are accurate for most lighting conditions and subject situations. But an SLR with a program mode plus others tends to cost a bit more than one with just an aperture-priority auto mode option.

As sophisticated as cameras' exposure systems are, they cannot judge whether a shot looks better with or without a certain amount of exposure adjustment. As your experience grows you may discover that a slightly incorrect exposure may give an even better result than a so-called camera-selected "correct" one.

Manual exposure mode gives more flexibility because the photographer has direct control over shutter speeds and apertures in order to get a correct exposure. The ability to override "correct" exposure settings to produce different effects makes an SLR with a manual exposure set-

Above: Some film boxes contain helpful information on suggested exposure settings for different lighting — handy if the battery in your manual focus SLR has run out of juice!

Above left: Correct exposure as calculated by the camera's exposure system.

Center left: Under-exposure by a 1/2 stop has darkened the scene and reduced the overall contrast.

Below left: Over-exposure by a 1/2 stop has lightened the scene and increased contrast.

Right: Adjusting the exposure by small amounts — in these pics by using apertures of (from top left to bottom right) f/8, f/8-and-a-half, f/11, f/11-and-a-half — gives a range of different results. There can be more than one "correct" exposure, depending on the effect you want.

Exposure chart

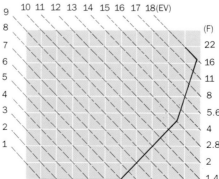

Left: A diagram of exposure values (EV). For further information see the box feature on page 12.

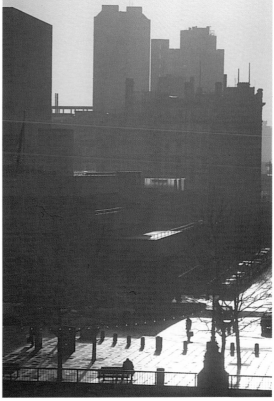

ting an extremely versatile tool. However, an additional automatic exposure mode such as aperture-priority auto or even program mode is a convenient standby for general photography situations.

The Metering System

Most SLRs have a built-in metering system which tells the camera's exposure system whether there is or isn't enough light to take a photograph by.

Most basic systems use *center-weighted metering*. This simply means that the metering cell in the camera measures the light mostly from the central part of the scene in order to calculate the exposure setting. Any light that's not within this central area, such as at the edges, is ignored.

The metering systems in more advanced models can measure light from several parts of a scene and, based on this measurement, work out an average exposure setting. This is called *multi-zone metering*. Advanced models have one of these light-reading methods plus, as an option, center-weighted metering.

Some advanced SLRs have an extra light-reading method called *spot-metering*. This reads the light falling on a very small part of the scene, and ignores everything else. Spot-metering is useful if a precise reading is needed off one particular part of a subject only, rather than the whole subject.

Certain SLRs allow several spot-meter readings to be taken, and then calculated by the camera to give an average reading. There are also special handheld spot-meters that can be used in this way. They have a more precise light-reading angle than built-in ones in SLRs, though most

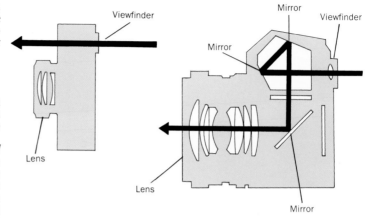

are expensive and less convenient to use.

But while an SLR with several metering systems can be convenient, giving the photographer plenty of options, a great deal of versatility is possible with just a simple center-weighted metering system.

The SLR Viewfinder

The initials "SLR" stand for Single Lens Reflex. This is a type of viewing system that shows, in the viewfinder, exactly what the lens "sees." In other words, with an SLR you are looking through the lens.

The two main benefits of this viewing system are the ability to see whether a subject is sharply focused, and the chance to make sure that the scene you're photographing is composed exactly the way you want.

When focusing you simply make sure that the lens is focused (either manually or automatically) until the image is sharp in the viewfinder. Most viewfinders in SLRs –

Above left: The viewing path through the direct vision viewfinder of a compact camera.

Above: The viewing path through an SLR viewfinder.

Below left: A spot-meter reading was taken from the white blossoms only.

Below: Meter-reading patterns: Multi-zone reads from several parts of a scene. Center-weighted, mainly from the center. Partial or Spot, from a small central area.

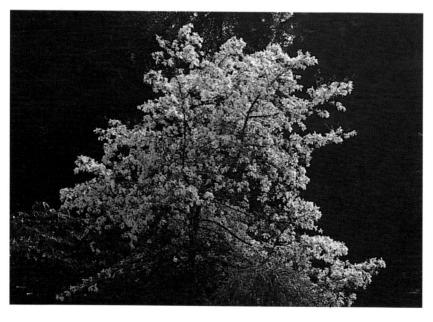

Multi-zone metering

Center-weighted metering

Spot metering

Loading and Unloading a Manual Focus SLR

A) Lift up the rewind spindle to open the camera back.

B) Pull out some of the film, then place the film cassette in the chamber.

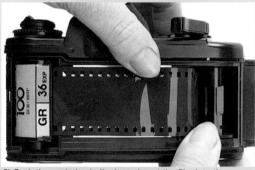

C) Push the rewind spindle down. Insert the film into the take-up spindle.

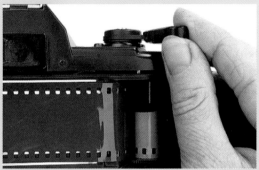

D) Wind the film on by one turn to make sure it's securely attached.

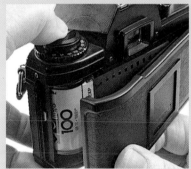

E) Close the camera back.

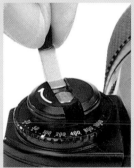

F) Turn the top of the *rewind* spindle clockwise until tight.

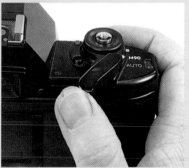

G) Looking at the frame counter, wind the film on up to frame 1.

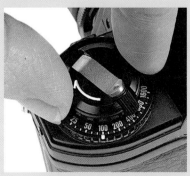

H) Set the ISO speed, by referring to the film carton.

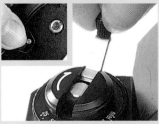

I) Press in the film rewind button, found on the base of the camera.
J) Turn the film rewind lever, on the rewind spindle, several turns clockwise. When it eventually feels slack, the film's wound back.

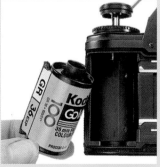

K) Lift up the rewind spindle, open the camera and remove the film.

whether they are manual focus or autofocus SLRs – have additional aids to focusing found at the center of the focusing screen.

Manual SLRs have a central split-image circle. This has two separate sections which, when brought together by focusing the lens, mean that the subject is sharply focused. Because the split point is usually horizontal this method is easy to use when the subject has vertical lines to focus on.

The split-image circle is usually surrounded by a microprism collar. This has within it an indistinct looking pattern which, when the lens is focused, becomes a clear, sharp image. The microprism collar is generally used for focusing on subjects which have no straight lines.

The rest of the viewfinder focusing area is a ground-glass screen. This can be used as a focusing guide, being especially effec-

Exposure Value (EV)

The exposure value of a metering system is the range within which it will give accurate exposures. In a camera's list of specifications two figures indicate the limits of the EV range, and are shown like this: EV2 to EV20 (ISO 100, 50 f/1.4). The first figure shows the widest aperture and the slowest shutter speed that the exposure system is capable of setting. The second figure, which is the other end of the scale, shows the fastest shutter speed coupled with the smallest aperture that the exposure system is capable of setting.

Note that each exposure value is given a number. The lower the first number and the higher the second number, the greater is the working range of the camera's system. In the above example, ISO 100 is the film speed and 50 f/1.4 is the lens that was used to base the EV range measurement on. This is for the standard program.

tive when focusing with telephoto lenses.

The above information is for those using manual focusing. After some time you may find one or other of these systems more easy to use, although the most precise method is via the split-image circle.

If you have an autofocus SLR there is an AF target area – usually consisting of two square brackets – in the center of the viewfinder. Place the AF target over the part of the subject you want sharp, half-press the shutter button, and the subject automatically comes into focus. As well as the scene appearing sharp in the viewfinder, a green-glowing LED lamp in the viewfinder border will confirm that the image is correctly focused.

Viewfinder information

The space just outside the viewfinder area in an SLR can show several features to do with the camera's operation. And the photographer can see them without having to refer to the other controls on the camera body, which would otherwise mean taking the eye away from the viewfinder window to have a look at them.

In a basic manual focus SLR there are usually colored LEDs, either in the form of dots, circles or + and − signs, which show whether there is or isn't enough light for the camera to produce a correctly exposed photograph. The + sign means over-exposure, while the − sign means under-exposure. Correct exposure will be indicated by both signs appearing lit or by another symbol, such as a circle or spot. Other information may also include the exposure mode chosen, the shutter speed and/or aperture and whether the lighting is so low that flash is needed in the flash "lighting" symbol.

The more expensive an SLR generally the more viewfinder information is available. Some of the more complex viewfinder displays can confuse the beginner though can be very useful guides for the more advanced photographer. But, for most users, the simpler and less cluttered the viewfinder, the better.

The Lens

The third most important aspect of an SLR camera, apart from enabling the photographer to see through the lens to accurately compose his pictures and to assess focus, is lens interchangeability. Whether the SLR is a manual focus or an autofocus

Left: Rangefinder focusing. Most SLR focusing screens have this rangefinder focusing section at the center:
A) Out of focus – the item focused on is disjointed.
B) In focus – the two parts of the image have been brought together.

Below: Hyperfocal distance:
A) Set the lens to infinity. Note the *closest focus setting* for your aperture of f/16.
B) Set this closest focus setting against the focus mark. Now everything from this setting to infinity will be in focus.

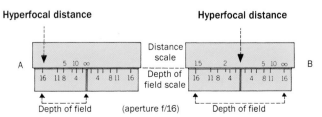

Hyperfocal distance Hyperfocal distance

28mm wide-angle

35-80mm wide-to-tele zoom

28-70mm wide-to-tele zoom

70-210mm tele zoom

75-300mm tele zoom

model, most have access to a huge range of interchangeable lenses that can be used with them.

Manual focus lenses can only be used with manual focus SLRs, while autofocus lenses can only be used with AF SLRs. However, there are exceptions to this rule, namely Nikon, Pentax and, to a lesser extent, Canon. All three allow a certain amount of lens interchangeability between their manual and autofocus SLR models. Some independent lens manufacturers (those that don't have SLR ranges of their own) also produce lenses which allow this type of flexibility.

Manual focus lenses have a manual focus ring and an aperture ring which has a full range of the most commonly used apertures. A manual focus zoom lens also has a zoom ring, which the photographer can use to alter the focal length. This varies the amount of the scene that will be seen in the viewfinder and the amount of the scene that will therefore be included on film. Typical zoom lens focal lengths are 28-70mm and 70-210mm though there are others with different focal lengths. have zoom rings.

All lenses have a scale on the lens barrel, in meters and feet, which is used to check the distance that the lens has focused on.

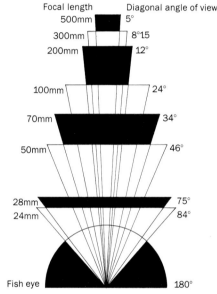

Focal length	Diagonal angle of view
500mm	5°
300mm	8°15
200mm	12°
100mm	24°
70mm	34°
50mm	46°
28mm	75°
24mm	84°
Fish eye	180°

Above: Commonly used lenses. The 35-70/80 and 28-70mm focal lengths are the most popular for general photography.

Left: Angles of view for different focal lengths. The angle of view is narrower for telephoto lenses.

Below: Angles of view at different focal lengths. Notice the dramatic differences between a 28mm wide-angle (top left) and a 300mm telephoto (bottom right).

28mm

35mm

50mm

70mm

100mm

300mm

But for most cameras you won't need to know this distance. Confirmation of sharp focus in the viewfinder, by a visual check or via an LED, will suffice. If you are closer to the subject than your lens's closest focusing distance will allow, this will also be seen in the viewfinder as an out-of-focus image or an LED warning of this, or both. Users of manual focus non-SLR cameras will need to be aware of their lens' closest focusing distance.

Fast and slow lenses

Some lenses have wide maximum apertures, such as f/1.8 and f/1.4 (the widest aperture commonly found on lenses). There are rarer, very expensive lenses of f/1.2 or even f/1.

Others start with smaller maximum apertures such as f/3.5 and even f/5.6. Wide maximum aperture lenses are referred to as "fast" lenses, while those with smaller maximum apertures are called "slow" lenses.

Zoom lenses have slower maximum apertures than fixed focal length lenses (ie 28mm, 50mm, 200mm and so on). And a zoom lens's maximum aperture changes, becoming smaller as it goes toward the long end of its focal length range. So while a 70-210mm zoom may have a maximum aperture of f/3.5 at the 70mm setting, this will become f/5.6 or smaller at the 210mm setting. With fixed focal length lenses, and some zooms, there is just one maximum aperture.

Focusing

Manual focus SLRs need to have the lens focused manually in order to give a sharp image. Autofocus (AF) SLRs are able to automatically focus the lens when the shutter button is pressed. Both have their benefits and though AF SLRs are generally more sophisticated and easy to use, manual focus SLRs are still popular, mostly cheaper and give a bit more user-control. Some manual focus SLRs are expensive too, and, while lacking autofocus, have other sophisticated features. Because of this and because of the amount of user-control they offer, many of these are popular with professional photographers. But many pros in certain fields (for example, sports and news photography) use AF SLRs for their sheer convenience.

Autofocus

There are, broadly speaking, two main types of autofocus system. The first, called *passive autofocus*, is used mainly in SLRs while the other – *active autofocus* – is used mainly in autofocus compacts. Passive autofocus is generally the more sensitive and more accurate system. To use it, first line up your subject using the AF target in the viewfinder as a guide. Press in the shutter button halfway and the lens will focus. The image will appear sharp in the view-finder and a LED in the viewfinder will confirm sharp focus. Once the lens has focused it can be temporarily locked, by a simple half-press of the shutter button. This feature is called *focus-lock*.

Then, to take the picture, simply press the shutter button in all the way.

There are two other autofocus functions available on AF SLRs: *single shot* and *continuous* autofocus. Single shot autofocus enables the photographer to focus on static subjects. Continuous autofocus, as its name suggests, continuously focuses on a subject and only stops focusing when the shutter button is pressed all the way in to take the picture. So it's ideal for focusing on moving subjects.

A refinement of continuous focus is a feature called *predictive focus.* In this mode the autofocus system doesn't just focus continually on a moving subject it also assesses where a moving subject will be moving to, so that when the shutter button is pressed the subject will be focused on at its new position.

Some SLRs have a variation of continuous mode called *trap focus.* Here, the lens is prefocused at a certain point, say the finishing line in a race. As soon as a moving subject reaches the preset point the camera automatically fires. This mode has obvious uses in sports and nature photography.

Some autofocus systems are even able to transfer focus distance information to the exposure system, to enable it to set the appropriate aperture for a specific depth of field requirement (see Depth of Field section).

Finally, all autofocus SLRs have a manual focus option, usually via a manual focus ring on the lens barrel. In virtually all cases, focus confirmation LEDs in the viewfinder will still operate.

Problems with autofocus

Although the standard of SLR autofocus is extremely high, it is by no means a 100 per-

Below: Lighting like this can cause focusing problems with an AF SLR's system. I used manual focus with this shot (35-70mm zoom).

Loading an Autofocus SLR

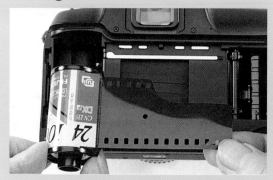

A) Pull out some film, then insert the cassette securely in the film chamber.

B) Pull the film tip out until it reaches the film index mark.

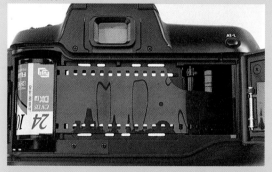

C) Ensure that the rest of the film is correctly positioned.

D) Close the camera back with a firm press.

E) Film winds on to frame 1, automatically, or after a button press.

F) Later, the film's rewound automatically or via a rewind control.

cent perfect system. While its ability to focus accurately in normal situations in most lighting situations is without question, it's in the area of non-standard lighting conditions and certain surfaces focused on where autofocus comes up against problems.

SLR autofocus relies on the contrast in a scene or subject to measure and set the correct focus. In low lighting, contrast will be lower than normal. In such conditions the autofocus system, therefore, has to work harder to achieve rapid and correct focus. If there's insufficient lighting and therefore insufficient contrast for the sen-

sor to target on, the lens will "hunt" – the lens barrel will constantly move in and out of focus – as it tries to find something to focus on.

When the available lighting levels drop lower than the autofocus system can sense, an autofocus illuminator, found in most AF SLRs, automatically switches on. It emits an infra-red beam that forms a pattern on the subject's surface. This gives the SLR's autofocus sensor an adequate area of contrast for it to sense and focus on. Many autofocus illuminators are able to function in total darkness.

If your AF SLR doesn't have an autofocus

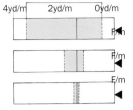

Max depth of field

Above: Depth of field gets greater the *smaller* the aperture. The shaded sections in the above diagram represent depth of field areas.

Above left: An aperture of f/2.8 has caused *shallow* depth of field. The center box is sharp, but the front and rear ones are out of focus.

Left: An aperture of f/8 has given *extensive* depth of field, with all three boxes being sharply in focus.

Below: Using the depth of field scale on a lens:
1) With the lens focused at 2m(yds) the aperture f/2 gives minimal depth of field.
2) Change the aperture to f/5.6 and depth of field extends from just over 1.5m(yds) to just under 3m(yds).
3) Set the aperture to f/16 and depth of field extends from 1.2m(yds) to well over 5m(yds).

Min depth of field

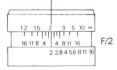

Depth of field F/5.6

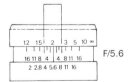

Max depth of field

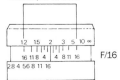

illuminator then you'll need to resort to manual focus via the distance scale on the lens. And if you find that even this calls for use of a torch (!) then it may be best to use flash. (NB. Special autofocus flashguns for use with AF SLRs also have built-in autofocus illuminators.)

Autofocus works best in, but not toward, bright lighting. If the SLR is pointed at or near very bright lighting – such as light sources and strong reflections – this can sometimes affect the autofocus sensor. The lens will either hunt for correct focus, or could be "fooled" by the reflections into giving incorrect focus. It may also hesitate when focusing on vertical lines.

Another problem area is that of a surface which has no contrast at all, such as a shadowless subject with one color, or a misty scene. Once again the lens will hunt. The solutions to these problems are either to use focus lock and focus on something that is in the same plane as the main subject, or to use manual focus.

Passive autofocus systems are able to focus through glass, although problems will occur if there are bright highlights reflecting off the glass surface.

Depth of Field

A correctly focused lens will produce a sharp image of the subject you're photographing. But some subjects, such as landscapes, also need to be sharp in the foreground and in the background, as well as the main subject area. The area of sharpness that extends from in front of, as well as behind, the subject is known as the *depth of field*.

Wide apertures, such as f/2, f/2.8, f/4 and f/5.6, give shallow depth of field, that is, there is only a narrow area across the subject area which is sharp.

Small apertures – f/8, f/11, f/16, f/22 and f/32 – give greater depth of field, which means that a larger portion of the scene in front of and behind the subject is sharp, as well as the subject itself.

A depth of field preview button or lever, found on many models of SLR, is used to close down, or "stop down," to the chosen aperture so that you can check in the viewfinder how much of the scene in front of and behind the subject is in sharp focus.

When using the depth of field preview control note that the smaller the aperture the darker the image will be in the viewfinder. So always make sure you have

Depth of Field

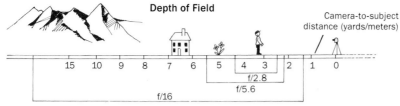

Camera-to-subject distance (yards/meters)

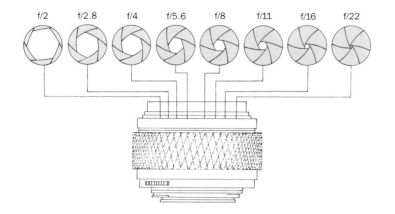

Areas of sharpness with specific apertures

f/2 f/2.8 f/4 f/5.6 f/8 f/11 f/16 f/22

Left: With your camera positioned at one point and readily focused, you can vary the amount of the scene you want to appear in focus, simply by choosing the appropriate aperture.

enough light to see by when checking depth of field.

Greater depth of field is ideal for landscapes or just general subjects where you want everything to be in sharp focus.

Shallow depth of field has its uses, too. A wide aperture can make background details unclear, so the viewer will only concentrate on the part of the scene that is sharp – the main subject. This can be very effective if photographing a person against a busy-looking background. Use a wide aperture and the distracting background will become indistinct. Shutter-priority exposure modes can do this for you.

A second benefit of shallow depth of field is that the wider the aperture the faster will be the corresponding shutter speed. This is excellent for photos of people, as movement, even changing facial expressions, can then be more accurately captured by the camera.

Below: Wide-angled lenses give extensive depth of field, which can be increased by using a small aperture.

Flash

Flash units are either built-in to the camera or separate. Nearly all compact cameras and some autofocus SLRs have a built-in flash unit. On SLRs this unit is situated on top of the camera. These units deliver enough power to be useful as emergency flash illumination for subjects within a close range. Some are even more sophisticated and can alter the coverage of the flash illumination to correspond to a (limited) range of lens focal lengths. But none have the power or advanced features of a separate flashgun. This separate unit fits into the hotshoe found on the top of all SLRs. While many of these flashguns are reasonably priced, the more powerful ones can cost as much as a mid-priced SLR.

This is because they are capable of giving illumination over a larger area. And they have additional features that make further use of this power. But there are many low to mid-priced models which give a good combination of reasonable power output plus other features.

Flashguns are divided into manual and automatic types, with many having both features. The most important difference between both is that manual flashguns, or guns that have been set to manual flash mode, give out a full burst of flash, while automatic flashguns give out a controlled burst of flash, that is, enough illumination to correctly light the subject but no more. The remaining flash power, left over from the flash charge, is saved and stored in a *thyristor circuit.* When the flash is then re-charged, the thyristor adds this power to

the next flash burst. This makes recharging times quicker and ensures that battery power is used more economically.

Flash power

Light, even if it's artificial like a flashgun, is too important an item for the photographer to cut corners on. A modestly powered, low-priced flashgun will be useful for some limited work in close-up photography and for fill-in flash. But for a wider range of subject-matter photographers need to choose the most powerful flashgun that they can afford, depending on the area that they wish to work in.

A very powerful automatic flashgun may also have power ratios. These are fractions of the unit's full power output and are useful when only a very small controlled flash-burst is required.

The power output of a flashgun is shown by its guide number (GN). A GN of at least 25 is recommended for use with an SLR. It will supply enough power for controllable flash illumination, plus a selection of other features for more creative and convenient flash use.

Compact cameras' built-in flashguns, because they need to be incorporated into the smaller camera design, have low guide numbers such as 10 or 14.

Guide numbers are included with the specifications of most flashguns, and are based on use with a specific aperture, film, and a specific camera-to-subject distance. The flash unit's recommended working range is normally found in the instruction manual.

A flashgun with a high guide number

Flash sync

The correct flash synchronization or sync speed is indicated by an "X" near the appropriate shutter speed on the shutter speed dial of a manual focus SLR. Alternatively, the sync speed may be highlighted by being in a different color to the other shutter speeds.

An autofocus SLR's flash sync speed is shown in the instruction book.

Typical flash sync speeds on older SLRs are 1/60sec or 1/90sec. On newer models the sync speeds are usually 1/125 or 1/250sec.

Although shutter speeds faster than the recommended flash sync speed will cause blacking out of part of the image, shutter speeds *slower* than the sync speed will not have this effect.

With very slow shutter speeds, a subject that's moving will appear as a blur, while flash will sharply freeze part of it. This gives an effect of movement though if you want to avoid this then stick to your SLR's fastest flash sync speed for sharp focus shots.

Left: The camera manufacturer's dedicated flashguns can provide superior flash control. Some independent flashguns use modules dedicated to different camera brands.

Above right: Room interior photographed without flash and using normal ISO 100. Orange result caused by normal film used in tungsten lighting.

Above center: Using straight flash.

Above, far right: Flash illumination bounced off the ceiling.

Below: The flash sync socket (center right) most often found on manual focus SLRs. A cable connects it to an off-camera flashgun for versatile flash illumination.

gives more powerful illumination, and covers a greater distance, than one with a lower guide number. A quick and easy way to find out a flashgun's guide number is to look at its model name. Most flashguns include their guide numbers in their model name for example Canon 30OEZ, Minolta 3200i.

Another feature to look for is the recharge time: how long it takes after one burst of flash for the flashgun's battery power to recycle and get ready for the next one. Flashgun manufacturers usually indicate the flash recharge time in the specifications but note that these figures will have been arrived at using fresh batteries. Under normal conditions the recharge times with repeated use will be slower than the figures quoted.

Using a separate flashgun

When the flashgun is fitted into the hotshoe it is not only attached physically to the camera but also electronically, via an electronic contact in the hotshoe itself. This connects with a contact on the flashgun's "foot."

The next step is for the SLR to be set to the correct shutter speed so that it will synchronize with the flash. Use too fast a shutter speed and part of the image will have a dark strip on it. This is because only a part of the image area has been uncovered during the duration of the flash, before the shutter has moved across the image area. With the camera set to the *flash sync speed* the complete image area is uncovered long enough for the flash burst to illuminate the whole film frame.

With the flashgun switched on, a lamp on it confirms when the unit is fully charged up and ready to fire. With most flashguns you'll need to set the appropriate ISO film speed on the unit. Coupled to this will also be an indication of the appropriate aperture to use for the intended flash-to-subject distance.

An automatic sensor at the front of the flashgun will take care of the flash exposure itself, making the flash provide just enough illumination to light the subject.

With a special flashgun, known as a *dedicated* flashgun, the camera and flash are able to communicate with each other. The dedicated flashgun can even set the appropriate flash sync speed. When the dedicated flashgun is fully charged up and

ready to fire this is indicated by a "flash ready" lightning symbol which appears in the SLR viewfinder. The exposure settings made on the camera are recognized by the flashgun and the amount of flash illumination adjusts to these.

Tripod

A tripod is a vital accessory if you intend shooting in conditions which require slow shutter speeds (at night, for example, or if you use a long telephoto lens which needs to be absolutely stable so as to avoid camera shake and therefore a blurred image).

The best tripod is the heaviest one you can buy, as the heavier it is the more rigid will be the support. This is perfect for the studio-based photographer though is not practical for photography that takes you out and about. If you intend to be more mobile then carefully select the heaviest tripod you can comfortably carry. Lightweight tripods will be extremely portable but will not give the solid stability that's required. A monopod – a single-legged "tripod" – is a reasonable compromise. Tabletop tripods are fine for emergency use or if there's nothing else available.

Tripods with swivel heads or some degree of movement are preferable, being able to adapt to a wide variety of shooting situations and positions. Those with a built-in spirit level are useful for photographing landscapes or architecture, as they ensure accurate horizontals and verticals in your image.

Camera Bags

There are several ways to carry your SLR and its accessories, such as camera pouches, shoulder bags, heavy-duty shoulder bags, camera cases and heavy-duty camera cases. Each has its advantages, depending on where you're going to be photographing and how much equipment you'll be taking with you.

But do not buy or use a so-called "ever-ready" case. An ever-ready case is usually supplied or is an option with the camera you buy. It's slow and awkward to open and close. It needs to be completely removed and replaced when loading or unloading film from the camera. And it doesn't provide ideal weather protection.

Below: Types of camera case.
1) Stiff camera case, with compartments for camera, lenses etc.
2) Rigid suitcase type. Foam interior has customizable compartments.
3) Soft gadget bag. Lightweight padded. Some are waterproof.
4) Traditional one camera/lens ever-ready case. Awkward in use.

Hard shoulder bag

Equipment case

Soft shoulder bag

Ever-reading case

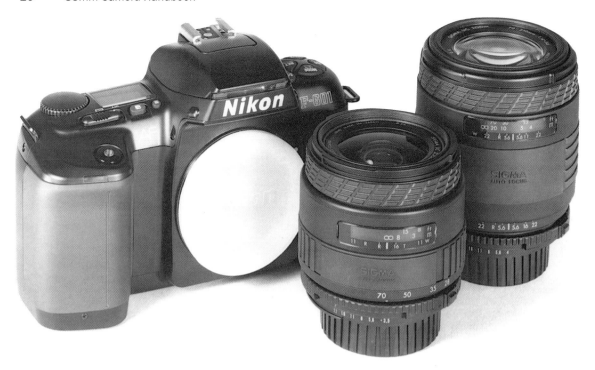

A First SLR System

Buying your first SLR can be a difficult task if you don't have at least an approximate idea of where you want your photography to take you. Does it look like it's going to be an active hobby and no more, or do you have the conviction that you can take it much further, and perhaps eventually become a professional photographer? Or perhaps you want to straddle both areas, taking photographs of saleable quality, then using any income you gain from photography to further your hobby or buy new equipment.

With all three options you'll need to look not only at cameras and lenses but also in closer detail at the camera system you're buying into. Accessories like specialized macro lenses and macro accessories such as close-up bellows and extension tubes, dedicated flashguns and databacks will all be important, depending on the kind of photography you're interested in. And if you intend following the professional route then you will also need to find out how easily, or otherwise, you can acquire or hire other peripheral equipment that fits your camera make and model.

Cameras

Do you want to buy a manual focus SLR or an autofocus SLR? Both have strong advantages, and can be summed up like this: manual focus SLRs give total user override over focus and exposure. They also have mechanical operation so, in an emergency, the shutter speed and aperture ranges can still be set manually by the user.

Manual focus SLRs also have a greater choice of accessory lenses to choose from than autofocus SLRs, Not only do SLR manufacturers have their own lens ranges but independent lens makers also produce lenses to fit most major camera brands.

Finally, most manual focus SLRs are, at the time of writing, lower priced than equivalent autofocus SLRs. And manual focus lenses are cheaper than autofocus versions. Add to this the fact that there is a huge market in second-hand SLRs and lenses and this is the ideal route for those wanting to buy a reasonably priced SLR.

Sophistication and ease of use are where autofocus SLRs win over their manual rivals. Apart from automatic and rapid focusing (including variations of continuous focus for moving subjects) autofocus SLRs have automatic film wind-on, winding and rewinding. There's a motor-drive system that powers the film through the camera, at one frame per second (1fps) or more.

There's an LCD window on the camera top plate that shows the apertures and shutter speeds and the mode chosen as well as operational information such as battery status and so on. Several have built-in flashguns and all have a manual focus option. And, apart from advanced metering and exposure systems, quite a few have a manual exposure mode plus exposure compensation and an auto exposure lock setting.

Obviously the more sophisticated the features the more expensive the SLR, But autofocus SLRs are coming down in price, with autofocus technology filtering down

Above: A basic SLR outfit could consist of a wide-to-tele zoom (ie 28-70mm) and a tele-zoom (70-210mm). This combination will handle 80 percent of subjects. Independent lenses are cheaper than those from camera manufacturers. Optical performance (and build quality) is very high and often as good.

Right: A more specialized optic, such as this 50mm macro lens, is useful for close-up work. It can also be used at normal shooting distances.

to mid-price manual focus SLR territory. In fact, if price is a major stumbling block, the technology has been around long enough for the existence of a healthily sized second-hand market in autofocus SLRs complete with lenses, and at competitive prices. And most earlier autofocus bodies are able to use current autofocus lenses.

Pros and Cons

So what are the disadvantages? The main problem seems to be learning to use the sophisticated features in the quickest, easiest way. The layout of controls and buttons seems to differ from range to range. While most provide a snapshot mode in which the autofocus, metering, exposure modes and automatic film winding default to a standard setting (leaving the photographer free to snapshoot), it isn't always easy to delve deeper without an in-depth read through the manual.

Some of the features on offer are genuinely useful. Other features, in the manufacturers' reasonable desire to appeal to everyone, are gimmicky. Some can confuse rather than assist the beginner or even the experienced manual focus SLR user who has decided to make the switch to autofocus. In order to get the best from these truly wonderful machines it's best to do some preliminary research. Look at photography magazine test reports, ask friends who have these cameras to show you how they work, ask camera shop assistants about specific features, study brochures and leaflets. This preparation will help you to get a much clearer idea of the camera with the features and price that will best suit your needs.

Lenses

SLR manufacturers have lens ranges that will suit most photographic needs. Whether you're into landscape, portrait, architecture, sport, travel or nature photography there's a lens for you. Most lens ranges have ultra-wide lenses at one end with ultra long telephoto lenses at the

other, both types of which are expensive. Those of more commonly used focal lengths from 28mm to around 300mm, tend to be more accessibly priced.

A zoom lens is an alternative, and has several focal lengths in one. Most lens ranges have a good sprinkling of these in different types and prices. The optical performance of zoom lenses, once lagging behind that of fixed focal length optics, has greatly improved. Results are now very close to those of fixed focal lengths and any differences will only be noticeable when magnified.

Possible lens outfits can comprise a 28mm fixed focal length wide-angle plus a 70-210mm zoom, or a 28-70mm or 35-70mm zoom plus a 70-210mm zoom. Some camera dealers "bundle" pairs of such zooms with an SLR and give a reduced price for the complete outfit. Competition has been so fierce in this sector that individual prices of these zooms are also very accessible.

With a two-lens outfit such as the above the photographer will be able to cover most subjects. And most have good close focusing facilities which allow some close-up photography.

Many new SLRs are still sold with 50mm "standard" lenses though an increasing number come complete with a wide to telephoto zoom, either a 35-70mm or a 28-70mm. Either zoom will cope with a generous range of subjects and situations and may be sufficient for those whose budgets are tight or who intend using them for general photography.

Those photographers who intend

Above: You can get a first-generation autofocus SLR at a bargain price by buying second-hand. With some brands it's worth checking out the availability of accessory lenses for the model you want.

specializing in particular areas such as nature or sports photography will need more specialized, though not necessarily expensive, lenses.

Independent lens makers produce similar lenses to those from SLR manufacturers, often at lower prices yet with competitive performances. If the prices of some of these advanced optics are still too high consider buying second-hand. Prices of second-hand equipment are considerably lower and shops offer reasonable guarantee periods. Buying equipment privately (through newspaper ads) or elsewhere is a risky business though it's possible to get a bargain at a knockdown price. In this case it's best to take a knowledgeable friend with you. (For buying second-hand see the next section.)

You can hire specialized equipment from professional dealers. Many have hire services for cameras, lenses and other equipment. The procedure normally involves supplying references and a deposit. The cost of hire is based on hourly, daily weekly or even monthly rates.

Buying second-hand

Advances in autofocus SLR technology in the past decade have led to a huge market in second-hand manual focus (and, to a lesser extent, autofocus) SLR cameras and lenses. Manual focus as well as first-generation autofocus SLRs can be found at bargain prices. Either types are well worth considering as potential purchases, with prices that can be attractive.

Buying second-hand is also a good idea for those who've spent heavily on an SLR body and want some reasonably priced yet good quality lenses.

It's possible to get some amazing bargains in second-hand equipment but it's also just as possible to buy gear that has been badly kept or works poorly or not at all. Some care is therefore needed when buying second-hand, though the advantages outnumber the disadvantages.

There are two main routes to buying second-hand photographic equipment. The first is to buy from a camera shop. This is the best approach as the equipment has often been thoroughly checked and is in working order, with a guarantee often included. This is usually for three or six months but can be longer.

While there will be more specific advice relating to specific items of equipment in this section some general advice is worth noting at this stage. When buying from a camera shop make sure that an instruction book is included. Most manual focus SLRs can be used without one, if it comes to that, but autofocus SLRs are more sophisticated (or complicated!) and an instruction book will be a vital guide. Also instruction books will give information that is not available on the camera body, such as flash dedication details, spot-metering angles, film wind speeds, and battery types usable with the camera.

Body-only camera prices are, of course, low but if you're buying a second-hand lens at the same time a discount on total price can *sometimes* be negotiated.

The second method is buying direct via newspaper ads or other means of private sale. This is a risky business although prices are generally lower than shop prices. The risk is that you, the buyer, have no way of knowing whether the equipment works well or not until you test it with a film. The phrase *caveat emptor* (let the buyer beware) could almost have been invented for the second-hand camera market!

Below: While many zoom compacts have traditional styling, the increase in features means that positioning of controls plays an important part in handling and ease of use. Many zoom compacts on the new and second-hand market follow this conventional design.

Left: Hybrid cameras, such as this model from Fuji, were built around a zoom with an extensive focal length range. They were a brave attempt at camera re-design, while still retaining hi-tech features. Because of the unusual styling, many also provide superb handling. Well worth checking out on second-hand shelves.

Check it out

Some general guidelines will help the unwary but these are not a cast-iron guarantee that the camera equipment you buy in this way will be 100 percent safe and reliable. It helps if you take along a friend who knows something about photographic equipment.

First, check the condition of the camera or lens. Equipment that looks in good condition is *mostly* in sound working condition too. But don't buy a piece of equipment on its appearance alone. Try out the controls to make sure that everything's working. Try out all the shutter speeds to make sure that they sound about right. Manual SLRs' shutter speeds tend to get slower the older the camera though rarely too slow as to be unusable.

Put the camera on B, keep your finger pressed on the shutter button to open the shutter and look at the film chamber for signs of dirt, fungus or rust. Fungus or rust are serious as they may not just be on the surface. Dirt can often be cleaned off and, if necessary, a manual focus SLR can be stripped down and cleaned.

Look also at the lens mount. The greater the degree of wear the more use it will have had, so it's best to make sure that lenses attach and detach via the mount with no looseness or rattling. It's also worth checking the working of appropriate linkages – apertures with manual focus lenses, and apertures, focus and other modes with autofocus lenses. Also AF lenses need to have their contacts checked.

The battery compartment is another vital area to check for dirt, fungus or rust. If an out-of-date battery has been left in the battery compartment there may well be corrosion on the contacts. This may or may not affect connections and therefore operation. This needs careful checking especially with autofocus SLRs as they are heavily reliant on battery power. If in doubt, don't buy the camera.

Check mechanical operations too, of the rewind lever, catches that attach the camera back to the camera, and the shutter button.

Check that the aperture ring on the lens moves positively and stops firmly at each aperture position. When carrying out this operation look through the lens at the aperture blades to make sure that these are functioning properly.

With lenses check for scratches on front and rear lens elements. Some minor scratches on front elements may only be noticeable when you photograph toward a light-source. Scratches on rear elements are more serious and will show as obvious image deterioration.

Dirt on the front and rear elements of the lens can be cleaned off with a lint-free cloth and some lens-cleaning liquid.

Focusing and zooming rings with grating sounds mean that grit has worked its way into the mechanism. It can be cleaned by dismantling the lens but, as with cameras, this can be costly.

Minor dents on lens barrels need only be a cause for alarm if they have caused a misalignment of the lens elements. This can be confirmed by a visual check through the viewfinder. Bring the lens to a focus and if one part of the image is still unsharp or distorted then the elements have been disturbed. More subtle misalignment of lens elements may only be seen on film and, if in doubt, try and run a film through the camera/lens combinations. Or if in doubt don't buy the lens. Misalignment can also occur with lenses that, from the outside, look in pristine condition. In fact, running a film through a camera/lens combination is the best way to check general reliability and working order. An honest seller should allow you to do this.

If at all possible, and especially if your intended purchase is going to be a costly one, it's worth finding out something about the camera or lens's history. A camera or lens that has belonged to a professional, say, will have had more hard use than one that's only been used for birthdays, holidays, or for snapshots.

Film

There are more film types available for 35mm than for any other film format, whether you use color or black and white. You can choose a film not just for its speed, color intensity and sharpness, but also for other qualities. A particular black-and-white film may give a very smooth tonal range (ie the change from light to dark areas) making it ideal for photographing, say, landscapes; a particular fast color film may have an obvious grain pattern that will give a distinctive look to portraits. Another film may give highly accurate reproduction of greens, useful when photographing plant life, and so on.

But all films, whatever their character and whether they're black and white or color, are made up of the same fundamental components.

Emulsion

This is the image-recording portion on a piece of film. It is made of gelatin and contains light-sensitive silver halide crystals. Black-and-white film only requires a few layers of emulsion, while color film, as you may expect, needs several. These emulsion layers are coated on to a hard-wearing polyester base. All film needs to be handled carefully but the side that the emulsion is coated on to needs extra special care when handling.

Constant research and development into silver halide crystal technology has produced better emulsions with more consistent characteristics, in both black-and-white and color films. The new generation of color films has better sensitivity to colors, higher sharpness, better tonality, more accurate color rendition and stronger color saturation.

Grain

One aspect of the extensive resources spent on film technology in recent years is the considerable improvement in grain structure. Grain is the distribution of silver halide crystals on the emulsion. It's only visible to the naked eye with ultra-fast films and for most films it is unnoticeable

Below: Choose a slow color slide film for very sharp results, good saturation of colors, and accurate recording of fine details (135mm Nikkor lens. Kodachrome 64).

except under magnification. Finer grain makes an image sharper and gives smoother tones. Generally speaking slow film has finer grain, while fast film has coarser, more apparent grain. But advances in film technology has narrowed the gap, and many fast films have barely noticeable grain patterns.

While smooth, even grain is generally desirable, a strong, visible grain pattern can add a bit of character to an image. It works especially well with subjects such as portraits and landscapes.

Film Contrast

Contrast is the difference between light and dark areas. Most films strive to reproduce the range of contrast in a scene or subject as accurately as possible. But some films have built-in contrast characteristics that are stronger than usual. These may be caused by the materials used in their manufacture or even the way they're manufactured. Some produce low contrast results while others produce high contrast results. Far from being drawbacks, these contrast characteristics can be used to good effect by a photographer who is aware of them. A film, be it black and white, color slide or color print, which delivers high contrast can be useful for adding impact to a scene or subject which has low contrast.

On the other hand a low contrast film can be used for a photograph that's going to be taken in very bright, high contrast lighting.

ISO Film Speed

The initials "ISO" stand for International Standards Organization, the body that agreed on a standard rating for categorizing films for photographic purposes. This has replaced the previous ASA standard with the letters "ISO," though the film speeds themselves are unchanged on some cameras' film speed dials.

The ISO rating for a film is a measure of how sensitive it is to light. The lower the figure, the less sensitive it is to light, the higher the figure the more sensitive it is to light.

Films with low figures are known as slow films and have the following ISO numbers: 25, 32, 50, 64, and 80. Slow films generally have excellent sharpness, low contrast and excellent tonal qualities. They give best results in bright lighting and with static subjects such as formal portraits or landscapes.

Those with higher numbers are called fast films and are as follows: 200, 400, 800, 1000, 1600, 3200. These are sharp, have high contrast, and are generally more grainy the higher the ISO speed. They are best suited to low-light or action photography as they will give fast shutter speeds.

And those of around 100 and 125 are

Above: Exposure compensation dial, used to compensate the exposure for a whole film, if required. Each setting is 1/3 of an EV step, from a modest fine-tune to a more dramatic 4x increase in exposure compensation, or anything in-between.

Below: "Pushing" a film, by using it at a higher ISO film speed setting, will yield faster shutter speeds, but it makes the grain more prominent and can affect color accuracy, (300mm Tamron lens. Ektachrome 400, rated at ISO 800).

called medium speed films. These give very good sharpness, have good contrast, and a good tonal range.

Film Types: Black and White

Black-and-white or monochrome film is a negative film, that is, the finished, developed film is in negative form. In order to see the finished "positive" image a print needs to be made from the negative.

Far from being a poor relation to color, black-and-white photography has its own kind of impact. The photographer using black-and-white film needs to use a slightly different approach to composition and lighting than is required for color photography.

The lack of color makes the viewer concentrate on other aspects, such as subject shape, texture, lighting, and tone. Colored subjects are shown as a series of gray tones. The way these tones are reproduced varies greatly with black-and-white films. Some show a gradual change from light to dark. With other films this change is less gradual and sometimes even dramatic. The variable tones give subtlety and character to a black-and-white image.

The right developer

Unlike color slide and color print film, black-and-white film has a range of different developers to choose from. One can be used to increase sharpness, another will make the grain pattern more prominent or lessen it, yet another might give a higher or lower contrast result. And the negative is just the starting point. There is also a wide choice of printing papers to choose from for different contrast and tonal effects. These can show subtle differences in the way the black-and-white image appears, which can be in different shades of black and white or (by way of toning) even in color. And just to add further variety there are also different paper textures.

Color Print

More commonly called color print film, color negative is the most widely available film type, used for general snapshooting as

DX coding

DX coding is a method that enables a camera's electronics to "read" a film's ISO rating. Markings on the cassette of a DX-coded film are read by contacts in the camera body, which transfer the information to the camera's electronics. A DX-coded film will also tell the camera what type of film it is and how many exposures are on it.

The main benefit of DX coding is that the photographer doesn't need to manually set the film speed. DX coding is a time-saver and is handy for photographers who may have forgotten what film has been loaded. It is not available on pre-1985 cameras, but DX-coded films can be used on these models as long as the photographer remembers to set the correct ISO speed beforehand.

There are few films without DX coding, and those without it tend to be films for special uses. If you're going to use these films in your DX-coding camera, the camera will set the film to a default setting, typically ISO 100 or 25. Whatever the ISO speed of your non-DX-coded film is, the camera will still set the default setting and you will need to adjust the exposure accordingly. A look at the camera's specifications will show the default setting for your model.

For those who intend using non-DX-coded film on a regular basis: there are special commercially available DX recoders on self-adhesive labels. These are stuck on to the cassettes of non-DX-coded films and are available in a wide choice of film speeds.

Above, far left: The chequered area is the DX code, which gives the camera information on ISO speed, exposure range and the number of exposures per roll.

Above left: Other details on the film cassette give useful information to the user. Holes in this part of the film feed information about it to electronic processing machines.

Far left: Kodak Tri-X b&w film, an ISO 400 film, was pushed to ISO 800 to increase grain and contrast (135mm Nikkor).

Below, far left: A color print from the color negative shown on this page. General color print film quality is the highest it's ever been, which is great news for snapshooters *and* more serious photographers.

Below: A black-and-white negative strip.

Below left: A negative strip for color prints.

well as professional photography. Color print film is used by professional photographers for the following reasons:

● The processing method – known as C41 – is widely available and easy to use. In an emergency it can be cheaply and efficiently processed in a local or mail-order lab.

● Mistakes, such as inaccurate color caused by photographing under artificial lighting, can be corrected in the darkroom.

● Enlarged prints made from color negative are currently cheaper to produce than prints made from slide film.

As its name suggests its base is a color negative from which prints are made. The range and characteristics of color negative films are colossal.

Image quality with the slow speed color negative films, once lagging a little behind color slide film, now competes favorably with it, with any differences in sharpness being noticeable only under close inspection. Similarly, low-cost local and mail-order processing have been improved to the extent that high-quality results are the norm rather than the exception. Competition between labs also means that prices for processing are reasonable.

Color Slide

Also known as color reversal film, most color slides use a universal process called E6, which is available as off-the-shelf chemistry or provided as a processing service by commercial labs.

Results are technically sharper than black-and-white or color print simply because the film itself is the final image. There is no intermediate stage, as with negatives for color or black-and-white prints, where there is minute quality loss when a print is made from the negative. This means that slow, fine grain slide film is sharper than black-and-white and color print film of the same ISO speed, though (admittedly) the differences are really only detectable under magnification.

Color slides have impact because of their see-through quality. Results, against illumination from a light-box or when projected, are bright and have strong contrast. This is a problem as prints made from them result in high contrast images with limited tonal ranges. The solution is to slightly under-expose slide film (usually by around a half-stop) when shooting it, so that resulting slides or prints will have a better balance of light and dark areas. A side-effect of this is that colors appear slightly richer. This will be appreciated in prints made from such slides and when projecting the slide. However, if you intend having your slide published in any form then it's best for it to be of normal contrast.

All the main film manufacturers have slide films within their ranges, with speeds from slow to fast.

The benefits of color slide film are: slides can be projected on to a screen, they have slightly better image quality than other

Right: Agfa Dia-Direct is a black-and-white slide film which has low contrast, a smooth tonal range, and very good sharpness.

Below: Kodachrome's strengths are excellent color accuracy and sharpness.

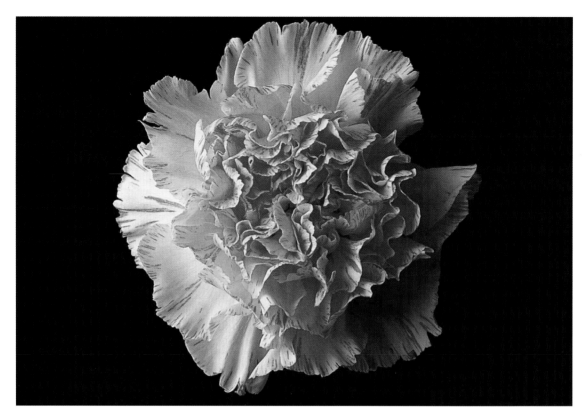

films, and a small number have processing included in the price of the film. These *process-paid* films come with a mailing envelope. You send the film to a specified processing lab and after a period of several days the film is returned, mounted or unmounted, depending on your preference.

The slightly higher than normal price of process-paid film will save you having to process it yourself, and money.

Clip test

If you've shot an especially important series of photographs but you're not sure what film speed was set, or if you want to find out what a particular push-process rating will produce, you can clip test. This means simply cutting off the first few frames of your slide film, in the darkroom or a changing bag, and processing them yourself or getting them processed at your

Above: This flower was photographed on Fujichrome 50 slide film.

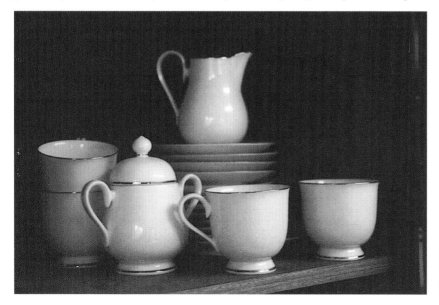

Left: This crockery, photographed using Polagraph black-and-white film (ISO 400), shows the characteristic grainy result and high contrast.

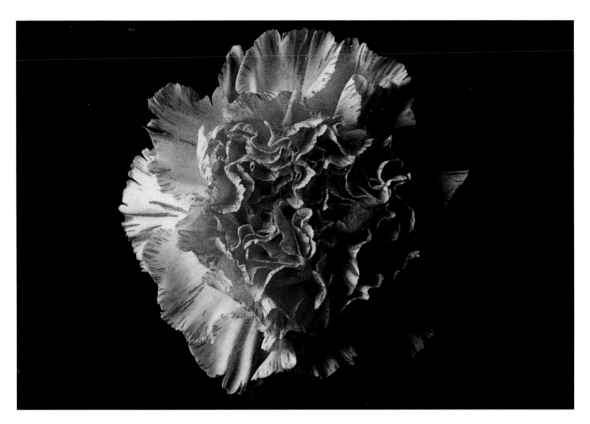

chosen film speed. When they're processed you can then use them to assess what to do next, whether to process the rest of the film at that rating or to alter the setting.

Clip-testing is important for portrait photographers who need to get skin tones exactly right or those who want specific color accuracy. It's also for those photographers who know they have some unrepeatable shots on film and want to be sure that exposure is spot-on.

Commercial processing labs will carry out clip testing for you, at a price.

Special Films

Black-and-white slide films

Also known as monochrome reversal film. There are only four types currently available. Agfa Dia-Direct and a range of instant films from Polaroid – Polagraph, Polapan and Polablue. Results can be effective, though each of these films has distinctive characteristics which need to be noted and adjusted for.

Agfa Dia-Direct is slow, with a variable ISO setting, ISO 32 being a recommended starting point. Contrast is unusually low for a slide film. It has an excellent tonal range and sharpness, and can be used for subjects that need these characteristics. It is a process-paid film.

The following films are instant Polaroid films that fit 35mm cameras. They require special automatic or manual Polaroid pro-

cessors for development. All the Polaroid films come with a processing pod that needs to be placed in the processor with the film for development to take place. An optional slide mounter plus Polaroid slide mounts are also available.

Polaroid instant 35mm films are not cheap but, in return, offer distinctive characteristics and on-the-spot processing.

Polaroid's instant Polagraph is a fast (ISO 400) high-contrast slide film with a distinctive grain pattern. Its gritty appearance can be used for portraiture or for low-contrast subjects or scenes that need to be enhanced.

Polapan, another instant Polaroid film, is a medium speed ISO 125 film. Sharpness is very high, while contrast is even. A good film for showing fine detail.

Polablue is a *blue* and white slide film with no tonal range. It has uses in graphics or for titles for slide shows.

Polaroid instant slide films have a very soft, easily scratched surface, and need careful handling and storage.

These Polaroid films must not be confused with the company's range of conventional 35m films, which comprise conventional color slide and color print types.

Some normal black-and-white films can be developed as black-and-white slide films. In order to do this, special processing methods need to be used. Further information and guidance can be obtained from film manufacturers.

Above: The same flower seen on the opposite page photographed using Polachrome slide film. The colors and contrast have been affected, but image sharpness is very good.

Polaroid color slide film

There are two kinds of Polaroid color slide film, called Polachrome and Polachrome HC. Both are rated at ISO 40 and have generally lower contrast than normal film. They both have a warm, pinkish color bias. This plus the linear screen that makes up the basis of the image forming layer – there is no grain in the conventional sense – makes Polachrome color slides stand out from the crowd. They are popular with photographic experimenters and those who want an image with a special effect.

Chromogenic film

This is a special type of black-and-white film that is processed in C41 chemistry, that is the type normally used for developing color print film. Mail-order prints on normal color paper produce an overall sepia tone, though blue, green and gray tonal variations are also possible! The negative produced is a black and white type which can be used for conventional black-and-white prints. Sharpness and tonal range are excellent.

What makes this film even more special is that it can be rated at different ISO settings on the same film, from ISO 50 all the way to 1600, or even 3200! An all-purpose black-and-white film suitable for general photography.

There's only one type available. It is manufactured by Ilford and is called XP2.

Tungsten film

Tungsten film is specially for use in tungsten lighting, such as room lighting because normal daylight film will give a red-orange cast when used under these conditions. While tungsten film corrects colors in an image shot under tungsten lighting it will give incorrect color reproduction when used in normal daylight. Results here will have a strong blue cast. The way to correct this is to use a pale orange 85B filter over the lens when using in daylight. An exposure increase of around 1 stop will be needed.

Tungsten film is useful if you intend doing a lot of photography without flash and using indoor lighting. But if you want to take just a few shots in tungsten lighting then a better alternative is to use a compensating filter. Try an 80A pale blue filter to start with. Because this filter reduces some of the light coming into the camera the exposure needs to be increased accordingly, by 2 stops. So if the normal exposure reading without the filter is 1/60sec at f/5.6 then this should be changed to either 1/60sec at f/2.8 or 1/15sec at f/5.6

Duplicating film

It may be necessary to make duplicates of original slides for purposes of protection or for making copies. Special film, called duplicating film, is available for this because making duplicates on normal film

Above left: Ilford XP2 film is processed in C41, the chemistry used for processing color print film. Prints made from it, on color print paper, have a strong blue, gray, or even a sepia result.

Above: However, Ilford XP2 negatives can be used to produce conventional black-and-white prints.

gives a high contrast result. Duplicating film is of low contrast, so reducing the effect.

The duplicating process needs even lighting to produce the best results and some preliminary experimentation may be needed. Special camera attachments are needed but you can also make duplicates by using an enlarger or photographing a projected slide. (For more on slide duplicating, see Chapter 8 – Special Effects).

Kodak's duplicating film, in black-and-white and color versions, is available in 35mm (36exp) cassettes or in bulk film lengths. Bulk film is several times longer than 36-exposure cassettes and is contained in special bulk film holders. Fuji's color slide duplicating film is available only in bulk film lengths.

Push-processing

Push-processing is used when you want to increase the ISO speed and sensitivity of your film. Say your camera is loaded with an ISO 100 film and a subject appears that needs a faster shutter speed than the light-ing conditions and your film will allow. Simply increase the film speed to a higher setting, ie ISO 200 or 400 or even 800. You'll then be able to use faster shutter speeds and correspondingly smaller apertures.

Push-processing is also useful when you want to take photographs without using flash, perhaps at a ceremony.

Pushed films need to be developed for longer than normal films. If you develop your own films, there will be instructions with the chemicals as to the correct development times for push-processing. If you have your films processed at a lab you must inform them of this, letting them know by how much the film has been pushed. A one-stop push, written as '+1', is from ISO 100 (or whatever is the original speed of the film you want to push) to ISO 200, a two-stop push (+2) is from 100 to 400 and a three-stop push (+3) is from 100 to 800. Note that the film speed in each case is doubled.

Push-processing is best used for effect or in an emergency, as it has some drawbacks.

Above left: Normal film (ie film for use in daylight), produces an orange-red result under tungsten lighting. This can look quite acceptable for inanimate objects, but less so for portrait subjects.

Above: Tungsten-balanced film's blue cast cancels out the orange glow, replacing it with a cool blue.

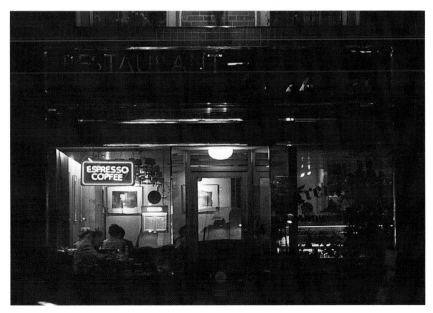

Left: A fast film, such as Ektachrome 400 (here pushed to 1600), is ideal for photographing in low lighting without flash. Its grainy quality and altered colors can be used for effect.

Left: Some fast films don't need pushing. Kodak's T-Max P3200 black-and-white film has an ISO rating of 3200, providing plenty of exposure flexibility, even when photographing in interior room lighting. Contrast and grain are well-controlled for such a fast film.

Contrast is increased, the grain pattern is more noticeable, and sharpness is slightly lessened. Also color accuracy can be seriously affected by pushing. While these characteristics won't appeal to those who need consistent results they may appeal to those who want special effects.

With manual SLRs simply adjust the film speed to the one you want. Most mid-priced AF SLRs (and above) have a manual, user-adjustable film speed range as well as a DX-coded one.

Slide films are best pushed to a maximum of 2 stops, while black-and-white film has a much greater push-processing range, depending on the film in use. It's possible to push-process color print film but this is less effective as it can result in unusual color casts that will be difficult to correct when printing.

How far can you push-process film? There's a limit, with +3 stops being a general maximum, before the image deterioration gets less acceptable. Some color slide films are custom-built for push-processing, with characteristics that help them to perform satisfactorily at different film speeds.

Black-and-white films suffer less drastically from extreme speed increases. Kodak T-Max P3200, for instance, is claimed to be pushable to ISO 50,000! This may seem excessive but in actual fact is only +4 stops increase from the film's nominal rating of ISO 3200.

Push-processing may not be suitable for general photography but, in the right situation, is an invaluable tool.

A less common practice is "pulling" of a film or giving it less exposure that its normal ISO rating. This is useful if you want to reduce the contrast of a high-contrast subject that you have photographed. It's also handy when you've accidentally overexposed a film and want to salvage it!

It works best with black-and-white or color slide films.

Films and airport X-rays

Most modern airport X-rays do not adversely affect films. It would take several passes through an X-ray machine to minutely affect the density (the image "thickness") of even the fastest, ultra-sensitive films, much less normal medium speed films. But even this will only be noticeable in a side-by-side comparison between a non-X-rayed film and an X-rayed one. However, while most modern airport X-rays are safe, there are airports with older machines that give out higher or longer lasting doses of radiation. Some are found on regular travel routes, while others are situated in destinations off the beaten track. In this instance, if in doubt carry your films in special commercially available lead-lined bags which give some protection. Alternatively, place your films in a plastic bag and ask for a hand-search.

Infra-red film is not affected by airport X-rays.

Film Facts

Manual/mechanical SLRs have little slots on the outside of the back of the camera for slipping in reminders of the film that's been loaded. Autofocus SLRs have small windows on the back plate which show just enough of the film cassette to reveal the film type, its speed and the total number of exposures.

Always keep film in its packaging until it's time to use it. Unpacked film left loose in a pocket or camera bag will pick up dust and bits of fluff which will lodge in the lips of the light-tight film cassette. This could cause a continuous scratch on the film when it's wound through the camera or may cause an opening in the lips that will let in light.

Always load and unload film in shade or subdued lighting, especially when using fast film. And when the film is finished and wound back into the cassette before opening the camera back always make these final checks: that the film rewind crank is loose and turns easily without resistance (manual SLR), that the LCD film symbol is flashing and/or that the letter "E" is visible (autofocus SLR and autofocus compact).

Once your finished film has been taken out of the camera and if it still has a bit of film leader sticking out – some autofocus SLRs do this – then use the spindle on the film cassette to wind the film all the way in. This is to ensure that the film is not acci-

dentally reloaded into the camera.

The reason many autofocus SLRs leave the film leader sticking out after rewinding is to make it easy for you (or the processors) to unwind the film for processing. If you prefer this then make sure that you mark the leader to show that the film has already been used. Either use a felt pen to write details on to the leader or place a sticky label on the leader with the appropriate processing information.

Most autofocus SLRs and many compacts have a mid-roll rewinding option, achieved by simply pressing in the film rewind control when you're part of the way through a film. Mid-roll rewinding is for those moments when the right subject presents itself but you happen to have the wrong film in the camera. But before you operate the rewind control make a note of the last frame number displayed in the frame counter or in the LCD window otherwise this could lead to some confusion at a later point. Then when you reload the film later you will know how far to wind on to when you start re-using the film.

Canon EOS SLRs wind a new film onto the last frame, so you *start* at frame 36 (or 24). This saves your exposed shots if the back is accidentally opened.

Left: Many manual focus SLRs have a metal pocket on the camera back. This holds the torn-off lid from a film carton, to remind you of the type of film that's loaded.

Film storage

All films should be stored in cool conditions, around 20°C. If they've been kept in a refrigerator they will need time – around two hours – to return to room temperature before being loaded and used. This is because cold film is brittle and could easily snap or kink if wound on too rapidly.

Films should never be kept next to a heat source or in humid conditions. Film emulsion is a perishable commodity and under these conditions will begin to alter characteristics and color rendition.

Ideally you should process films as soon as they've been shot, but if this is not possible then films should be kept in a cool dark place.

Expiry dates for unused film are usually around two years for color and three to four for black-and-white film. However, well-stored, unused films that are around six months past their expiry dates should still be usable, with little or no deterioration in image quality.

Light and Composition

Light is the vital component of photography. There are two types of lighting used in photography: natural and artificial.

Natural light isn't just the lighting that's provided by the sun during the day, it also exists in the period before sunrise and just after sunset. With today's films you can photograph under these low light conditions as well as in normal daylight.

The lighting at various times of the day gives different results. Once you know how to use all kinds of daylight you will have more control over the results you get on film.

Color casts

A color cast is caused by the "color temperatures" of different kinds of light. Unfiltered daylight in mid-morning has a blue-tinged cast that gives a cool look to colors, and needs filtration to make them appear more neutral. Late afternoon lighting has a warm color cast that may also be filtered but tends to be left untouched because it gives an attractive tinge.

Color casts caused by artificial lighting are more severe and need to be corrected by filtration. Localized color casts can even be seen in pale-colored areas, caused by nearby colored objects.

Artificial lighting is provided by a flashgun or light bulbs, strip lighting and street lighting. The main advantage of artificial lighting is that you can use it to light your subject even when there's no daylight to photograph by. But artificial lighting also has a drawback. The different artificial light sources that are available will cause a color cast to appear in your photographs if you use normal daylight film. This is because daylight film is only able to accurately record the range of colors found in daylight. If you want to shoot in artificial lighting with film that's intended for daylight photography only and you want the colors to appear as if they were in daylight, then there are two ways to solve the problem. The first is to use special filters to adjust the colors so that they'll come out correctly. Or you can use special film for

Right: Electric lighting at night provides its own illumination as well as being the subject itself (28mm Nikkor, Fujichrome 100).

Color temperature

Color temperature is the color of light under different conditions. The color temperature scale, measured in degrees Kelvin (K), shows the colors of daylight at different times of the day and under different conditions. It also shows the colors of various forms of artificial lighting. It can be used to show how much corrective filtration is needed to convert other lighting to normal daylight (5500K). Flash illumination is around 6000K and requires no corrective filtration.

For most photographic purposes, it's necessary to know that the color temperature of tungsten lighting – 3200K for studio lamps, and under 3000K for normal tungsten room lighting – will need a blue filter to make the colors neutral.

Different times of day have varying color temperatures, too. If you wish to correct them to bring them to "normal" lighting you can use corrective filters. With lighting such as dawn and dusk (around 3500K) and sunset (3000K), corrective filtration may destroy the visual impact that this lighting has on a scene (for more on filtration see Chapter 4 – Filters).

Left: Low early evening lighting demands a lot from an ISO 100 film, even when using a compact camera like the Canon Prima.

Below: Flash, the most convenient form of emergency lighting, clearly illuminates the subject.

Far left: A simple still life setup using one light-source. The one-sided illumination shows surface detail. Instead of a studio flash you can use a normal flash unit connected to your camera's sync socket.

Left: A reflector placed opposite the light-source bounces light back into the subject's other side. This shows more subject detail and shape.

photographing in artificial lighting, which will also reproduce colors accurately under the particular conditions.

There is one source of artificial lighting where accurate colors will be maintained when used with daylight film: *flash*. Flashguns, and studio flash, are approximately the equivalent of daylight.

Learning to use flash well takes a little time but is worth the effort. Once you know how to get the most out of even a basic flashgun you will have a powerful tool which will allow you to take photographs anywhere, no matter how bad the available lighting.

Still Life – first steps

Controlled lighting, using just a basic flashgun, can be used indoors for simple but effective still life shots. Shadow areas should not be too dark and the highlight areas not too bright, with enough of both to show the form and texture of the photography subject.

The lighting itself can be diffused by tracing paper or a large diffusing attachment, many of which are made to fit flash units. Or the flash illumination can be used direct, depending on the lighting result you want.

Similarly, the background color must be chosen to emphasize the subject. While you can use any material, say, a dark, non-reflective cloth or a material with a shiny, textured surface, a good starting point is a sheet of white pliable card. This can be bent upward behind the subject and held in position by a rod or taped to a wall.

Place your camera on a tripod and position your flash to one side of the subject at an angle of 45 degrees. You will need a camera with a flash sync socket to connect to the flash so that it can be used away from the camera. If your SLR doesn't have one there are special hotshoe mounted adaptors that have one built in.

The sensor in the flash unit, when pointing toward the subject, may not give a correct exposure in this setup. A remote sensor placed in the camera hotshoe will be able to read the reflected light from the flash, via the subject, and give a correct result.

Although this setup will pick out the subject's surface details and form well, the side of the subject that's away from the flash illumination will be in shadow. This kind of lighting is good for emphasizing texture or other relief details of a subject, such as a statuette, and can even add a bit of drama. But you may want to throw some light back into this shadow area for a more balanced result. If you haven't got a second

Below: A simple studio setup, using two units. Both were either side of the subject at a 45deg angle and were covered with diffusing material.

flashgun then place a reflector – a large piece of stiff white card will do – close to this side of the subject, though not so close that it will be included in the photograph. The shadow area will then be greatly lessened and details on this side of the subject will be clearly seen.

The above is a basic setup that can be used for a range of small still life objects.

You can add variety by changing the angle of the flash, using a different colored background, using reflectors other than white, such as silver or gold foil. You can also use another flashgun, perhaps a lower powered one, as a secondary light source. To control this second unit from the camera you can use the hotshoe-fitting multi-flash adaptors that have more than

Flash

The flashgun that attaches to a camera is a versatile portable light source. Although there are many models on the market, they fall into two main categories. The first type is an automatic flashgun, with a manual option. With this unit, in auto mode, you set the aperture on your lens, and your camera's flash sync speed, then set the ISO speed on the flashgun.

Depending on how advanced your auto flashgun is, you may also have the option of setting the aperture automatically from the unit itself and either read off or select the distance to the subject. A sensor in the flash will make it give out just enough illumination to light the subject, and no more, before turning itself off. The built-in thyristor circuit will hold back the portion of the battery charge that hasn't been used for this flash burst and will add it to the next one.

With the flash set to manual, the flash output is not automatically regulated. It comes out as one full-power flash burst. The amount of light that reaches the subject is regulated by the size of the lens aperture. Manual flash may seem wasteful but it's a boon for illumination in very dark conditions, and for large or distant subjects that require a full-power burst of flash. It's also useful for illuminating a large area, for bounce-flash work, or for special effects photography.

The second type of flashgun is automatic with a manual option, plus a **dedicated** TTL option. These special flashguns work closely with specific brands of SLR. Information is exchanged between the flash and the camera, details such as the aperture and shutter speed used, the distance that the lens has focused on, the ISO speed and the state of readiness of the flashgun (ie whether it's charging up or fully charged). Depending on the dedicated flash system you use, there will be information in the viewfinder relating to flash use. A flash-charging or flash charged symbol will appear. An "OK" sign may light up to confirm that the flash exposure was correct. Alternatively, a green flashing lightning symbol lights up.

Those SLRs that have special sensors to read light coming off the film itself (ie OTF sensors) can be used with dedicated flashguns.

Most flashguns manufactured by camera makers for their own models are dedicated units. And some independently manufactured flashguns have attachable modules that offer dedication to specific SLR makes.

The dedicated modules are produced to link up with the main SLR brands. And those for AF SLRs have built-in autofocus illuminators.

Top: An SLR's features enable photography in very low lighting but shutter speeds of 1/15sec and slower will cause image shake. The color cast was caused by using daylight balanced film in artificial lighting.

Above: Direct flash illumination records the subject in sharp detail, and gives accurate color rendition.

one flash sync socket. Simply attach another flash lead between the camera and the second unit. The second flash can also have a diffuser over the flash-head, or you may prefer not to use one, so as to give a harder lighting effect on the other side of the subject.

You can keep fine-tuning the lighting results you want by using different types of reflector, diffusing material. even different exposures.

As your skill and experience grow you may want to graduate to a single and then two or more studio flash units. These come in a range of power outputs and prices but are more powerful than ordinary flash-guns, giving plenty of creative control over lighting.

Composition

Composition is the arrangement of different parts of a scene or subject to produce a photograph. Good composition is when a photograph has all the parts in the right balance so that, together, they provide an image that pleases the eye. Poor composition is when the eye is left to wander over the scene or is distracted from the main subject by a distracting color or shape, away from the main area of interest.

The Golden Mean

Renaissance painters established a set of proportions on which to base the compositions of their paintings, drawings and sculptures, and which produced a balance of elements that was most pleasing to the eye, or to most eyes. Called "The Golden Mean" it was used as a basis for much of their work and can be used by the photographer to ensure a well-balanced and visually pleasing composition. It is based on a rectangular frame, with the center of interest being positioned one-third of the way into the picture.

Many people find this an acceptable and comfortable balance of elements. It is still in use today and is especially useful when you're presented with a great image waiting to be photographed but haven't found the best way to arrange its elements in the camera viewfinder.

Poor composition can happen even with a subject that is beautifully lit, properly exposed and sharply focused.

A guideline for good composition is the rule of thirds (see The Golden Mean box (opposite)). It states that if the main subject is placed about one third of the way into the frame then the whole composition will have a pleasing balance to it. It is a rule that is often used in painting and it does

give a short-cut to a well-composed image. It is especially suited to landscape photography where the viewer needs to find a focal point in a large expanse of scenery. There are other rules relating to lens use that need to be observed if you want a well-composed shot. For instance, wide-angle lenses should not be used for close-up portraits as they cause unflattering distortion of the subject's features.

Rules of composition like these are well worth following if you want to ensure that your shots are well-composed and pleasing to the eye and, in the case of portraits, pleasing to the sitter, too. *But* if you stick to them for every single shot your photographs may eventually have a sameness about them. Try breaking the rules now and again. An image that breaks all the rules of composition can sometimes have

Above: The SLR viewing facility makes it very easy to fill the frame. This was taken with a 28mm Nikkor on Kodachrome 64 film. A small aperture of f/11 gives extensive depth of field.

great impact. This could be due to an unusual combination of elements or colors or simply something special about the subject itself, perhaps an expression on a portrait subject's face which doesn't need to rely on conventional composition for its impact.

For the image to have real impact it could grab your attention in a quiet way or a dramatic way. Ultimately, the way it achieves this is up to you, the photographer, and the way you want to record a scene or subject.

Depth

There are different ways to give your pictures a feeling of depth. The most obvious way is to show objects receding into the distance. With landscapes you could include part of a foreground subject: a rock, a plant, perhaps a road or river leading into the scene. Alternatively you could lower your viewing angle so that one or more of these elements is directly in front of the lens. You'll need to do this with care so that the foreground doesn't dominate, obscuring the rest of the scene.

The effect will work better if the depth of field that's chosen is small so that the foreground items are sharp too.

Scale

Scale shows the relationship of an object to the rest of the composition, so giving an idea of size. In a landscape shot, for instance, a human figure or some animals

give a measurable scale to the shot. And if you need to convey scale in close-up photography, an item such as a pin or any small everyday object will give an impression of the size of the subject you're photographing.

It works well in a landscape where the scale of a scene, say a stretch of water, is shown by the inclusion of a human figure or a boat.

Abstract

An abstract photograph is one where the image is not recognized as a conventional scene or subject yet the different elements

Right: The cars give a clear idea of the building's size.

Below: Careful positioning keeps unwanted details out of the image.

Bottom: This abstract relies on a balance of shapes and colors.

in it combine to form a composite whole. But whether the composition is attractive or not depends on the viewer. What might be considered a masterpiece by one person may be rejected by another.

At its best abstract photography is an exercise in photographic composition, using the simplest elements to create impact.

Filling the frame

Filling the frame with your subject keeps all the elements of the photograph within the image area and improves composition. SLRs, because of through-the-lens viewing, make it easy to fill the frame with the subject. Another useful compositional tool is the zoom lens, which enables tight and accurate framing of a scene or subject by a simple adjustment of the zooming ring.

Cropping

While it's possible to make all the compositional decisions at the picture-taking stage this may not always be easy, due to time, viewing angle, obstruction, etc. Many images can be saved or even created later at your leisure by cropping at the printing stage or by masking out unwanted areas in a projected slide. In fact it's a good exercise to place two pieces of L-shaped card to form a rectangle over a contact sheet or single image and see the effect that cropping the image in different ways, perhaps even isolating a small part of the image, has on the composition.

Viewpoint

The angle you take a picture from can sometimes make the difference between an ordinary shot and a winner. When

you're confronted with a photogenic subject, whether it be a landscape or a portrait, photograph and include all the elements about the scene that made it photogenic in the first place. Then change your position, move forward a little or backward. Shoot low from the ground or, alternatively, find a high position like a hill or a window in a building to photograph from. These will not only give a new and different look to your shots but may also include other elements, many of which may strengthen the composition as a whole. Of course, they may also include elements that detract from the composition. It's up to you to try it out, exploring every angle, including the obvious ones. You will end up with the same scene shot from several different viewpoints. This will give you a greater number of images of the scene to choose from and, if it's taken while traveling or on vacation, should make a re-shoot less necessary.

Framing

A photogenic subject may have nearly all the components for a great composition but there may be that extra something that's lacking. Finding a suitable frame to place around the scene is one way of holding the composition together. Trees are a good way to frame a landscape, as are silhouettes of man-made structures such as gates, the broken walls of dilapidated buildings, anything that provides an outline for your image.

Windows are ready-made picture frames, looking out at a garden or street.

Top and above: Cropping. A cropped version of the above image emphasizes the flowers and vase.

Left: Viewpoint. This was photographed through a skyscraper window and looking down (135mm lens).

Above right: A window created a frame for this image.

Right: Patterns. The repeated patterns of these berries create their own impact.

Patterns

Patterns are found everywhere and can say a lot about the particular scene you're photographing. Lots of cars photographed with a long telephoto lens to dramatically compress perspective can say something about traffic congestion. Alternatively, rows of flower-heads with their repeated colours and shapes convey an impression of colour in nature without the need to show their stems or the flower-beds.

A zoom lens will help to crop in on pattern subjects, giving you the flexibility of choosing how much or how little you wish to include.

Focal point

The center of interest or focal point (nothing to do with focusing) is the part of your composition that will first attract the viewer's eyes. It could be anything, a patch of red, a strong silhouette, the expression on a person's face, a bird in flight. It is whatever there was about the scene that made you want to capture it in the first place. But it needs to be used with care. Too strong and it could make the rest of the scene unnecessary, or it may be the key element that holds the scene together. Nearby colors or strong shapes that compete with it may reduce the impact. Similarly if it's not clearly shown or if it's a very small part of a larger, busier scene or subject it will also lose its impact.

With static subjects such as nature or landscape it's often easier to choose a focal point. But with portrait photography, unless it's a formal composition, the move-

Above: A Cokin gray graduated filter and a Hoya polarizer added drama to the stormy sky.

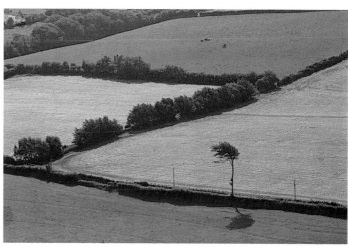

position. Vertical framing suits portrait subjects or tall items such as buildings or trees. Most photographs are taken in the horizontal format but a suitably composed vertical subject will give a welcome change of pace for the viewer.

Using color as emphasis

In color photography color itself is the dominant element and, whether you want it to or not it will, nine times out of ten, control a composition no matter what else is included in the frame. So it needs to be used in the right amount and at the right position in the frame. However, some colors will enhance and even strengthen the composition. Try experimenting with one or two colors, perhaps one dominant color and one secondary color. The most important factor is whether the image as a whole holds together.

Above: The tree and its shadow are positioned approximately at the intersection of thirds (see The Golden Mean, page 40). 135mm lens, Fujichrome 100.

Below: The same scene as above, but as a vertical composition. With the tree placed at the lower center of the scene, the composition has a more rigid, closed-in look.

ment of people and their positioning in the scene will give rise to more than one focal point. The trick is to try and anticipate when a particular picture shape, a particular grouping of people, will arrange itself into the right composition, to try and predict what will happen next. This is a skill that needs to be learned and, coupled with a knowledge of human nature, are important parts of the armory of an experienced photojournalist.

Vertical or horizontal?

By simply turning your camera on its side and framing a vertical view of your subject you will dramatically transform it. You will need to re-position your center of interest and look for other, vertical elements in the scene to make an effective, balanced com-

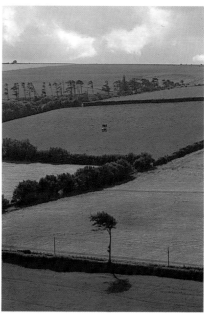

Colors in nature generally complement each other well. It's only when man-made structures or objects are photographed side by side or next to nature that it's necessary to take more care in positioning the picture elements.

Ultimately there are few hard and fast rules. A subject with a jumble of different colors may make as effective a composition as one with just one or two colors. The main thing to remember is that if it's a strong color (ie red) it needs to be at or near the center of interest of the composition so as to emphasize the focal point. Position it at the edge of the scene and it will draw the viewer's eye away from the center of interest.

Breaking the rules

All the above rules will help the photographer to create order out of what might have been an undisciplined composition. But use them with every shot and your images will have a predictability about them and may even under-exploit some of the stronger picture possibilities.

Try out new and different arrangements of picture elements sometimes, use the "wrong" lenses for the wrong subjects, use shallow depth of field for a subject with lots of foreground or background interest.

While focusing systems strive to give the sharpest focus possible, why not try a totally defocused image? Pick a subject that has bright colors or a strong shape and then defocus it so that no part is sharp,

with the image being broken up into a series of just recognizable blobs. There are any number of "wrong" ways to use the camera controls to get an image that stands out. It just takes a little trial-and-error, imagination and luck! (see Chapter 8 – Special Effects).

Breaking the rules once in a while is a healthy habit well worth losing a frame or two off a 36- or even a 24-exposure roll.

Developing your own style

Your own style of photography is dictated by the things you look for when you photograph, whatever the subject-matter. It's having absorbed the rules of composition and then totally rejecting them, or adding your own twist. It's a result of the way the photographer instinctively arranges elements to form a composition, preferences in exposure or lens or filter use, preferences in the processes and procedures used in darkroom work. Style is also a result of the images that have inspired you, your emotional response to certain colors, even your upbringing has a role in establishing your particular style of photography.

For something that's not easy to accurately define, the style of a photograph is immediately recognizable. The more you take photographs and the clearer you are about the results you want from your images, the stronger your photographic style will become.

Above: Color as the composition. Although the veins of this leaf and the droplets are clearly seen, the green hue is the overwhelming impression. Tamron 35-80mm SP.

Above left: Color as emphasis. Red is a dominating color, but here it balances with the distant skyline. 28mm Nikkor.

Left: Breaking the rules. I intended to get a blurred result by using a slow shutter speed (1/30sec). Instead, I got this grab shot.

Common Picture-taking Mistakes

Flash hotspot

This appears as a strong highlight on a shiny surface such as a window behind or near the subject. Alter your position so that the flash is not in the line of sight of the shiny surface or get your subjects to position themselves in front of a different background.

Foreground subject too close to flash

An over-exposed "burnt-out" effect is because the flash is too close to the foreground subject. The effect is especially disturbing if a highly reflective surface such as a white table-cloth is in the foreground. The cure is to raise the camera a little to exclude the foreground object. Or you could move further back so that the effect of the flash on the foreground object is lessened.

Redeye

This common complaint is caused by the flash's illumination reflecting off the blood-rich retina at the back of the eye, causing the red coloration. The redeye reduction systems found in many compacts, and one or two autofocus SLRs, can sometimes reduce the effect. They use one of two methods of redeye reduction. The first is via a pre-flash or several pre-flashes which are emitted before the main flash fires. These pre-flashes cause the pupils (the apertures) of the eyes to contract so reducing the size of the area of potential redeye. The second method uses a steady beam, with much the same effect, before the main flash fires. However, there is often a noticeable delay between the pre-flash or beam before the main flash fires. This can sometimes catch the subjects, and

their expressions or poses, at the wrong moment.

If you don't have a redeye reduction system then try these methods. Just before you take your photograph ask the subjects to look at a light source so as to contract their pupils. And try and use your flash off-camera, as the closer the flash is to the lens, the greater the risk of redeye. If you use color print film you could correct this at the printing stage. Or, as a last resort, you could use black-and-white film!

Incorrect flash sync speed

The flash sync speed is the fastest shutter speed that can be used with flash, at the moment when the whole of the image frame is uncovered. Never use a shutter speed faster than your camera's flash sync speed or one part of the two-part shutter curtain will be included in the image, causing a dark strip.

Above: Camera shake. Slow shutter speeds and low lighting don't mix, unless your camera is rigidly supported.

Left: Redeye, a common problem with built-in flash, but there are ways to solve it (see text for methods).

Camera shake

The image blur caused by camera shake can be cured by holding the camera more steady or leaning it against a support of some kind or using a tripod. A shutter speed at least as fast or faster than the figure for your lens's focal length (ie 1/60sec for a 50mm lens, 1/250sec for the longest focal length of a 70-210mm zoom) should also solve the problem.

Subject too small in the frame

With the subject too small in the frame the eye is left to wander around the picture when it should be concentrated on the focal point (ie the subject). A closer viewpoint will help to strengthen the composition. In fact, filling the frame with the subject, whether it's a portrait, landscape or whatever, should dramatically increase its visual impact.

Background sharp, subjects not sharp

A common fault with users of autofocus cameras who omit to use the focus lock facility. The autofocus target area has focused on what was at the center of the scene rather than on the two subjects. Some of the more advanced cameras have multi-zone autofocus which also senses subjects outside the central area and gives correct focus.

Tree growing out of subject's head

Take note of what is behind or next to your subject when composing your image, so as to avoid combinations like this! Look out also for nearby signposts or symbols.

Horizons not level

This can happen when you're concentrating too hard on getting the shot and not enough on camera alignment. A mild tilted horizon may be corrected by cropping or may not be so noticeable in, say, a landscape scene with hills or vegetation. It will be more noticeable in a scene with a distinct horizon line such as a seascape or a city skyline.

Left: Autofocus systems target the center of a scene, so that items not in the center won't be focused on. This (see picture) is a common error and can be corrected by using focus lock on the subject first, then pressing the shutter button.

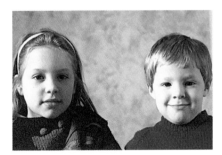

The X factor!

Sometimes – very rarely – an image that breaks all compositional and other photographic rules can have an impact all of its own. Some of the best photographic special effects have been stumbled upon in this way. And if you can remember the camera settings and conditions in which the shot was taken, all the better!

Blank frame

This could mean problems with your shutter or film wind-on mechanism. A more common reason is that the film has not been properly wound on. Commercial processing labs regularly receive large numbers of (blank) films that haven't been wound on, though auto film wind systems in cameras are making a difference. Some cameras have a device that moves to show when film is advanced through the camera. This can be checked, so ensuring that the film has been properly wound on.

Left: A symmetrical composition can sometimes work. In this image, there is visual interest in all three planes (ie sky, middle and foreground).

Filters

Filters can be divided into two broad categories: those that are necessary and those that don't need to be used so often, yet can produce a great image if used in the right way. Special effects filters are in the latter category. In this chapter we'll be looking at the necessary filters. (For more on special effects filters and the effects that can be achieved look at Chapter 8.)

Filters are either round or square. Round filters are made of optically clear glass and screw on to the front of the lens. They come in different sizes to correspond to the filter thread size of the lens. A lens's filter thread size is written on or near the front, in millimeters (49mm, 52mm, etc). This detail is also found in the lens cap.

Square filters slot into a special holder which itself has an appropriately threaded adaptor ring that screws on to the front of the lens. Square filters are made of optical resin and are lighter than glass ones. But they scratch easily and need to be handled and used with extra care.

All filters placed over the lens reduce the amount of light that enters the camera. Some reduce the light very slightly, while others cut out three or more stops (apertures) of light. The amount of light that is reduced will need to be compensated for when the exposure is calculated manually or electronically, in order to give a correctly exposed shot. This is called the filter factor and is shown by an "X" following a number. Each of the filters mentioned in this chapter will have its filter factor shown near it, so you will know how much adjustment is needed to give a correctly exposed shot.

However, as 99 percent of SLRs have through-the-lens (TTL) metering systems, they will adjust exposure automatically to compensate. In this case, the filter factor can be used merely as a guide to show the amount of adjustment that will take place. So if the filtered exposure setting is going to result in a much slower shutter speed than you'd planned for, or an aperture that's a little too big for the depth of field you want, then you can anticipate it.

UV and skylight filters

An ultra-violet (UV) filter (1X) reduces the very pale blue cast seen when shooting hazy subjects in daylight with color film. The UV filter has the effect of making colors slightly stronger and also cutting down the haze seen in the distance in landscape shots.

Skylight filters (1X) are a very light pink

and give a slightly stronger effect than a UV filter would give.

Both these filters are additionally useful as protectors for the vulnerable front elements of your lenses against sand, moisture and knocks. And as they both have low filter factors the increase in exposure that's required is virtually nil.

Above: Square filters fit into special adaptors with filter thread sizes suitable for different lenses.

Filter Factors

The following table shows the approximate amount of exposure increase needed to compensate for a common range of filter factors (FF). Note that the filter factor figure is a guide to the f/stop adjustment required for correct exposure.

FF	Exposure increase in f/stops
1 to 1½×	½
1¾ to 2½×	1
3 to 5×	2
6 to 8×	3
12×	4

Polarizing filters

Polarizers (3.5X) reduce the amount of polarized light that reaches the lens. Polarized light is reflected off the surface of shiny objects. A polarizing filter, when placed at right angles to the sun, cuts down or completely gets rid of the reflection. So what you see is the subject in all its true colors.

Most consist of two separate pieces of glass which can be rotated independently of each other. Polarizing filters are rotatable in order to help you find the best angle to give the best polarizing effect.

The effect of cutting down the polarized light is dramatic. Reflections disappear, even the sheen on water vanishes so that it becomes completely transparent. Removing the shine makes leaves look greener.

In addition to removing reflections, polarizing filters make colors more intense. When polarized light from a blue sky is reduced by the filter the sky becomes a stronger, richer blue.

There are two types of polarizing filter: linear and circular. "Circular" in this case simply refers to the type of polarizer rather than the shape of the filter itself, as 99 percent of polarizing filters are round anyway.

Both filters deliver the same end-result. But if your camera uses a beam-splitter when sensing light for exposure or auto-focusing then using a linear polarizing filter will affect the efficiency of both systems. In this case a circular polarizing filter should be used as it will not adversely affect exposure and focusing. Your camera manufacturer will advise whether you need to use a circular polarizer.

Color correcting filters

These are filters that can be used to tweak colors so that color consistency can be maintained from one batch of film to another. Many professional photographers rely on these to ensure a high degree of color accuracy in the various subjects they photograph.

About the only color correcting filter that may be necessary for general use is an 81A. This pale pink filter is similar to a skylight filter. It's useful when photographing

subjects in daylight as it reduces the pale blue cast that often occurs. It also gives an overall "warm" appearance to scenes. And as it has a filter factor of 1X the exposure will only need to be slightly adjusted.

Color compensating filters are vital if you intend using daylight balanced films in artificial lighting. There are two main types of artificial lighting to deal with: tungsten and fluorescent.

Top: Without a polarizer this still-life scene includes the unwanted reflection.

Above: Using a polarizer the scene has lost nearly all of the glass reflection.

Left: Subtle use of a light gray Cokin filter has darkened the skyline.

Tungsten lighting

If you use daylight balanced film in tungsten lighting the result will be a strong yellow-orange cast. This may suit a small proportion of shots (ie if you intend to create a particular mood), but for most purposes the results are unattractive and give highly inaccurate colors.

In order to produce colors that are close to normal a blue filter needs to be placed over the lens when using daylight film in tungsten lighting. The strength of the blue filter you will need varies, but a good starting point is an 80A blue filter. This is dark blue and has a filter factor of 2.4X, so an exposure adjustment of just over one stop will be needed.

Fluorescent lighting

A common result when using daylight balanced film in fluorescent lighting is that everything takes on a greenish hue. Colors are consequently affected, especially pale ones. To bring the colors closer to normal you need a filter which has a strong pink hue. Try using a 30M (magenta) filter or an FL-D (2×) filter over the lens.

If these filters are difficult to obtain, or if their filter factors are too strong for your needs, then one alternative is to use color print film. Most film processing lab machines automatically compensate for all but the most extreme color casts when printing. Or if you develop your own films you can simply adjust the filtration at the printing stage to get rid of the color cast.

Another answer is to try fast slide film. The color balance of many of these fast films, especially those using earlier film technology, is such that they often neutralize color casts so that resulting colors are generally closer to acceptable and often don't need filtration.

If you intend doing a lot of photography under artificial lighting then a powerful flashgun is another answer. Or if you prefer you could use a tungsten-balanced film, made by Kodak or Fuji, that is specially balanced for use in artificial light.

Filters for black-and-white film

Colored filters can be used with black-and-white film to make some subjects stand out in relation to others. Depending on the color you use, the filter will give lighter or darker tones, or contrast to the scene or subject. They also affect overall contrast. Some colored filters have more subtle effects than others. And different

Neutral density filters

While films and exposure are geared toward providing adequate light for a given subject and lighting situation, there can also be too much light. A fast film such as ISO 400, when used on a bright day, may demand an exposure that goes beyond even the combination of the fastest shutter speed and the smallest aperture that your camera and lens set-up can handle. Photographing, say, a white sunlit building may give an exposure setting which may be at the limits of your shutter speed and aperture ranges, such as 1/1000sec at f/32. And the camera may *still* give an "overexposed" warning.

Since you cannot increase the shutter speed or make the aperture any smaller so as to give a correct exposure setting, you'll need to reduce the amount of light that's reaching the film. To do this a darkening filter, called a neutral density (ND) filter, needs to be placed over the lens. It's a uniform gray color, and its only effect is to cut down the light going through the lens and reaching the camera's meter. The resulting exposure reading it gives will not be at the limits of your shutter speed and aperture combination. Therefore the resulting exposure reading will give you more room to maneuver. A neutral density filter will not directly affect the colors of your chosen subject.

ND filters come in a range of strengths, so being able to cut down the amount of light reaching your film, no matter how strong the lighting.

A polarizing filter can also be used as an ND filter.

strengths within these color groups (ie light, medium, dark or very dark) further affect the result.

The following filters are a good starting point for adjusting results in black-and-white images.
● Yellow: Darkens skies and increases contrast. It also acts as a haze-reducing filter. Filter factor: 2X (requires an exposure increase of one stop).
● Orange: Makes skies very dark and increases contrast more than yellow filter. Also darkens greens. 2.5X (increase of just over one stop).

Right: An illustration of the dramatic ways that — from top to bottom — yellow, orange, and red filters can affect a black-and-white image.

Far left: Fluorescent lighting has caused this color cast.

Left: Using a Hoya FL-D filter has neutralized the color cast.

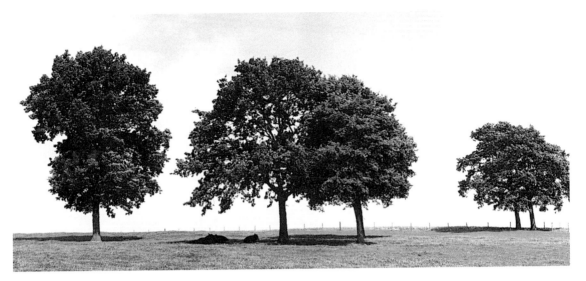

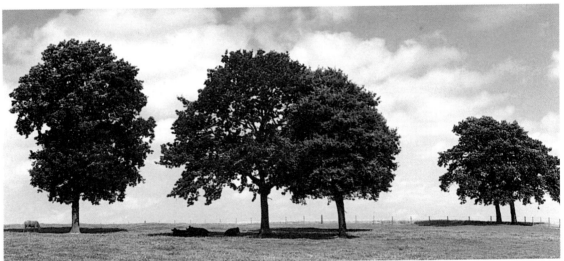

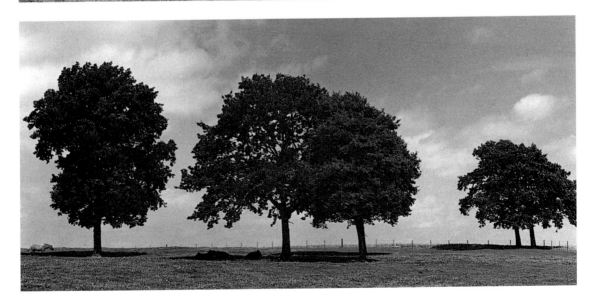

● Red: Makes blue skies, and greens, almost black. Gives extremely high color contrast. 8X! (increase by three stops).

●Green: Darkens skies but lightens greens. Enhances skin tones. 4X (increase by two stops).

● Polarizer: The versatile polarizer can be used with black-and-white film, too. Here, it also reduces or eliminates reflections. It makes a blue sky a darker shade of gray. Use a polarizer and a red filter together to create ultra-high contrast for dramatic results. But take note of the combined filter factor: around 12X!

If you want to keep things even simpler then use either a yellow or an orange filter. These can be used to increase contrast yet have reasonably workable filter factors. And they can double as ultra warm-up filters when used with color film.

Tips
● Vignetting is darkening at the corners of an image. It occurs when using a long telephoto lens. It is also caused by a filter with a deep rim, or more than one filter on the lens at once. To minimize the problem try and use one filter at a time. Also, try and find filters that have shallow rims. Where possible favor a wider rather than a smaller aperture, as smaller apertures emphasize vignetting.
● Clear glass filters, such as UV filters, can be used to create soft focus effects. Smear grease over the surface to cause a softening

of the whole scene. Or breathe on the filter and the condensation will form a misty coating that gives a soft focus effect. You can also draw on the surface with colored felt pens, creating your own special effects filters.
● Keep two UV filters, one for home-made special effects, one for normal use.
● If a filter is screwed too tightly on to a lens tie a rubber band around the filter ring to give a better hand grip to enable you to unscrew it.
● Filters are easily scratched, especially those made of resin. However, one or two tiny scratches may not affect your photographs unless you include part or all of a light source within the image.
● When not in use *all* filters should be kept in their cases or, if attached to a lens, covered by a lens cap.
● Camera shops often include filters in bargain boxes, and it's possible to pick up some very reasonably priced ones this way, such as UV, skylight and colored filters for use with black-and-white film.
● The larger the circumference of a filter the more it costs. So, if you have several lenses that share the same filter thread size, this will save you from having to buy several sizes of the same filter. Alternatively, the adaptors that fit into the holders for use with square filters are accessibly priced. If you have lenses with different filter thread sizes it shouldn't cost much to have two or three of these adaptors of the appropriate filter thread fitting.

Right: An unfiltered pic of a low sun in October (500mm mirror lens).

Below right: An orange filter has given the image a warmer look.

Below: A gray graduated filter was used to give tonal interest to a bland sky (135mm Nikkor. Kodak Tri-X black-and-white film).

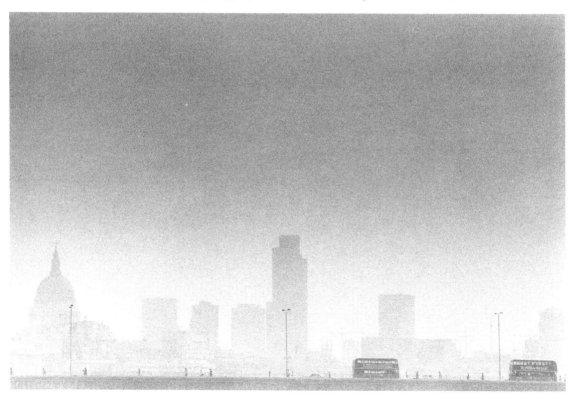

People

Clearly, people can be photographed doing a range of activities and in a variety of situations, with expressions and postures that show every emotion. They are also one of the most challenging subjects to photograph well. Part of what makes a successful portrait is the photographer's interaction with his subject.

People photography can be divided into specific areas:
● The simple yet ever-popular family snapshot brings joy, records important or just everyday occasions, and is a source of pleasant memories. And, thanks to auto-focus and sophisticated exposure systems, the spontaneous snapshot is now easier to photograph than ever.
● There's also a place for more formal portraiture such as the recording of events like weddings or graduation ceremonies.
● Sports and action photography capture people at a peak of physical effort, and demand both technical and creative skill from a photographer.
● Good reportage and news photography involving people sometimes consist of an

Left: Smiling family snaps are easy and have obvious appeal but, as the costume suggests, this little boy was playing a serious role!

Below: This mother-and-daughter portrait, although clearly a studio shot, benefits from the relaxed pose of both subjects.

Far right: A wide-angle lens already pre-focused at around 3m was used for this shot.

emotional element with lightning-fast re-actions.

Getting good photographs of people can be a stimulating challenge. The advice in this chapter is intended merely as a starting point for taking memorable portraits of people. Constant practice plus looking at good photography in newspapers, color supplements, magazines and books will help to develop your photographic "eye" and a style of your own.

Equipment

Lenses
People can be photographed with any lens though it's useful to have an awareness of the characteristics of certain lenses and the effects they will have on portraits.

Wide-angle lenses are ideal for photo-graphing groups though the barrel distor-tion, most noticeable at the edge of the frame, that's evident with lenses of 28mm focal length and wider, will show distor-tion in the subject you're photographing. And close-up portraits taken with wide-angle lenses will show more pronounced, even grotesque, distortion. This is fine if you want to convey an off-beat, comic angle to the portrait. But they should be avoided if you want to take a flattering photograph of your subject.

Wide-angle lenses are suitable for photographing a portrait subject or sub-

jects in a particular setting, including ele-ments of that setting in the picture. Because of this aspect, reportage photo-graphers and photojournalists have tended to favour the 35mm focal length. This has the ability to give a wide-angle view of a scene as well as including one or more

Above: People in their work-places make ideal portrait subjects. Their surroundings add a real-life dimension to the composition.

Above right: In this photograph of East European refugees, the strong focal point – the woman's face – plus the body language of her brothers, combines to create a powerful emotive image.

Right: People constantly and unknowingly arrange themselves into photogenic groups or formations that need to be quickly captured.

Left: The three groups of people in this shot are united by the snowy surroundings.

portrait subjects in the frame. And all without extreme barrel distortion. It's very useful as a "normal" lens, too.

A telephoto lens is another useful portrait tool. It is able to close in on a face or head-and-shoulders, isolating the subject from his or her surroundings. And as you can comfortably fill the frame from a distance with a telephoto, it's ideal for candid photography.

Telephoto lenses also have the ability to flatten perspective which, with people, means that facial features are shown as if they were all on one plane. This can have a flattering effect, making aspects such as large noses or protruding chins seem less so when photographed straight-on. And the longer the focal length the more flattering is the effect. This "lie" by the lens (not the camera!) is important to portrait subjects who wish to appear more attractive and is just one tool in the armory of a skilled portrait photographer.

Another advantage of a telephoto lens is the shallow depth of field it offers, useful for getting rid of distracting backgrounds.

For photographers and portrait subjects alike who want a more accurate recording of the face and its features, a moderate telephoto lens is best. Telephotos of 90mm and 100mm have become regarded as *the* portrait lens focal length. They record the different parts of the face in accurate relationship to each other, yet they flatten

perspective sufficiently so as to flatter the subject.

Telephoto lenses also create a physical distance between subject and photographer. This is reassuring for shy portrait subjects, making them feel less intimidated by the photographer's presence.

Above: A wide-angled lens has effectively captured this group and the surroundings.

Far left: A long telephoto lens was used to capture – undisturbed – this homeless man (Tamron 300mm SP, Ektachrome 400+1 stop).

Left: A wide-to-tele zoom may be all you'll ever need for your portrait photography (Tamron 35-80mm SP).

Most major SLR manufacturers and independent lens makers include a 90mm or 100mm portrait lens in their ranges. Some of them have additional optical features that enable them to double as macro lenses. But both types of telephoto tend to be more expensive than a standard zoom lens which incorporates these focal lengths within its range.

Tripod
This is ideal for formal portraiture or photography where the subject or subjects are likely to be in one specific area. A tripod with a freely moving ball-and-socket head will make it very easy to adjust the camera position.

A tripod-mounted camera also leaves your hands free if you need to hold a flashgun off-camera, or a reflector.

Cable release
A cable release cord enables remote firing of the camera, so reducing the risk of camera shake. The cable release cord has a plunger at one end that screws into the threaded hole in most manual SLRs' shutter buttons. At the other end of the cord is the button which activates the plunger and therefore the shutter button. Few new autofocus SLRs have cable release sockets, either mechanical or electronic. Those that do have either an electronic release or an infrared wireless remote device. It's suited to photography in static situations.

Flash sync socket
This socket offers a connection from the camera to an off-camera flashgun, via a flash cable. Most manual focus SLRs have a flash sync socket. A small number of autofocus SLRs do, too.

Flash cables vary in length, so it's possible to use a flashgun that's connected to the camera yet some distance away, for some versatile portraits.

Lighting for Portraiture

Available lighting
With a range from soft, diffused to harsh, strongly angled illumination, a number of different moods can be conveyed with available light.

Unlike the photographing of objects such as plants, landscapes or architecture, available light used for portraiture needs to convey, if not an over-flattering result to a portrait subject, then at least a minimum of ugly shadows. Ideally, there should be sufficient shadow to convey the shape of the facial features, yet not so much that they obscure other parts of the face. So the direction as well as the quality of the light itself is important.

Clever positioning of the subject in relation to existing lighting as well as careful use of reflectors and exposure are some of the skills that the available light photographer needs to master.

Those who are aware of the different

Right: Adriana was posed near a window, with daylight illumination coming in through a lace curtain.

Far right: A Hoya diffusing filter was used to soften the lighting. Both images on Fujichrome Provia film.

Below right: For successful candids you need to work quickly and quietly. Total familiarity with your equipment leaves you free to concentrate on capturing the fleeting moment.

Below: Playwright Arthur Miller was photographed in ordinary room lighting.

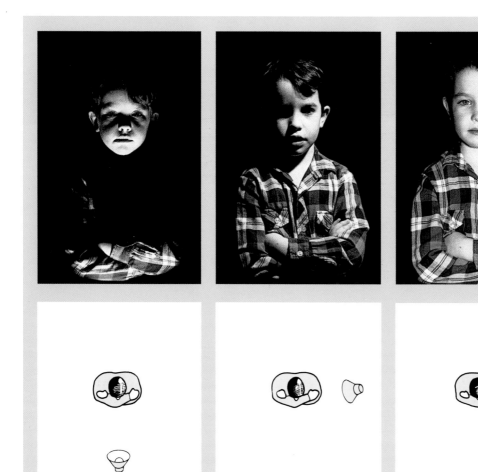

Simple studio flash

A studio flash unit is nothing more than a flashgun, but a more powerful one with some extra controls. Two of the more usual features found on a studio flash unit are a power ratio control and a modeling lamp. A power ratio control can be used to regulate the output so that only a half or a quarter of the unit's power is used. This enables it, if required, to be used as a supplementary light to another flash head for fill-in purposes.

A modeling lamp is a light bulb situated next to the flash tube which acts as a guide to show what the finished flash shot will look like. When the flash itself is fired the modeling lamp automatically switches off.

A studio flash will cost a lot more than a normal flashgun, but its extra output makes it a highly versatile tool

for portrait work. Just one unit plus a large reflector can be used to carry out a considerable amount of simple yet effective portraiture. If your finances can stretch to it, two or more studio flash units plus a reflector will enable a wider range of work to be achieved, including complex multi-lighting setups.

With studio flash, once you have a unit or units with ample power output the trick to successful studio portraiture is where you position the lighting in relation to the subject. Try and think of a studio flash unit as a miniature Sun and then calculate the effect it will have on your portrait subject.

The accompanying illustrations show just three of the basic lighting effects that can be achieved, and can be used as a starting point for more ambitious work.

And, with practice, a wide range of lighting effects can be achieved using the most basic equipment.

Above left: A single flash, positioned below the sitter, was directed upward to create this result.

Above center: The flash was positioned close to the right side of the camera and directed at the subject for this shot. These basic examples can be changed and refined. Try repositioning the light source, using a secondary flash, reflectors or diffusing material, or filters.

Above: The flash was positioned at about 45 deg above and to the right of the photographer.

kinds of available lighting will be able to control the pictorial effects as well as the mood of the resulting portraits.

Portable flash

Photographing in available lighting indoors means photography in artificial lighting. Normal (ie daylight) balanced film gives a yellow-orange cast with tungsten lighting, and a greenish cast with most fluorescent lighting. These casts can be lessened by using an 80A blue filter for tungsten lighting, or an FL-D filter for fluorescent lighting. An alternative is to use a tungsten-balanced film. This is specially balanced for use in artificial (mainly tungsten) lighting.

The best solution is to use flash. A powerful, portable flash unit gives the portrait photographer total control over lighting. A flashgun with a guide number of at least 25 gives enough power for versatile lighting, yet doesn't have the weight of batteries of a more powerful flashgun to make it cumbersome to use on-camera.

A powerful automatic flashgun will produce properly exposed flash shots, but the way the lighting is controlled in the resulting image depends on the photographer. There are several ways to control flash illumination to give the result you want.

Direct flash provides total illumination of a subject but gives harsh lighting. For most portrait work a softer effect is best

Left: This studio portrait has used a combination of more than one light source, and a soft focus filter to create this result.

and there are different ways to achieve this with on-camera flash.

You can use a diffuser made out of opaque material such as tissue or a piece of white plastic placed over the flash head. There are many purpose-built diffusers made of plastic and available from retail outlets. Most are made to fit standard-sized flash heads. This type of diffuser

Below: Maria was placed close to a wall to minimize the shadows falling onto the background. Illumination was from an EOS SLR's built-in flashgun.

Left: Direct flash gives overall illumination but the result is harsh and over-bright.

Left: The flash-head was pointed toward the white ceiling, and the diffused illumination was bounced down toward the subject. The lighting is more even and shadows are softer. If you want to reduce shadows further, place a white reflector — a sheet of white card or cloth — below the subject. This will bounce extra light back into the shadow areas.

softens the light as a whole as well as taking the edge off hard shadows. With all but the thickest diffusers no exposure adjustment needs to be made.

Indirect flash involves positioning the flashgun off-camera, either by holding it or attaching it to a special bracket that fits to the camera's tripod bush. The flash also needs to be connected to the camera via a flash cable. This cable in turn fits into the flash sync socket on the camera. If there's no flash sync socket there are special flash sync adaptors that can be fitted into the hotshoe. Separate hotshoes with b/i sensors can also be used for off-camera flash.

Flash used off-camera offers a range of lighting options though this requires careful positioning of the flash head, or heads, plus use of reflecting surfaces.

Bounce Flash

Bounce flash gives more control over the angle at which the light reaches the subject and therefore where shadows will fall. It also gives a softer spread of light. A flashgun with a Guide No. of at least 25, with a suitably adjustable head, will give sufficient power output for the use of bounce flash.

Because of this, the exposure will need to be set accordingly. With bounce flas, the aperture will need to be widened to enable more light to reach the film. A good starting point: open up the aperture setting by two stops more than the one you'd normally need if you were using direct flash. So if it's calculated that a normal direct flash setting of 1/125sec at f/8 is needed, this will have to be changed to f/4

Accessories

A flash meter works in a similar way to a conventional daylight-measuring meter. The film speed is set on the meter (which is connected to the camera via a cable) and the flash is fired. The flash-meter then shows the aperture required for a correct flash exposure. As with daylight-measuring meters, flash meters should be used as guides only. There are other variables that need to be taken into account when calculating the exposure for studio flash: the power of any other flash units you might be using, whether diffusers or reflectors are being used and the effect these will have on the overall exposure, and so on.

The other accessories available for use with studio flash are for controlling the raw flash output.

A bowl reflector is a shallow metal cone that fits around the flash head. The most common types are silver or white, and both have the effect of spreading the flash illumination,

There are two main devices for directing the spread of the flash illumination. The first is a set of "barn-doors," simply a gadget with two or more hinged flaps that fits around the flash head. These

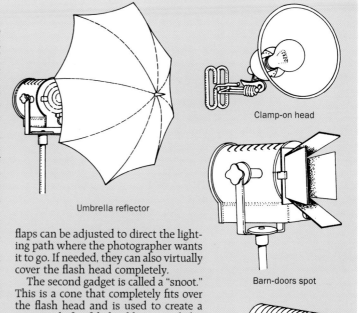

Umbrella reflector

Clamp-on head

Barn-doors spot

Snoot

flaps can be adjusted to direct the lighting path where the photographer wants it to go. If needed, they can also virtually cover the flash head completely.

The second gadget is called a "snoot." This is a cone that completely fits over the flash head and is used to create a narrow shaft of light, like a spotlight, that falls on just a small part of the subject. In portraiture, it can be used to light part of a face or to highlight the subject's hair.

for bounce flash use. Or the shutter speed can be reduced accordingly, in this case to 1/30sec.

The easiest way to use bounce flash is with the flashgun set to manual. If any further adjustments are needed then these will be easier to set, and to remember. And if you should change your flashgun for another one of similar power output, also set to manual, there will be very little variation in procedure.

If the flash head is pointed toward a ceiling, the bounced illumination will come from above, in much the same way as overhead lighting does out of doors. So there will still be shadows below the eyes, nose and chin that will need to be lessened.

One answer is to place a reflector beneath the subject so as to bounce light back into the facial shadows. Some flashguns have a built-in secondary flash head with a lower power output, especially for fill-in purposes like this. Or something as simple as a large reflective area on the floor like a light-colored carpet or white paper, will be almost as good.

Note that the bounced flash illumination will take on the coloring of the reflective surface it is bounced off. A white (or even a light gray) ceiling is fine as it won't create a color cast. Avoid colored ceilings as they will cause a noticeable cast on color film. Of course, if you're using black-and-white film this will be less of a problem. In this case, just ensure that the

ceiling is of a light hue. Darker ceilings will absorb more light and an additional exposure adjustment will therefore need to be made.

Flash illumination can be bounced off a wall too, and here the same precaution of using a white or gray reflective surface applies. If the ceilings and walls are unsatisfactory a bounce flash reflector that attaches to the flashgun can be used. This usually consists of a white card on a bracket that is fixed to the flashgun itself. In this case the exposure adjustment that's needed is minimal as the flash illumination has a shorter distance to travel to reach the reflecting surface.

Bounce flash is suitable for a lot of flash portraiture, giving more even lighting than direct flash. But its even light does little to emphasize the shape of a subject's face. Using direct or direct diffused flash, and with the unit placed to the right or left of the camera has the effect of giving shape or "modeling" the subject's face. This approach will make the nose and chin cast shadows, so a reflector positioned at the opposite angle to the flash will compensate. There should be enough shadow area remaining so as to suggest the shape and form of the face.

But such techniques defeat the object of a flashgun's mobility, speed of use and on-camera, hands-free working position, and are more suited to the static nature of studio flash.

Landscapes

Landscapes are among the most popular subjects for photography. Because landscapes are static, they give the photographer ample time to compose and shoot. And the basic equipment that's required is simple.

Good landscape photographs can be found throughout the year and almost anywhere. The range of subjects within landscape photography, the different kinds of lighting, the seasonal colors, plus the effects obtainable with different focal lengths, all offer the keen landscape photographer an almost endless supply of techniques and approaches. It's no surprise that some photographers put a lot of effort into the search for perfect landscapes.

Equipment

A 35mm lens is fine, though if you intend specializing in ultra-wide landscapes then you'll need something that shows more of a panorama. Lenses of 28mm or wider (ie 24 and 20) will enable you to fill the image frame with huge expanses of landscape.

But the wider the angle of view, the more pronounced will be the barrel distortion, which is most noticeable at the edges of the frame. The image will have straight vertical lines (ie trees or a building) bowed slightly outward. The wider the lens's angle of view the more pronounced will be this bowing effect. Certain lens manufacturers produce ultra-wide-angled lenses (ie around 17/18 and even 15mm) where the bowing effect is reasonably controlled. Generally speaking, a good compromise is around a 20mm lens, although it will be more expensive than a 24mm or 28mm wide-angle lens.

Because of the nature of most landscape subjects (having few if any vertical lines toward the edges of the frame), mild barrel distortion is not often a major problem. What could be a problem with some of the ultra-wide-angle lenses (ie 17mm or less) is bending of the horizon line at the edges of the frame.

Another problem that needs to be

Right: A classic landscape image, with a perfect balance of foreground, mid- and background elements.

Below right: The buildings give a sense of the scale in this image photographed in Murcia, Spain.

Below: A gray graduate filter plus a polarizer was already attached to my 28mm Nikkor lens for a previous shot. The image could've been cropped, but I preferred the darkened corners.

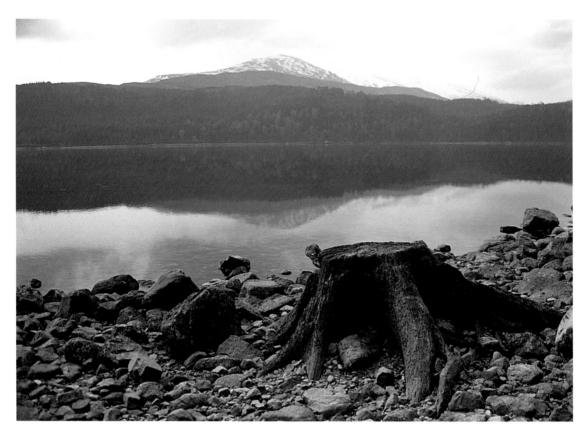

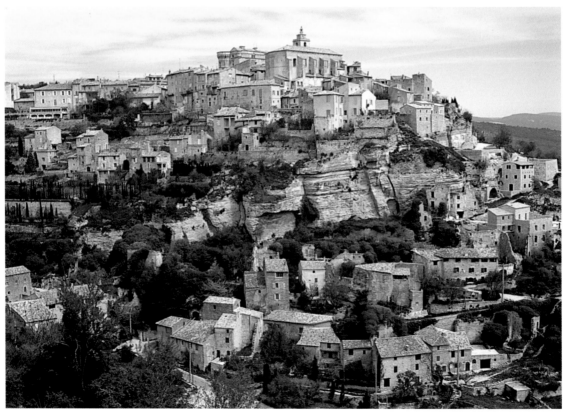

worked around is vignetting or darkening at the edges of the frame. This occurs most commonly with wide-angle and telephoto lenses, and there are several causes. It could occur when one or more filters are attached to the front of the lens. The rims of the filters cover the corner of the image area so causing vignetting. There are two solutions to this. First, use as few filters as possible at any one time. Note that even one filter (ie certain types of polarizer with high rims) can also cause vignetting even when used singly. Second, the wider the aperture, the less obvious will be the vignetting.

Vignetting also occurs when a lens hood is used. This can be a real problem with wide-angle lenses because of their generous angles of view. Special shallow hoods are made for use with wide-angle lenses though even these need to be used with some care if you want to avoid images with darkened corners.

If vignetting is unavoidable (ie when having to use more than one filter at a time) a last resort is to crop the image at the printing stage, or use special slide mounts that cover slightly less than the full image area.

Keeping it simple

Improving your eye for landscapes takes constant practise but the equipment required is minimal. You could, for the rest of your career, take landscape photographs with one camera and one moderately wide-angled lens. But such is the availability of accessories like other lenses, as well as the added versatility of items like tripods and certain filters, that the opportunity to use something different, as well as the chance to add some variety to your landscape shooting, is hard to resist. Any extras need to be added with care and for a specific purpose or effect otherwise you may acquire a lot of equipment, and end up using very little of it.

Some accessories are more useful than others. For example, a polarizing filter will, by taking the surface shine off subjects, show true colors of a scene or object. Or if you intend photographing at dawn or dusk with slowish film then a tripod will help to avoid camera shake and image blur.

But you can go a long way with the absolute minimum: a camera loaded with your chosen film and a wide-angle lens.

Keeping it straight

A common problem with landscape photography is trying to keep the horizon straight. Aligning the horizon should become a regular habit when photographing landscapes, although in the haste to capture a particular light effect or composition this can easily be forgotten. With scenes which lack a definite horizon line, such as shots including hills, this may

Far left: The colors suit the location of this image, photographed in the west of Scotland (Tamron 35-80mm SP, Fujichrome 100).

Below, far left: The architecture of this hilltop village in the Dordogne region of France seems to blend in with the land.

Below left: This scene photographed without a polarizer would, by itself, seem to have all the makings of a good landscape image.

Below: Use of a polarizer has brought out the true colors in the scene and given it a warmer appearance.

seem less of a problem though is actually more difficult to achieve. With hilly landscapes a spirit level will make absolutely sure that the horizon is level. Some accessory manufacturers produce a spirit level that slots into the hotshoe for easy reference. In scenes which include a horizon line such as the sea or a flat field you need to simply make sure the horizon line is set parallel to the base of the viewfinder frame.

A tripod is a useful aid when aligning horizons, if you have the time to set one up before taking the shot. But if you don't have time to do this, perhaps if the light is changing quickly, then you can use the horizontal section of the split-image rangefinder circle in most viewfinders as a quick reference.

Filters
A polarizer has several uses in landscape photography. It takes the surface shine off objects like leaves and grass so you can see the true colors underneath. It also reduces the reflections off water so that it becomes more transparent. Its effect on a blue sky is to intensify the blueness and make white clouds stand out in stronger contrast. In an emergency it can double as a neutral density filter, reducing the amount of light entering the camera in lighting conditions which would otherwise cause over-exposure (ie if you happen to have fast film loaded in the camera and the lighting conditions are too bright to effectively use it).

Filters that take the blue edge off daylight shots are also useful. A UV or 81B warming filter will do this adequately without requiring a drastic alteration to the exposure. To intensify the warming effect use a stronger orange or reddish filter though make it suit the conditions. A warm orange filter used for photographing a sunset or late afternoon scene will look more natural than if used in mid-morning light.

A graduated filter has one half which is clear while the other half shows a color with a graduated tone. Graduated filters come in several colors, in round screw-on and square slot-in filter formats.

Pink and gray graduated filters can enhance some landscape scenes, especially adding visual interest to dull skies. Gray graduated filters are especially useful. A light gray graduated filter can improve the sky area and instead of its color taking over from the background hues it includes these in the graduated effect, giving a more natural looking result. If the filter brand you intend buying has a choice of gray graduates then go for the lighter one.

Some graduated filters show less smooth graduation between dark to light areas than others. This will show as an obvious difference between light and dark areas, especially noticeable if your composition has large areas of plain color. They need to be used carefully if you don't want

the end-result to appear as if a filter has been used. One solution is to use as wide an aperture as the lighting conditions and your depth of field allowance will allow. A small aperture will emphasize the difference between the graduated and plain areas.

Black and white
A polarizer is a very useful accessory with black-and-white film. Apart from its other properties, it also reduces haze.

Yellow, orange and red filters respectively add contrast in increasing strengths, with red giving the greatest contrast.

Gray graduated filters are very effective when used with black-and-white film, looking less obvious than when used with color film. A gray graduate can give an effective burned-in (ie darkened) look to a scene with a featureless sky. This will save you from having to burn in the sky, so as to add some drama, at the printing stage.

Exposure
The most common exposure area to consider when photographing landscapes is

Above: Sometimes filters need to be used sparingly, or they will take some of the viewer's attention away from the main elements of the scene.

Below: A pale orange filter has given some color to this scene, which was gray *without* the filter.

the sky. Obviously the brightness of the sky will vary depending on the time of day, but a good starting point is to take a meter reading off the land and then increase exposure by around 1 1/2 to 2 stops. This should give a balanced exposure between sky and land but if you want to create a silhouette effect of the land or a tree outline then take an exposure reading off the sky only. For an even stronger silhouette reduce the exposure by an extra stop.

Most landscape subjects fall within a medium contrast range, so exposure for them can be worked out mostly with general metering systems found in SLRs or even auto-exposure modes which have an auto-exposure lock option.

However, it's the scenes which have large bright areas, such as snow or sand, where exposure needs to be more carefully judged.

Landscapes with snow need to be over-exposed by around 2 stops, otherwise the exposure system will be "fooled" and the result will be under-exposed, showing snow as a murky gray instead of brilliant white. Similarly sand, although slightly less reflective than snow, needs to be

Left: This ready-made scene was just waiting for one more element — the woman and dog (135mm Nikkor, Kodak Tri-X+1).

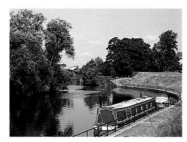
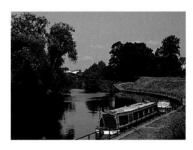

adjusted for. A good starting point is to increase exposure by around 1 stop.

Multi-zone metering systems can be used for landscape photography, though it would be sensible not to rely on them 100 percent if you're after a specific effect to do with exposure. And make sure to tweak the exposure if the lighting conditions are tricky. Many mid to high-end SLRs have auto-exposure bracketing (AEB), a system which enables three shots to be taken one after the other, at three different user-selected exposure settings. This aspect of automation is useful, though to avoid the hit-and-miss approach it will take some educated guessing to ensure that the exposure differences you tap in will include the perfect one for your purposes.

Many AEB systems give a choice of 1/2 or up to 2 full stops above and below the "correct" exposure setting, as indicated by the camera.

Auto-exposure bracketing uses up film at three times the normal rate so it will be absolutely necessary to keep plenty of spare film ready if you intend doing lots of bracketing.

Films

The type of film you use depends on the effect you're after. This is especially true with landscapes where a particular film's characteristics may suit specific light conditions and locations. It also helps in giving your landscape photographs a style of their own.

If you want to show landscapes in as much detail as possible then you will need to use a slow, fine-grained and sharp film. Currently the slowest speeded conventional color film is ISO 25. However, the slow speed will also mean that shutter speeds selected for correct exposure will be slow in all but the brightest light. So if a

Above: If you're not quite sure about the right exposure you want, try bracketing your shots. *Center shot:* camera-chosen "correct" exposure. *Left:* 1/2 stop over. *Right:* 1/2 stop under.

Below: You can use bad weather to your advantage. The low cloud and dull lighting helped to create a moody image.

breeze causes say tree branches or grass to sway then this could register as blur in the resulting photograph.

ISO 25 films should therefore be used in conditions where the lighting is sufficiently bright to allow a usable balance of shutter speeds and apertures.

ISO 50 and 64 films give a bit more latitude in exposure and yet in quality terms are not far from results on ISO 25 film. In fact, these are among the favorite standard films used by professional landscape photographers.

The current high quality of medium speed films, notably ISO 100, means that more photographers are opting for this speed range and gaining from the resulting smaller apertures and faster shutter speeds.

Faster films, such as ISO 400 and above, can be used for effect. Films of this speed and faster show grain patterns that are more distinct than those of slower films. This grain gives a patterned surface appearance to photographs that can look effective, though fine detail may be lost with these faster films.

The grainy, gritty qualities of fast black-and-white films can give a moody effect to landscapes or, with a suitably historic subject or location, evoke older times. For this reason also grainy black-and-white films give plenty of impact in photographs of cityscapes and moody landscapes.

Light

Bright sun, clear sky, mid-morning and noon – these are the conditions when available outdoor lighting is at its strongest. Subjects are brightly lit and exposure readings will give fast shutter speeds and small apertures, enabling even the slowest speed films to be used with ample ranges of shutter speeds and apertures. A perfect combination for pin-sharp images with extensive depth of field.

But there are disadvantages, too. The contrast between light and dark areas is extreme, causing over-brightness in the lighter areas or colors of the scene and even a washed-out look to the more subtle hues. At the other end of the contrast scale there will be dark shadows with little or no detail in the areas that don't receive light.

The overall lighting effect is harsh and will not show the subtler hues and textures of landscape at its best.

In bright skies, early morning light just after sunrise can sometimes take on a golden appearance, bathing everything in this warm light. At its best, this type of lighting gives the effect of a warm-up filter and will enhance an already interesting landscape scene. Mountains and hilltops are picked out clearly and, in cityscapes, buildings are also highlighted in this way. But you will need to move quickly, as this light doesn't last long. Try and anticipate it – perhaps the previous days have had the

Below: The fore, middle and sky work together in this image shot in the South of France (28mm Nikkor, polarizing filter, Ektachrome 400, rated at 800).

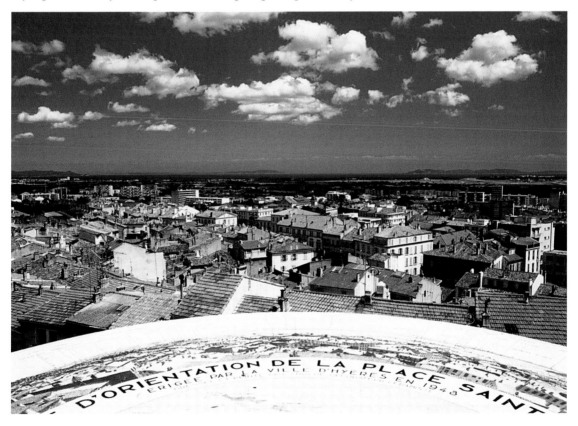

Left: Time of day (and the season) shows a big difference in lighting. This Thameside cityscape was photographed in late morning lighting.

Below left: An afternoon shot, later that same year. The lighting is warmer, its angle clearly picking out shapes and textures.

Right: When the sun slips below the horizon the afterglow can make an effective backdrop for silhouettes (28mm Nikkor, Fujichrome 100).

Below right: The clouds add extra interest to the sky in this sunset silhouette (135mm Nikkor, Fujichrome 100).

same kind of lighting – and get yourself prepared and in a good position to be able to record it.

As with early morning light, late afternoon illumination has a warm look. But unlike early morning light, this illumination gets more yellow-red as time goes by, until the sun sets.

Just before sunrise the light is mostly blue though there is a short period immediately before the sun rises when there is a pink tinge to the sky. There may or may not be enough strong illumination to photograph a landscape scene by, but the sky itself can form an excellent backdrop for a silhouette of trees or hill outlines or buildings.

Just after sunset can give much more scope for picture-taking than the actual sunset itself. The sun below the horizon reflects on to the sky or clouds, creating an ever-changing display of warm, orange-red color effects. Here again is an excellent backdrop for silhouettes. If you're using cityscapes as silhouettes the pinpoints of light from streetlights and lit windows will form an effective part of the scene.

In a cloudless sky, especially in summer as the sun sinks lower below the horizon, the warm color of its afterglow will gradually be overtaken by the blue of the night sky. A wide-angle lens is effective for showing the range of color graduations and in situations like this the sky itself can be the main subject.

Sunsets are a popular and easy subject to photograph. A good example will stand out in a slide show or among a selection of

prints. Simply set the lens focus to infinity, take a reading from the sun and shoot. If you want to show some foreground detail (ie an expanse of water or land) then open the aperture by a stop or two.

It's important to choose the right focal length when photographing sunsets. A short focal length (ie anything wider than 50mm) will show the sun very small in the frame, but will also include a large expanse of sky. This can be effective when there's some interest in the sky (ie cloud formations) or a flock of birds. It can also be useful for showing a lot of foreground details. But a short focal length is less effective with a plain sky.

A longer focal length (ie 100mm and above) will show the sun larger in the frame, making it a more prominent part of the composition. Less foreground detail is included so that the composition, with a long telephoto such as a 300mm, is reduced to the sun and the sky and clouds that are near it.

Sometimes the vibrant colors of a sunset may need boosting by the addition of other elements to the picture. A silhouette of a foreground object is a natural first choice and trees, bridge outlines, rooftops, streetlights can all be an effective counter-balance to the strong highlight of a setting sun.

If you want to give your sunset shots an added boost a warm orange or red filter will further strengthen the color. Judge this carefully as, in ideal conditions and with a carefully exposed shot, filtration of this kind won't be necessary and may even spoil the result.

Panoramas

Panoramic photography gives an alternative image shape to the conventional 35mm dimensions. This makes a panoramic image stand out and gives it instant impact, even before the subject-matter within the frame is considered. To get the panoramic frame shape an area of the 35mm frame is masked off so that only a narrow strip remains. This strip is 36mm across by anything from 12-14mm in height.

Many 35mm cameras nowadays come with a panoramic option, whether in the form of a drop-in mask that fits over the film chamber or via a built-in mask that can be freely altered between normal and panoramic formats. These are extremely versatile.

Where to find landscapes

If you live in or with easy access to countryside then landscape shots will be easy to find. Make the effort to pinpoint interesting locations that you may see on country rambles or outings. Try to see the location in different kinds of lighting and at different times of day. Then go back at your chosen time of day and with the appropriate equipment. The least promising location, at the right time of day or time of year, might well turn out to be the source of some impressive landscape shots.

If you don't live near some attractive countryside then you can try and exploit locations that are closer to home. City dwellers have access to parks or city views which they perhaps pass by on a regular basis and never give a second look. Yet this can give an opportunity to gauge when the conditions (either time of day or time of year) will be perfect for an effective and, if you're lucky, stunning landscape. Even in parks, the trees and vegetation reflect the changing seasons and what once seemed drab and gray can, in early morning or late afternoon lighting, with the right composition, turn into a strong and interesting image.

A panoramic image can certainly give a different look to your landscape shots but the narrow frame tends to emphasize the visual information that's included. This needs to be allowed for when composing and, as the shape of the format dictates the kind of shot or subject matter that's photographed, it's likely that many people will take panoramic photographs of the same kind of subject, in the same kind of way. So the photographer will need to work harder to achieve an effective and original image. The main concern will be finding the right subject that will be fully included in the unusual frame shape yet one that still works as an effective and attractive, viable composition.

One obvious answer is landscape photography. In fact a good panoramic image can perfectly convey the impression of open space and depth of a landscape scene far better than a conventional frame. But here

Below: A selection of shots made using the panoramic frame, showing the need to compose and to fill a narrow image strip.

Page 82, top pictures: A panoramic image can help to concentrate the eye on the main area of a composition. The panoramic frame crops a slice out of the full 35mm frame.

a balanced composition is even more important otherwise the eye will be looking at a wide view with nothing specific to lock on to. As with the conventional film frame, colors, shapes and focal points are still relevant to a good composition but need more emphasis in order to stand out in the elongated image area.

The panoramic format also suits cityscapes, with rows of buildings or street scenes conveying a good impression of a bustling city or town. The format is also effective with architecture. The seemingly wide but low-cut image strip can, for instance, show a row of buildings of different architectural styles.

Panoramic images are perfect for framefilling group photographs. Weddings or other get-togethers are perfect venues for panoramic portraiture. And don't forget moving groups of people, too, such as at a sports event or a parade.

The panoramic camera can be tilted on its side for elongated looking vertical shots and is effective with tall buildings or trees, or even the odd portrait!

You don't always need a camera with a panoramic feature to get a panoramic image. Just do what the majority of 35mm panoramic systems do and crop off the top and bottom parts of the film frame, leaving a narrow strip of image in the middle. Choose one of your images which lends itself to being cropped to the horizontal,

Panoramic cameras

These range in price from cheap disposable cameras to models costing many times as much. The fully manual Horizon 202 is comparatively low priced for a dedicated panoramic camera. It has a lens which rotates to give an angle of view of 120 degrees. Comparing this to the 75 degree angle of view of a 28mm wide-angle lens gives an idea of how much more of a scene can be included in the frame. Naturally, the dimensions of the frame need to be able to encompass the extra image area. The Horizon 202's film frame is 24 × 58mm. The generous frame width also means fewer images per film, the camera giving 23 frames on a 36-exposure roll. It comes with special slot-in filters.

100% PANORAMA	PANORAMA / STANDARD	PANORAMA / ᵇᵗᴬⁿᴰᴬᴿᴰ	ᴾᴬⁿᴼᴿᴬᴹᴬ / STANDARD
100% PANORAMA	PANORAMA / STANDARD	PANORAMA / STANDARD	PANORAMA / STANDARD

Left: Cameras with the panoramic option often include adhesive stickers for labeling films, so as to inform commercial processors.

Please refer to the Operating Instructions for details on how to use the stickers.
Einzelheiten zur Verwendung der Aufkleber sind der Bedienungsanleitung zu entnehmen.
Consulter le Mode d'emploi sur la façon d'utiliser les autocollants.
Consulte el manual de operaciones para conocer los detalles sobre cómo utilizar los sellos.
このシールの使用方法は取扱説明書をご覧ください。

then mask it off so that you include the subject-matter that fills the elongated image frame. Special masks are obtainable for slides or, if printing, you can do the cropping in the darkroom.

Another way to get a panoramic image is to take several shots of a scene, then join the separate images together to form a composite picture. Some camera manufacturers include a special attachment for a tripod that enables the mounted camera to be moved to set positions in an arc, in order to produce a set of separate images for this purpose.

Accessories
Tilted horizons will be more noticeable with the elongated image frame of a panoramic shot than a conventional one. So you'll need to ensure that horizon lines are straight when lining up your compositions. Where this is difficult, such as in landscape photography, use a spirit level. A tripod will also help in ensuring that, once the horizon is aligned, the camera remains level.

Processing
Many labs are familiar with panoramic prints although it's necessary to let them know this beforehand. Because the narrow area of film needs enlarging to be comfortably viewed print sizes will be bigger. Prices are charged for batches, usually 1-6 prints, 7-15 and so on, although larger numbers of prints can also be supplied (ie 1-15, 16-28). Some labs supply jumbo panoramic prints.

Below: Disposable panoramic cameras are a fun way to get wide-looking shots, though optical quality doesn't match that of conventional compacts.

Nature

Nature photography is an area where the photographer has very little control of the subject. The photographer's technique must be adjusted to suit not just the lighting and location, but also the changing character of a subject. Whether it be the sudden movements of wild animals or changes evolving over a period of time such as a caterpillar's transformation into a butterfly or the seasonal changes in plants, timing as much as photographic technique will make all the difference between an ordinary record shot and a great one.

It's worth reading up about the habits and habitats of animals and plants so as to learn where they can be found.

This chapter is merely an introduction to a challenging and rewarding area of photography that requires several photographic skills and techniques.

There are, broadly speaking, two areas of nature photography: animals, and insects and plants. Both require different equipment, and both involve spending large amounts of time outdoors to set up and take a good picture.

Equipment

The equipment needed will depend on the subject you choose. Photography of wild animals requires a telephoto lens, preferably the longer the better. A 300mm telephoto lens or greater will enable you to

Top: An unusual subject for a 500mm mirror lens. The long telephoto has lessened the distracting background.

Above: A long telephoto lens.

Left: The change in the seasons dramatically affects trees, giving a different appearance in (clockwise, from the top left): Spring, Summer, Fall, and Winter.

Right: The time and trouble to set up an image like this can pay off.

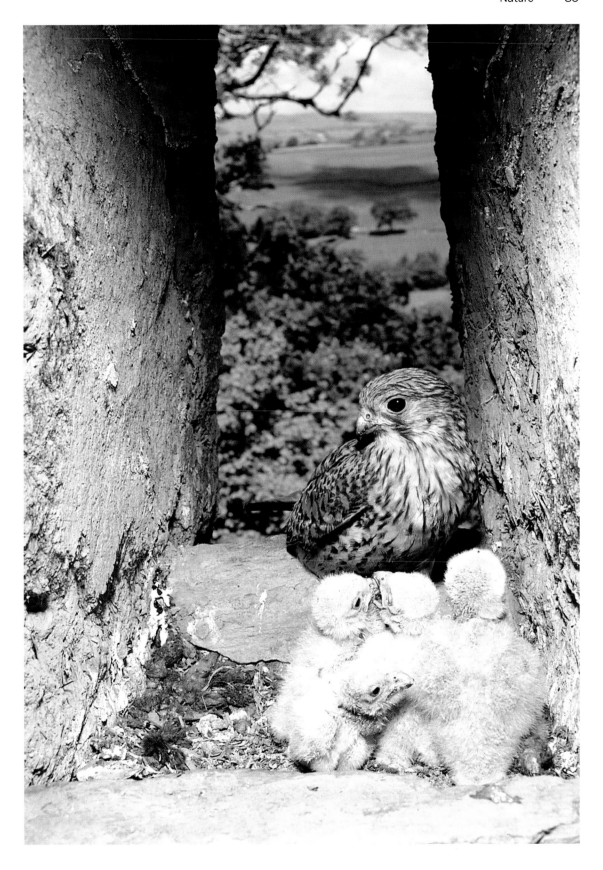

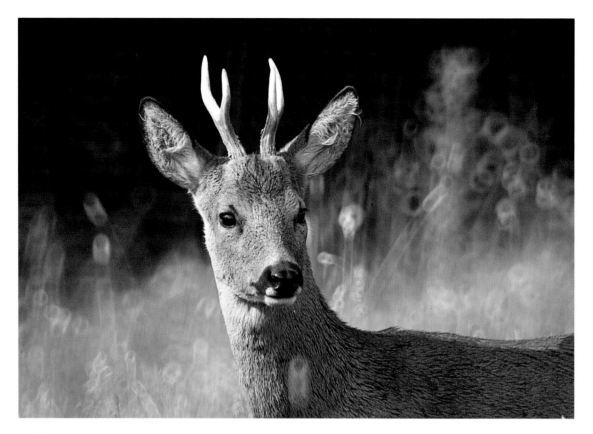

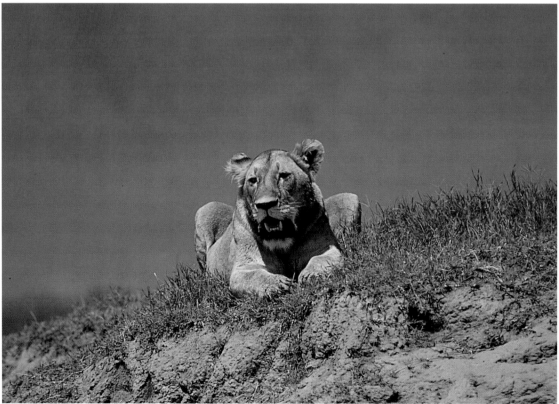

close in on shy animals without disturbing them. A long range zoom such as, say, a 70-300mm or similar, will be more flexible. Further versatility can be added by using a tele-converter to double or treble the lens focal length. A tele-converter is a cheaper alternative to buying an ultra-long tele-photo lens such as a 500mm or 1000mm. The main drawback is that it affects image quality, notably sharpness and contrast. This will be less noticeable if your original lens is of high optical quality in the first place, and the converter you use with it is of similar quality.

A slightly less expensive alternative to a physically huge telephoto is a mirror lens. This lens uses mirrors within it to bend and reflect the light in a shorter space than a normal telephoto would need. The result is a shorter though wider lens that is light enough to be used handheld in emergencies, with a lower risk of camera shake. But there are two main drawbacks with a mirror lens. The first is that, due to the way the lens is constructed, there is only one aperture. With a 500mm mirror lens this is usually f/8, and with a 1000mm it's usually f/11. What this means in exposure terms is that you will always have to adjust the shutter speed rather than the aperture when you want to alter exposure. So its best to use fast film when using a mirror lens, to keep to the necessarily fast shutter speeds that you'll need for photographing animals.

A second, less awkward characteristic of

Above, far left: A deer captured by a mirror lens. The out-of-focus ring-shaped highlights are characteristic of a mirror lens.

Below, far left: A long telephoto lens safely photographed this lioness from a distance.

Other Accessories

Nature photography doesn't always take place in the sunniest, driest conditions, so the keen nature photographer should also be prepared for wet and cold weather. As well as warm clothing, your photographic equipment will also need adequate protection. There are a number of weatherproof coverings for cameras and lenses made by different manufacturers. Most will keep equipment dry and easy to get at.

Gloves are an obvious advantage when photographing in cold weather. Make sure they're the kind that allow enough free movement of your fingers so you can handle the main camera and lens controls.

Depending on the type of nature subject you are planning to photograph, it is also worthwhile purchasing some form of illustrated reference work that provides details of possible animals and

plants you are likely to come across on your expeditions.

Finally, don't forget that patience is an essential attribute for anyone trying to capture animals in their natural environment!

Above: One way to sharpen your wildlife photography skills – photograph your pet!

Left: This leopard was photographed from the safety of a vehicle. Night photography of animals – dangerous or otherwise – demands careful pre-planning and the right equipment.

a mirror lens is that out-of-focus high-lights, as in background lighting, are ring-shaped. Depending how large they are in the frame, they can be visually distracting unless you carefully compose your shot to avoid or minimize the effect.

Shorter focal length lenses are of use when photographing animals that are accessible at close range, such as at a zoo, wildlife park or in domestic situations such as at a farm, or even the family cat! Domestic animals provide ample opportunity for you to practise your nature photography skills and are interesting subjects in their own right.

Tripod
Long telephoto lenses and longer focal length mirror lenses are heavy and can rarely be used for handheld shooting as they will cause camera shake. unless the lighting conditions and fast film provide top shutter speeds. Also, the narrow angle of view of telephotos means that even the slightest blur that's caused by camera shake will be more noticeable because the image is magnified. A tripod is, therefore, a must and the heavier the better. Ones with a generous amount of free movement in the ball and socket head are obviously useful as are other features such as a spirit level and, found on some makes, waterproof legs.

Film
A lot of animal photography requires use of fast film though, in bright conditions and with shorter telephotos, slower films can be used. But expect shallower depth of field under these conditions, if you want to maintain a fast shutter speed so as to keep your main subjects sharp.

Close-up photography
Close-up photography opens up a whole new world of technical and creative challenges. You can do it at a simple level, where equipment is minimal and comparatively cheap, or at the advanced level, where the price of equipment and, just as important, the technical demands are greater.

One of the most easily accessible close-up accessories is, surprisingly, the standard lens on your camera. The majority of standard lenses provide close focusing of around 55cm when in normal use. But, because of their lens construction, they are capable of much closer focusing when the lens is reversed. A special reversing ring attaches to the filter thread at the front of the lens, which then fixes to the SLR body. A reversing ring costs about the same price as a filter.

This is a cheap way to get into close-up photography but there are some disadvantages. Central sharpness is fine with such a setup, but performance at the edge of the frame is poor. And, because the lens

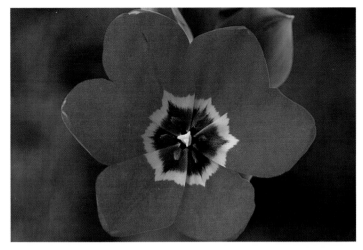

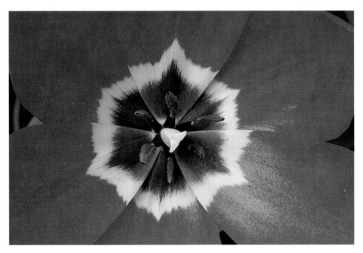

is reversed, any electronic or mechanical connections to the camera are lost. But it will be easy to make an exposure if your lens has an aperture ring. Reversing rings will even work in manual focus mode with autofocus lenses though you will lose the confirmation of focus via the LED in the viewfinder. The way around this is to focus the lens via the manual focus ring on the lens barrel.

An alternative and roughly the same price level as a reversing ring, is a close-up or supplementary lens. Despite its name it looks like a filter and also screws on to the front of your lens. Supplementary lenses are graded according to their magnification and these grades are called *diopters*. A typical range includes +1, +2, +3 and +4 diopters, each number up the scale giving greater magnification than the previous one. They can be used separately or in different combinations. If used in this way the supplementary lens with the highest number must be nearest the camera lens. Using the right setup it's possible to get extremely close focusing distances, as close as 10cm from a subject.

Top: This tulip head was photographed using a Pentax 50mm macro lens.

Above: The macro lens's capabilities enable frame-filling close-ups.

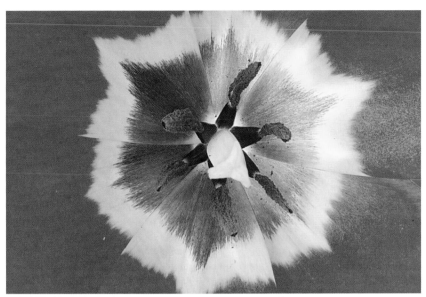

As supplementary lenses are made of optically clear glass they don't require exposure compensation. They have two disadvantages, though these may be considered minor ones by the photographer simply trying out close-up photography for the first time. The first is poor sharpness at the edges of the frame. The second is vignetting which occurs when several diopters are used in combination,

Above left: The same tulip head but photographed at 1:1 life-size reproduction.

Left: A set of extension tubes. These fit between the lens and camera body, and are used singly or together.

Below: An image taken with a macro lens and flash.

Yet another device that screws on to the front of a camera lens is an achromatic lens. This gives generally sharper results than a reversed lens or a supplementary lens. There are also variable close-up lenses, more versatile than supplementary lenses, giving greater magnification of the subject, but these are more expensive.

Next up the price scale is a set of extension tubes. These consist of three separate lens-shaped tubes which fit between the camera body and the lens. They have no glass and give close focusing simply by extending the distance between the film and the lens. They can be used singly or, to give 1:1 or life-size reproduction (see box), in combination.

There are two types of extension tube. Manual types have no mechanical linkage to the camera, apart from physically attaching to the body at one end and the lens mount at the other. It's cheaper to buy a set of manual extension tubes than a macro lens.

Auto-extension tubes retain the automatic exposure connections between camera and lens, and are consequently more expensive.

The main disadvantage of extension tubes is some loss of light, as much as two stops if you intend using all three tubes together. So you will need to plan accordingly, such as using a faster film than you'd normally use, and ensuring that there's a generous amount of lighting available.

If you want further flexibility in close-up photography then the next choice is a set of close-up bellows. The bellows are mounted on a rail which has focus distance markings. While the other close-up accessories so far mentioned have fixed magnification settings, the close-up bellows offer variable magnifications and at variable focusing distances. As with extension tubes they're available in manual and auto-

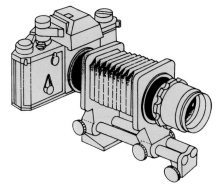

Left: A macro bellows unit fits between the lens and the camera body. The amount of extension can be varied, making it more versatile than tubes.

matic versions. Bellows units are heavy and all have a tripod bush for use with a tripod for stability.

As with extension tubes there's the problem of light reduction with bellows units, which will need to be adjusted for.

The most useful close-up tool is a macro lens, a lens specially designed for photographing at close ranges. Most can focus as close as 1:1 (life-size) and those that can't have access to optional attachments which enable them to do so. They are also designed to have good flatness of field so that they can photograph flat objects like stamps or documents. In appearance most have a deeply recessed front lens element, the front part of the lens casing acting as a built-in lens hood.

They are found in fixed focal lengths only and are mostly of around 55mm and 90 or 100mm. Although intended mainly for macro work, they can be used to photograph normal subjects. Another common characteristic is a maximum aperture of f/32, providing the maximum depth of field that is necessary with all close-up photography. Using a macro lens with one or more of the previously mentioned accessories makes a versatile close-up photography setup.

Above right: A 35-70mm zoom's close-focusing facility allowed this close-up.

Right: The photographer shot this caterpillar with a single high-positioned flash. Background was gray card.

Below: With a macro setup, photographing fine detail like this butterfly wing is no problem.

Life-size reproduction

Books and technical literature on close-up photography refer to life-size or 1:1 magnification. This is sometimes called the reproduction ratio. It simply means that the item of equipment will photograph an object that, on the film frame, will appear as life-size.

Many macro lenses are capable of photographing objects at 1:1 magnification, and this is mentioned in their specifications. Many zooms have very good close focusing capabilities, although never at 1:1 magnification. Magnification ratios of 1:2 (half life-size) and 1:4 (quarter life-size) are common with medium range zooms.

Alternatively, a lens which has a 2:1 magnification ratio will produce an image on the film that is twice life-size.

Depth of field and close-up photography

The closer the focusing distance the shallower the depth of field will be, so depth of field plays a crucial part in close-up photography. The close-up photographer needs to use all of his technical skill and experience to maximize depth of field. In order to achieve this the following items are vital: a depth of field preview control on the camera, the brightest lighting that's possible, and as fast a film speed that you can use without compromising image quality. Fortunately, medium speed films of around ISO 100 now offer a good balance of quality and speed.

However, if you intend using a slower film or the lighting conditions just won't give the depth of field you want, or if you simply want a more controllable light-source then you will need to use flash. The bright illumination offered by flash will give you a greater choice of workable apertures, and therefore greater depth of field.

Flash for close-up photography

You don't need ultra powerful flashguns for close-up work, just ones that offer a degree of control. A low-powered flashgun with an auto eye sensor is ideal. The sensor will obviously have a working range within which it'll be most effective.

The advantage of flash is that you can position it according to the lighting effect you want. A good starting point is to place it at a 45-degree angle to the subject. Or you could position it near the front of the lens to make the colors of the subject stand out more strongly. Try positioning it behind a translucent close-up subject to strengthen the see-through effect.

The flashgun can be hand-held (with the camera on a tripod to leave your hands free) though it's more convenient to use special clamps to hold the flash. These are available from accessory manufacturers.

It will pay to have a trial run with your macro and flash setup on a subject which has an average range of tones. Then, starting with the aperture that's best for close-up work (recommended by the flashgun manufacturer in the instruction book), take a series of shots at and around this aperture setting. Make a note of the apertures used as well as the camera-to-subject distances. You can then use these as a basis for your close-up photography. With a high- or low-contrast subject you may only need to tweak the exposure accordingly.

A ringflash is a special flashgun designed for close-up photography. It has a circular shaped flash-head which fits around the front of the lens. It gives an even, shadowless spread of light which is suited to photographing close-up subjects. Some models have an option to switch off part of the flash-head so as to give more angled illumination.

A ringflash's average Guide No. is lower than normal, around 8 or 14.

Above left: Noctuid moth, photographed with 21mm extension tubes, with single flashgun (Tamron 35-80mm SP zoom. Fujichrome 100).

Below left: The low viewpoint adds drama to this shot which, like the above, was photographed in a home studio.

Below: Ringflash softens or deletes all shadows, providing an even, all-round lighting. Its low Guide No. makes it ideal for close-up work.

Special Effects

The 35mm camera can be used for more than just "straight" photographs. There's a huge selection of special effects that can be obtained, by clever use of the camera controls or by using other accessories such as filters, flash, or special films.

These special effects can be pieces of simple trick photography that look like proper photographs, such as a double exposure, with two images of the same person on a single frame of film. Or you can achieve more unusual results, some of which may not even look as if they were produced by a camera at all.

In this chapter the special effects are arranged starting with simple-to-do in-camera effects that don't require additional accessories, to filters, and films which do require accessories and some basic skill. Most require a little trial-and-error to get the right result, but using say a handful of shots off a 36-exposure roll is not asking much. In fact if you're really keen you could regularly put aside five frames from each 36-exposure roll you use, solely for special effects or experimentation. The additional time and effort could eventually pay off with a selection of images that are full of impact and will stand out from the crowd.

Any of the following effects can add interest to slide shows or portfolios.

In-camera effects

The simplest in-camera effects are to do with exposure. While basic under and over-exposure will slightly alter the look of the image, greater under- or over-exposure will heighten the effect. Extreme under-exposure (around 2 stops if you're using black-and-white or color slide film) can give a sunlit scene the appearance of one that's been taken at night or in moonlight. On the other hand extreme over-exposure (again by about 2 stops) will give a high-key result, with all colors or tones taking on a pale appearance. This can actually be very effective with flowers, female portraits or some landscapes, giving the effect of a light and airy water-color.

And, as with all special effects that involve exposure, it's worth bracketing your shots. So take one over-exposed and one under-exposed shot as well as the suggested exposure setting.

The exposure difference will show a definite result with slide or black-and-white film. If you're using color print film under-exposure will create muddy colors.

Another simple effect is blur, created by simply using a slow shutter speed with

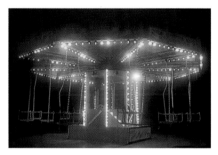

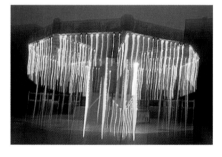

Top left: Colorful artificial lighting like this empty fairground ride makes a strong visual subject.

Left: Breathing on the lens gave this soft focus result.

Below left: Moving the camera downward during the exposure of 1/15sec caused these light streaks.

Below: Heavy under-exposure is another special effect technique. Here the strong highlights are able to suggest the shapes of the vehicles.

Above right: The exposure system has read for the main, central area of brightness, leaving other parts of the scene in shadow.

Below right: Increasing the exposure by two stops has opened up the shadows. Central detail has almost disappeared.

moving subjects. Most moving objects will show some blur if you use a shutter speed of around 1/15sec. The slower the shutter speed the stronger will be the blur effect.

If you want even more blur then set your shutter speed to B and hold down the shutter button for a few seconds.

The technique involves some experimentation but when the effect works it can be strengthened or enhanced by bright colors and bright highlights, such as sparkles or reflections off shiny surfaces.

When you combine slow shutter speed blur with flash, the effect looks even more unusual. Part of the object will be clearly lit by flash while the rest will be a blurred streak of color. With flash plus the B setting the result can be even more extreme.

The B setting on its own can be used for some unusual effects. Find a place where you can photograph a night-time scene of traffic and cars' headlights. Place your camera on a tripod. Set a small aperture on the lens (say, f/8). Then press the shutter button down and hold it there for two or three seconds. The headlights and tail-lights of the cars will record as long streaks of bright color that stand out strongly against the darkness.

Using the B setting you can keep the shutter open for as long as several seconds or several hours. With a long enough exposure it's possible to transform a night-time scene into day. The duration of the exposure depends on the speed of the film that's loaded in the camera. The faster (ie more sensitive) the film the shorter the exposure time that will be needed to transform night into day.

A by-product of the ultra-long exposure times are the unpredictable and interesting color shifts which occur. The accident by which normal films produce abnormal colors in this way is called Reciprocity Law Failure. All films are manufactured to give their best results within a particular range

TV Pictures

It is possible to take photographs of your TV screen by using a shutter speed of 1/30 second or less, but don't use too slow a shutter speed in case the image changes during the exposure. One or two compacts have a special TV mode which sets their shutter speed for just this purpose.

If your TV screen has a bowed surface use a telephoto lens, as the flattening of perspective will lessen the risk of bowed corners, though make sure that the camera is tripod mounted. The room needs to be darkened, too, to avoid reflections or, to get a similar result, you could place a home-made tube between your camera and the screen.

Above: One of the easiest special effects: a slow shutter speed with a moving subject. Despite blur the subject's still recognizable.

Right: Slow shutter speed with flash creates blur with sharpness, yet also conveys an impression of movement.

of exposure values. An average daylight film for instance will deliver stable, consistent color reproduction at exposures from dusk at one end of the scale to the bright light of midday in summer. The film emulsion has not been designed to record colors with accurate consistency beyond either ends of this range. When exposures start being measured in seconds instead of fractions of a second then the color of a red sky, say, may reproduce as pink or purple.

While the color casts that long exposures produce can often be visually acceptable there's an additional problem: normal exposure timings no longer apply the longer the exposure goes beyond normal limits. So a camera-selected exposure setting of, say, 10 seconds at f/8 may actually cause under-exposure. The true figure needed to give a correctly exposed result may well be around 20 or even 30 seconds. If it's vital that your intended shot has color compensation filters to adjust for any color shifts then these too will add extra time to the overall exposure. The color shifts are often interesting in themselves and sometimes enhance a low-light scene so effectively that many photographers tolerate the new inaccurate colors.

Use a small aperture when photographing toward a light source and the light source will become star-shaped. The smaller the aperture the stronger this effect will be.

Double exposure
Double exposures are possible with a manual focus SLR by first taking a shot which will be the first part of your double exposure. Then by pressing in the film rewind pin, usually sited on the baseplate of the camera, and turning the film wind-on lever at the same time, the film will not wind on to the next frame. You can then take the second part of the double exposure and it will be superimposed on the same frame as the first exposure.

A classic double exposure is to combine

Above: Long exposure night shots need a tripod.

Below: A double exposure, superimposing the moon over an image of a building, both shot against a dusk sky.

a shot of the moon, taken with a telephoto lens, with a shot of trees or a specific skyline. With a double exposure you can position picture elements anywhere you like in the frame, the trick being to make the finished result look like one complete image. If using slide film, the exposure setting will need to be doubled. So a normal setting of 1/125sec at f/8 would need to be divided up into two separate exposures, each of 1/250sec. With triple, quadruple or more exposures the exposure setting would need to be further adjusted accordingly. This is not such a problem with color print films as they have greater exposure latitude.

Many cameras have double or multiple exposure options as standard.

Night photography

Night photography opens up a range of weird and wonderful possibilities for the special effects enthusiast. With the B setting the exposure times are long enough to capture any night-time scene and even turn night into day.

Photography at night means shutter speeds measured in whole seconds instead of fractions of a second, so a rigid tripod is an absolute necessity. A cable release will also help to make sure that camera shake is avoided.

The long exposures will also mean that any bright lighting in a moving subject (ie

car lights) or, with a long enough exposure, even the moon and stars, will record as a streak across the image frame. These are very easy to get on film and are a popular night photography effect. If you want to avoid them then only photograph subjects that you know will be static, such as a floodlit building or static shop signs or street-lamps. Another way to avoid or minimize light streaks in your image is to use a fast film. Though slow film gives stronger colors and sharper images, the exposure times will, of course, be longer than

Above: The color cast was caused by artificial illumination. Eros statue, Piccadilly Circus, London.

Below: The car's shiny top reflects the neon sign. Deliberate under-exposure emphasizes the lighting.

on fast film. With ISO 100 film try the following: 1/15sec at f/3.5 for a city at night; 1sec at f/8 for moving vehicle light trails.

The B setting table gives some suggested exposure times for particular night-time subjects. With night-time photography it's also worth bracketing your shots to give you a greater choice in the results.

Open flash
With the camera set to B it's possible to operate the flash more than once during a long exposure. This open flash technique is what architectural photographers use to illuminate dark shadows in building interiors. The effect can also be used out of doors at night. Ask a friend to move slowly across your camera's field of view, while you fire the flash at regular intervals. (He or she may have to stop after each flash burst and wait for the flashgun to recharge.) The resulting image will show several flash-lit images of your friend, in a sequence, and all on one frame.

Slide sandwiching
Another technique that will produce unusual images and doesn't require extra equipment is slide sandwiching. This involves simply sandwiching two slides together in the same mount. The trick is to combine two separate slides that produce something that works as a new and interesting image. It helps if one of the slides is lighter in color and exposure density. A good starting point is to sandwich a silhouette or a dark image against a busy or patterned background. It's an easy and fun way to get new images from old or little used slides. Or you could shoot specific subjects or backgrounds that will be used for slide sandwiches.

When sifting through your slide collection and trying out possible combinations make sure you place the two mounted slides together while they're still in their respective mounts. Putting two unmounted slides together in one frame takes some care, not just in lining them up for maximum effect but also in trying to avoid tiny pieces of dust or grit lodging in between the slides. These could cause scratches on the film surface.

Special effects accessories
Filters are the cheapest and a convenient way to create different images. Many of those usable for special effects are reasonably priced or, if money is really tight, try the bargain bins in camera shops.

Simple colored filters will immediately change the look and feel of an image. Lighter colors will give an odd though almost familiar look to what would otherwise be normal scenes. Darker hues will emphasize the effect still further though you will of course need much more exposure compensation for the darker colored filters.

Left: A sandwich using a silhouette and a shot of the sky. Try out different combinations to get the result you want.

Right: A simple unfiltered subject — the starting point for a special effects filter shot.

Below right: A Cokin Impressions filter softened the details and created some color alteration.

Below: This image using a red filter was deliberately underexposed to accentuate the water highlights (28mm Nikkor).

Many manufacturers now carry whole ranges of filters specifically for special effects purposes. The filters are found in these following general categories:

● Soft focus. These come with a clear center-spot, or varying degrees of softness, graduated soft effects, or colorless streaking effects. Also found within this group are diffuser and fog filters, which give overall soft focus effects at different strengths.

● Star filters. These have varying numbers of fine etched lines to produce pinpoint star effects.

● Multiple-vision filters. These give more than one image of the same subject. Also within the same group are filters which give streak effects to convey the impression of speed and movement, with fainter replicas of the main image as part of the streaking effect.

● Half-color filters. This group includes graduated filters in a range of colors as well as gray. Also included here are filters which are part-colored and part plain, without a graduated effect in between.

● Colored polarizers. These combine the polarizing effect with a range of colors, so you get a colored filter with all the benefits of a polarizing filter.

Any of these filters will produce a distinctive result though don't hold back from further experimentation, such as using different filter types together, or even using two graduated filters at either end of the image frame. The possibilities are almost endless. One filter trick worth trying is to

use three separate color filters, say, red, blue and yellow, one after the other in one shot. This will obviously require separate exposures (see "Double Exposures" for details) and needs a tripod to keep the rest of the image absolutely still. The effect works well with moving water, such as a waterfall, fountain or waves. And bright, angled sunlight enhances the effect.

Above: A Hoya Spectral Cross filter has created an effect around each pinpoint of light.

Left: A simple image will let the effect by clearly seen.

Right: The Hoya multi-image filter has a secondary rotating ring to adjust the effect.

Page 104: B&W Infra-red film works best in bright light.

Page 105, top: The Hoya Rainbow spot filter has a rotating ring for positioning.

Page 105, below: A Cokin Tobacco filter has helped to create a simple, effective image.

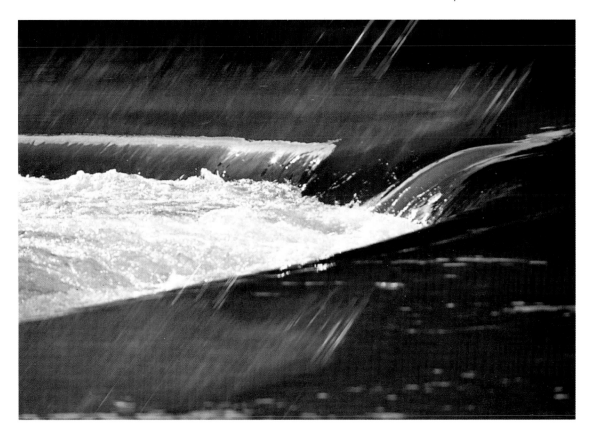

Left: This flower shot was photographed on Fujichrome film.

Below left: The same flower, but photographed using Polachrome color slide film. There's a slight color shift and contrast is higher – a different yet acceptable result.

Right: An image photographed on Fujichrome film. Colors are accurate and strong.

Below right: This is how Kodak infra-red Ektachrome film sees the same subject! Different filters give different results – great for bizarre color effects.

Filters and flash

Colored filters used with flash open up yet another interesting avenue for the enthusiast interested in photographic special effects.

You can position a colored filter over the flash-head and pointed toward the background of the scene, and a different color over the lens. Or no filter over the lens so that the background is eerily lit while the subject is photographed normally. As with lens filters the permutations here are many. A flashgun with a tilt-swivel head will be especially useful.

Films

Certain films are tailor-made for special photography effects. The first and most obvious candidate is infrared film, in both its color slide and black-and-white negative versions. Infrared film is sensitive to infrared radiation as well as normal light. This means it is able to record normal scenes *plus* the warmth of living subjects, from plants to animals to humans. It is also ideal for penetrating haze.

There is only one type of infrared color film produced and it is by Kodak. Called Kodak Ektachrome Infrared it is a slide film and when used with a Wratten 12 deep yellow filter – as a starting point – has a film speed setting of ISO 100. Like all infrared film it needs careful handling and storage. This is because infrared films are mainly sensitive to waves of infrared light. This is lighting that we can't see but is all around us, and is at its strongest in bright sunlight. Infrared film is particularly sensi-

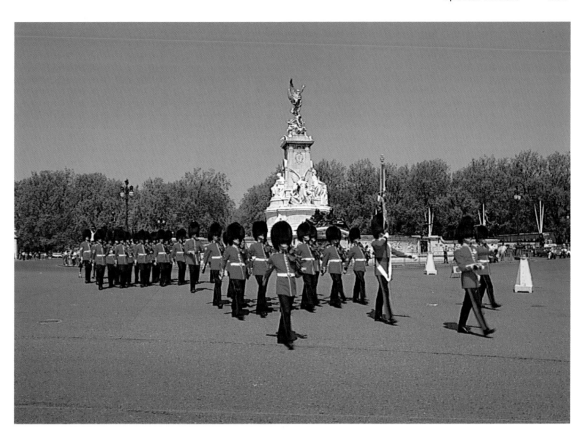

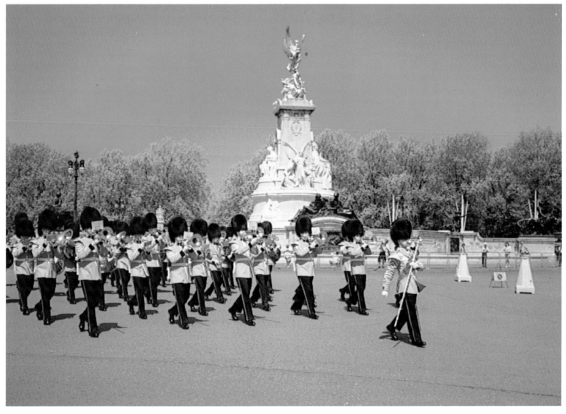

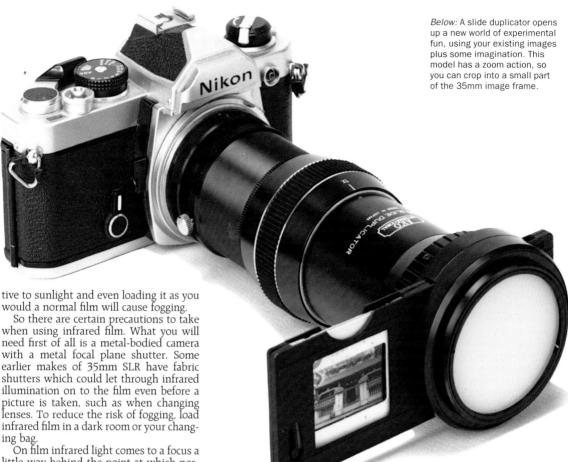

Below: A slide duplicator opens up a new world of experimental fun, using your existing images plus some imagination. This model has a zoom action, so you can crop into a small part of the 35mm image frame.

tive to sunlight and even loading it as you would a normal film will cause fogging.

So there are certain precautions to take when using infrared film. What you will need first of all is a metal-bodied camera with a metal focal plane shutter. Some earlier makes of 35mm SLR have fabric shutters which could let through infrared illumination on to the film even before a picture is taken, such as when changing lenses. To reduce the risk of fogging, load infrared film in a dark room or your changing bag.

On film infrared light comes to a focus a little way behind the point at which normal lighting comes to a focus. So while your focused image may look sharp in the viewfinder it will not be sharp on the film. In order to adjust the focusing so that it will be correct you will need to use the infrared index mark found on lenses. It is very simple to use. First of all, focus as you would normally, and make a note of the distance focused (by looking at the lens's distance scale). Turn the focus ring until this distance setting is lined up against the infrared mark and you will be in focus. Mostly. The approximate position may not satisfy those who demand pinpoint focusing, even under these conditions.

One solution is to use a wide-angle lens, whose generous depth of field characteristics should make up for any inaccuracies in focusing.

Another aspect to look at is the strength of the infrared effect. Resulting colors will be unpredictable and filtration, with a range of filters from red and orange to black, offers a way of controlling the colors and also adds to the visual effect. Its uniqueness has made color infrared film popular with photographic experimenters.

Black-and-white infrared: This is a bit simpler in use, although the same general rules (ie careful loading and handling, and focusing using the infrared index) apply.

Cross-Processing

There are further special effects tricks that can be carried out in the darkroom and as your skill in darkroom work grows (see Chapter 12 for more information on film processing) so will your confidence in experimentation. There's one trick related to film processing that certain pro labs will, for a fee, do for you. This is something known as cross-processing, which is processing a film in non-standard chemistry. A popular trick is to process color slide film, (most types of which use a chemical process called E6) in C41 chemicals, which are normally used for processing color print film.

The result is an image with false and garish, sometimes luminous colors. These hues are far from accurate though their intensity of color leaps out at you from the image. The process has been popular with photography of pop musicians, an area where such stark, off-beat images find a ready market.

The effect with black-and-white infrared is not so garish and almost like normal black-and-white film until you take a closer look. Pictures of plants, for instance, show healthy foliage as a glowing white. So a sunlit meadow and trees will take on a strange snowy appearance.

Portrait shots on black-and-white infrared film are similarly unusual. Skin takes on an eerie glow and surface blemishes on portrait subjects' skin will not be reproduced on film.

Black-and-white infrared film can be used with and without filters. Different filters give different intensities of the infrared effect. A good starting point is a Wratten 25 deep red filter which needs a film speed setting of ISO 50.

There are two brands of black-and-white infrared film available: Kodak and Konica. Kodak's film, called Kodak High Speed Infrared black-and-white film, is the more sensitive of the two, and covers a broader range of infrared wavelengths. It requires special handling and processing but it is able to handle a greater range of infrared illuminated subjects.

Konica's black-and-white infrared film is not sensitive to as wide a spectrum of infrared radiation and has a more subtle effect. It is also more convenient to handle and process because of its lower sensitivity and has smoother grain than Kodak's film.

Some autofocus cameras which use internal infrared systems, for tasks such as reading data off the film, are unsuitable for use with infrared film. Check this with your particular camera's manufacturer first.

Infrared films are not DX-coded.

Slide duplicating

The special effects enthusiast will find slide duplicating a useful skill, giving a range of creative and corrective benefits. Slides can be duplicated for several reasons:

● To make a high contrast duplicate from a low contrast, underexposed original.
● To add a filtered effect to an unfiltered original image.
● To make a double exposure using two slides photographed together.
● To make duplicates of original images that can be used for projection or publication, so ensuring that the precious original is kept safe.
● To re-shoot a color original on to black-and-white film; to superimpose a title over an image.
● To photograph a small part of an original slide.

There are different types of slide duplicator, but most just consist of a simple holder to put the original slide into and a light source. Some have a way of varying the output of the light source while others also have cropping capabilities. The cheapest and most popular consist of a lens-

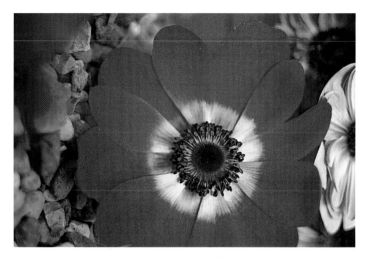

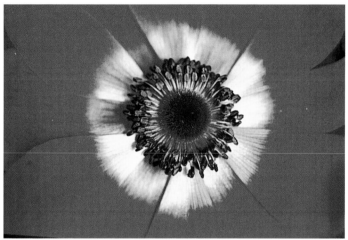

shaped tube that attaches to the SLR body. There isn't a focusing ring because the focus has been set at the manufacturing stage. Some have a zooming sleeve allowing the tube to be slid forward to crop part of a section from a full-frame original.

On the side of the slide holder – between the light source and the slide duplicating unit – is a diffusing panel. This gives an even spread for the illumination to shine through. The illumination itself can be simple outdoor lighting (a bright overcast sky with a large area of even cloud is a good starting point) or flash. Flash is the more controllable though you will need to place the flash at different distances in front of a basic slide duplicator, and facing toward it, before you find the distance that will give the best result for your particular flash-camera setup. As a starting point, and with a low to medium powered flashgun connected to your SLR by a flash cable, position the flash about 60cm away from the front of the slide duplicator. NB Only look through the SLR viewfinder when lining up the slide in the duplicator, but *never* when firing the flash.

Top: The photographer wanted to zero in on the flower's vivid red, so decided to do a tighter crop.

Above: Using a zoom slide duplicator, he managed to isolate the flower from its surroundings. Duplicating gives increased contrast in the resulting photograph.

Compact Cameras

The Clever Compact
Compact cameras, especially zoom compacts, are now so advanced that many are close to SLRs in features, apart from through-the-lens viewing and lens interchangeability. Even here they have come up with a viable alternative. Zoom compacts' viewfinders, and the coverage of their built-in flash units, change automatically to adapt to the zoom setting that's been selected.

Their focal length ranges have now gone beyond the traditional 35-70mm setting that used to be the norm. Zoom compacts with telephoto focal lengths such as 115mm, or as wide as 28mm wide-angle, are rapidly becoming the standard.

An additional attraction is that only the most immediately useful and popular features are included, so making them less cluttered than a high-end SLR and more convenient to use. They're also smaller than equivalent SLRs, though not always cheaper. Some cost as much as or more than a basic SLR with zoom lens!

While the focal length ranges of zoom compacts are expanding, they still have some way to go to rival the extent of an SLR system's lens range. While the adaptable viewfinder is a step closer to SLR through-the-lens viewing it misses out on the sheer framing convenience and ease of picture composition of through-the-lens viewing. Photographing close-up subjects, for instance, can cause framing inaccuracies in spite of a compact's built-in viewfinder adjustment for close-up shooting.

However, these drawbacks don't stop single-lens and zoom compacts being very popular second cameras for many SLR owners.

Compact Camera Types

Single lens or disposable
This is basically a camera built around a film. The lens focus is fixed and covers a range of from around 1.5m(yds) to infinity. Film winding is manual via a thumbwheel control at the rear. Some have built-in flash, the power supplied by a small battery with sufficient flash power for the number of exposures, usually 12 or 24.

Instructions for use are usually imprinted on the casing.

When the end of the film is reached the complete camera is handed over to a processing lab, who dismantle it, take the film out and process it. The camera can only be used once.

Prices are the lowest of any 35mm camera. Disposable cameras come in many types: with or without flash, with panoramic format, weatherproof and underwater.

Disposables are aimed at those who want to carry around a cheap, easy-to-use camera for happy snaps. Results are very acceptable considering the simple nature and low prices of disposables.

Fixed focus
This is the next step up from a disposable camera, with the main difference being that this camera is re-usable. Like the disposable, focus is fixed, although its closest focusing distance may be a little better, around 1m(yd) to infinity. Film wind may be via thumbwheel or may be automatic, depending on the price.

Most have built-in flash units, with a manual on/off switch for flash use. More advanced versions will have auto flash, the flash operating automatically when light levels are low. Some may even have redeye reduction flash.

Fixed focus compacts are made by a range of manufacturers including big-name SLR brands. The features of fixed focus compacts are limited by their basic specification and by price, especially considering the ever-lower prices of models in the next category: autofocus compacts.

Autofocus compact
The combination of autofocus, small, pocketable dimensions and keen pricing has made this category very popular. This camera range runs from very simple autofocus models, usually equipped with basic three-zone autofocus, to those with multizone autofocus and hi-tech features.

Above: Top of the range compacts, like the Contax TVS, have features that can compete with some of those found on SLRs. Some compacts lower down the price range have similarly competitive specs.

The average middle level autofocus compact has a 35mm lens, a built-in flash with the following modes: auto flash, flash on/off, redeye reduction flash. An alternative to a redeye reduction pre-flash is a beam, which is emitted before the main flash fires.

Virtually all have automatic film wind-on (when the film is first loaded into the camera), then auto film winding for subsequent frames and rewinding. Some offer refinements such as mid-roll film rewind and a self-timer. Nearly all have, in addition to a normal image frame used for composition, parallax marks. These are used as guides so that objects closer to the camera (but not seen directly in the viewfinder window) will not be left out of the finished image.

Many offer close focusing ranges of around 1m(yd) and some focus closer.

Shutter speed ranges of around 1/15 sec to 1/250sec give great flexibility with exposure under different lighting conditions, as does a more extensive film speed range, typically ISO 50-1000 or 3200, with the higher priced models.

Top of the range models may offer extremely compact bodies, an LCD information window that shows camera status, mode set etc., wider angled lenses (ie 28mm), ultra close focusing (typically around 60cm (two feet), exposure compensation (usually around +1.5EV), and continuous film wind-on (ie like a motor-drive) of around one frame per second.

Autofocus zoom compact

Most zoom compacts have a focal length range of around 35-70mm (although the trend is toward wider, ie 28mm, and more telephoto, ie 105mm, 135mm, or 140mm focal lengths). The viewfinder and, with most of them, the flash adjusts to the different focal lengths. The zoom controls are usually found at the rear of the camera where the thumb falls or somewhere on the camera top plate within easy finger reach.

Zoom compacts have all the features found on single lens autofocus compacts and may have extras such as more sensitive and more accurate autofocusing, a greater range of shutter speeds, automatic macro setting for close-up photography, an intervalometer for interval shooting, perhaps even an infrared remote-controlled firing facility.

With a greater range of features over a normal compact plus the additional space needed for ever longer focal length ranges, zoom compact cameras are considerably bigger than single lens autofocus compacts. In fact, only a small minority of zoom compacts are easily pocketable (ie small *and* light). However, the top of the range models approach hi-tech SLRs in terms of their features, and handling – and, of course, price.

Shutter open.

B setting.

Time duration.

Battery warning.

Film symbol.

Flash-off/cancel.

Fill-in flash.

Exposure compensation.

Double exposure.

Intervalometer.

Film winding.

Double self-timer.

Close-up setting.

Continuous wind.

Slow shutter speed.

Slow shutter speed with flash.

Backlight compensation.

B setting with flash.

Redeye reduction.

Landscape mode.

Self-timer mode.

Redeye reductions.

Weatherproof/underwater compact

These are mostly mid-priced single lens autofocus compacts with reinforced and sealed housings, and shouldn't be confused with the less rugged underwater disposable cameras. Most can comfortably be used in wet weather, while a minority function as fully working underwater cameras to certain depths. Their stronger than usual construction makes them ideal for knockabout photographic situations such as on vacation and for travel photography. Some have autofocus although, with most, an optional manual focus setting is used when photographing under water.

Above: A selection of symbols used in compacts' LCD panels, or on the cameras themselves. They are common to most compacts and so give the user easy familiarity with different brands.

Top of the range is the Nikonos, a direct vision viewfinder model (ie like a compact) which is watertight to diver's depths and has interchangeable lenses.

Hybrid camera

This incorporates a built-in zoom lens, usually of an extensive focal length range, in a non-standard body shape. The models currently available offer varying degrees of comfort in use, though their size and shapes make them difficult to carry in a pocket. They're certainly not among the bestsellers of the 35mm camera world, which is unfortunate as some have generous and genuinely useful feature ranges.

High-end autofocus/manual focus cameras

These are expensive top-of-the-range models which offer the most immediately useful features, in top-quality body casings, and are the compacts to be taken seriously. Optical performance is also among the best to be found in 35mm compact cameras. Most have manual focus and autofocus plus other benefits of electronic cameras: auto film wind and rewind, LED confirmation of focus, and flexible flash modes.

A major facility that makes them stand out from the crowd is the amount of exposure compensation they provide, either via extensive exposure compensation ranges (ie giving over *and* underexposure options) user setting or override of film speed, as well as a manual focus option.

Top of the range is the manual focus Leica rangefinder camera which takes interchangeable lenses.

The Contax TVS is a top-end compact with a Carl Zeiss zoom lens.

Getting the best from your compact

Today's compact cameras are flexible machines with more features as you go up the price scale. Although they don't have the versatility of SLRs, there's still a lot you can do with them photographically, once you're aware of their strengths and their weaknesses.

The Lens

The lens focal lengths on compacts seem to be getting more versatile with each new model. The widest focal length currently found on a compact is 28mm, while the longest on a conventional compact is 140mm. So, although you won't get an SLR's freedom of lens interchangeability, there's still a huge range of subject-matter that the available focal lengths can cover.

A single lens compact may be all you need, depending on your range of photographic interests. Landscapes, people and moderate architectural photography can all be comfortably accommodated with

just a single lens compact. These subjects benefit from the moderate wide-angle focal length of single lens models, typically 35mm, and even frame-filling portraiture may not be overly affected by the slight barrel distortion that occurs.

Another benefit of a single lens compact is that it's cheaper than a zoom compact and, because of the lens design, requires a smaller camera body. Single lens compacts can also focus closer than zoom compacts, a bonus if you want close-ups of flowers or flat subjects such as paintings or drawings.

However, zoom compacts have been dropping in price and size. They also offer a range of focal lengths and therefore a range of compositional choices. If you don't like the way a composition looks at 35mm then a change to 70mm, or maybe in-between, may offer an improvement. Zoom compacts, because of their telephoto settings, also enable more effective framing of head and shoulders portraits. The long focal length can also get across physical boundaries (ie at a zoo or a concert).

A problem with zoom compacts and, to a lesser extent, single lens models, is that

Top: Standard focal length range in a zoom compact is 35-70mm. The 35mm setting, used here, gives a wide view which is suitable for landscapes.

Above: The 70mm setting brings the subject a little bit closer. It's good for selecting parts from a larger scene, and for portraits.

they have smaller maximum apertures than their SLR lens equivalents. A minimum aperture of f/3.5 for a 35mm lens is standard for a compact but is considered slow in a lens for an SLR. Similarly many zoom compact's maximum apertures start at around f/4.5 at 35mm, and this becomes an even slower f/6.7 at the 70mm setting.

This will, of course, mean that correspondingly slower shutter speeds are chosen. In order to maximize the shutter speeds you will need to use faster film. At the same time if you don't want to sacrifice image quality, you'll need to use as slow a film speed as possible for the lighting conditions and the subject. Some possible solutions are to photograph in the brightest light available, to use flash to freeze the action, or just use a fast film.

Lens performance

The performance of an average compact camera lens is astonishingly high, considering the optical compromises that have had to be made to include a lens in such a small camera's dimensions.

Performance at the center of the image is best and this gradually tails off toward the edges of the frame. Generally speaking, the more expensive the compact, the better the center and the edge lens performance. You can see this in enlargements made from negatives or slides taken on a compact. Most compacts are capable of producing reasonably sharp to excellent 10x8in

Left: Most lenses on today's compacts deliver good to excellent sharpness. This image was shot on a Leica autofocus compact.

prints, while a small and expensive minority are able to produce sharp results at much bigger enlargements.

You can maximize your compact's lens performance by using the slowest speeded film and avoid shooting toward a light source such as the sun or a lamp, as this will affect sharpness and contrast. Simple

Below: Date and time imprinting are optional extras, as are numbering and even pre-printed messages!

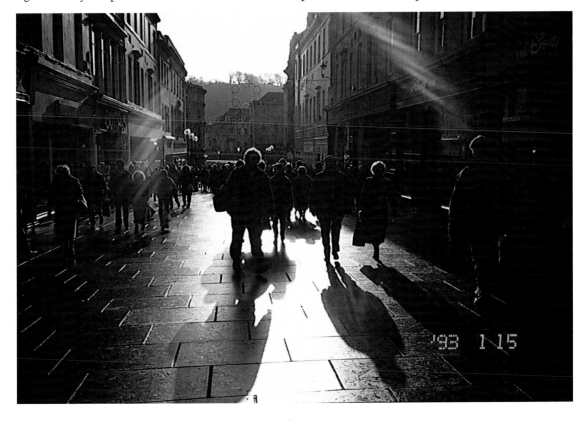

precautions, such as holding your camera steady when photographing or placing it on a supporting surface such as a wall or tripod, will help to make the most of your lens's sharpness. Try to keep the lens clean at all times and free from dust, dirt and scratches. Finger marks too can affect image sharpness plus acid from the skin will, over time, affect the lens coating. A built-in lens cover gives good protection, as does carrying the camera in a soft pouch case.

A major problem is vignetting, darkening at the corners of the image frame. This is caused by a combination of the lens design and the positioning of the lens in relation to the image area on the film. Zoom lenses in compacts are more prone to vignetting than single lenses though, as lens/camera designs do differ, this can vary.

Ultimately vignetting as a problem is a minor one, given the design limitations of compacts. Even the cheapest compacts seem to have the problem under control. Where it's obvious it can be cured by cropping at the printing stage or, if projecting slides, by use of smaller than normal mounts.

Focusing

Be aware of your compact's limitations and work within them. Closest focusing distances need to be adhered to if you want to ensure sharp shots. Some compacts don't allow the AF to operate if the subject is closer than the minimum distance, while others do.

Use the technology by referring to the LED in-focus confirmation indicators. Focus-lock is ideal for locking on to off-center subjects, although there are some compact models with multi-zone autofocus that use more than one focusing target area, ensuring that centered subjects, as well as those on either side, are all in focus.

Filters

Filters can add fun and creativity to compact photography but the design of most of today's models means that it is difficult though not impossible to use filters with them. Few compacts have a filter thread for screwing on round filters, or adaptors that can take square filters. Those that do are generally older compacts or top-of-the-range models that may have optional filters in their accessory ranges.

The main problem with large filters such as square ones is that there's a danger of obscuring the infrared focus eyes, thus affecting focusing. An alternative is to use a smaller round filter, though this can be difficult if there's no way of attaching it to the front of the lens. Cokin produce a special adaptor that fits compact cameras.

The filter you use, especially if it's going to cut some light reaching the film, should also cover the exposure sensor cell, as the camera will then adjust accordingly.

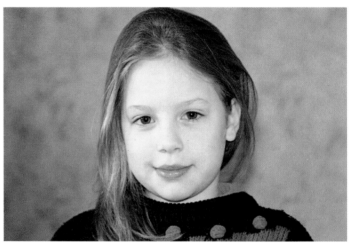

With the filter-attaching problems out of the way you may also encounter problems with certain filter types, namely polarizers and graduated filters. With a polarizer it's comparatively easy to turn the rotating element and visually check the effect you're getting before placing the filter carefully over the lens ready for the shot.

With a graduated filter, getting the area of graduation at the correct position in the picture area can be a hit-and-miss affair. Carefully lining up the filter with the lens and trying several different positions will give a good chance of success. It's at moments like these that you'll begin to appreciate the greater versatility of an SLR's through-the-lens viewing system!

Flash

The small dimensions of compact cameras limit the size of flash that can be used with them. Most have a guide number of 10-15, giving ample coverage at standard working camera-to-subject distances of around six feet. Some built-in flash units are very sophisticated and are able to reduce flash

Top: This is the result if you're closer than the camera's closest focusing distance. Some compacts may lock the shutter.

Above: Take note of the too-close warning lamps in or near the viewfinder, and alter your distance.

Above right: Some compacts allow filter use, though it must not interfere with any sensors (Orange filter. Minox GT).

Right: Focus lock and built-in flash caught this seagull in mid-flight (Ricoh AF-5).

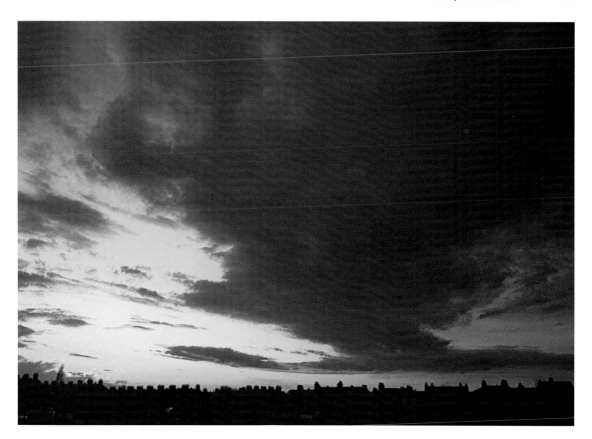

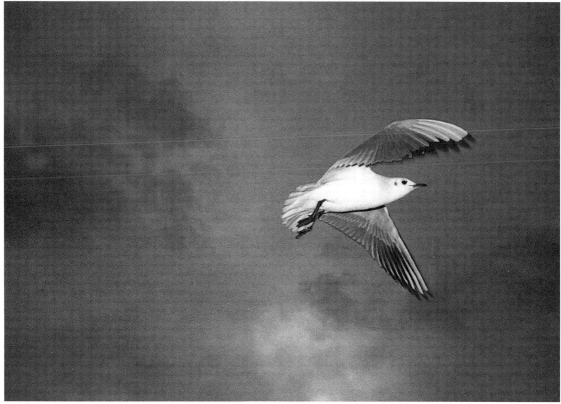

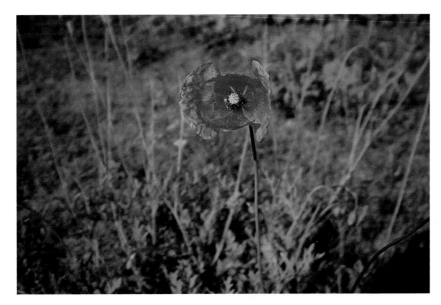

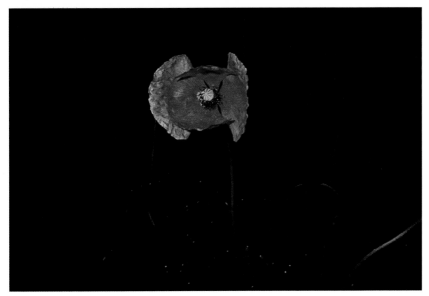

Left: A straightforward programmed exposure shot, no flash.

Below left: Some compacts balance flash illumination with existing light but the flash setting on this compact was less subtle.

Right: The late afternoon lighting gives a golden look to these plants and brickwork.

output for closer subjects and even macro subjects. However, few can totally illuminate the image area at distances of more than 3m(yds). Some models get round this problem by providing a slow shutter speed with flash setting. Here, the flash illuminates the main subject, while the rest of the exposure (with the slow shutter speed duration) records the surroundings. This gives a well-lit result right across the image frame, although moving subjects will be blurred.

In order to extend the range of compacts' flash units some manufacturers market special adaptors which contain a slave cell and holder which is attached to a more powerful flash unit. The slave cell is positioned over or near the compact's flash. When the compact's flash unit fires, it trig-

gers the slave cell which, in turn, fires the main flash. It's worth it if you want more powerful flash results such as bounce flash, but then if you do it may be time to ask yourself whether an SLR, with its greater flash accessibility, will better suit your needs.

Redeye reduction
This is a useful gimmick that works most of the time, though it comes at a cost. This cost is the delay time between the redeye reduction operation, be it a pre-flash system or a steady beam. Facial expressions or movements with, say, posed portraits may be lost or can look forced as the subjects, unfamiliar with the variable delay time of the different systems, will not be sure when the main flash has fired.

Right: Using flash has neutralized the colors and given a harsher lighting result.

Many compacts have a straight auto flash option, worth the risk as redeye doesn't occur with every flash shot. Ultimately, it's best to have both flash options.

Another option well worth having is flash-off or flash-cancel. While autoflash has proved itself to be a real boon there are times when it can totally destroy the "feel" of a photograph. A compact with slow shutter speeds or B will mean that exposures without flash are possible though, of course, some kind of steadying support will be necessary.

Flash recharging time of compacts is typically around four seconds with new batteries, though these will obviously get longer as battery power diminishes.

Composition

The main difficulty of composing with a compact is the parallax error: what you see in the viewfinder is not exactly what the lens records. This effect can be more pronounced the farther away the viewfinder is in relation to the lens, although frame marks in the viewfinder give an approximate guide for framing. With zoom compacts the frame changes to correspond to the focal length selected.

Aligning what's in the center of the viewfinder on to the finished film is easiest with compacts whose viewfinders are directly above the lens. Centering of subjects will then be easy. For tighter framing for closer subjects first frame the composi-

Batteries

The main battery types for use in compact cameras are: 6V lithium 3V lithium CR123A and manganese-alkaline AA or AAA batteries. As compact cameras get smaller, more will use the tiny CR123A lithium batteries.

The manganese-alkaline batteries are the most widely available and, in an emergency, can be borrowed from portable radios or cassette players. Rechargeable NiCard batteries can be used in some photographic equipment, but check your instruction manual first.

Batteries need to be protected from knocks, extreme cold, extreme heat and fire. Used batteries should never be left in a camera as they will corrode the electrical contacts and even the interior of the camera, possibly beyond repair. Batteries need to be kept away from children and animals, and used batteries need to be disposed of safely.

tion within the frame lines, then tilt the camera up very slightly to allow for what's below the level of the viewfinder window to be included.

Try this exercise. Look through the viewfinder at a subject and make a note of the area that's included in the viewfinder's frame lines. You'll be surprised at the extra elements of the scene, unseen by you, that the lens has captured. The resulting image will also give you a more precise idea of just how much of the scene will be included when composing with your particular compact.

Centering of a subject will obviously be more difficult with close-up photography. Many compacts adjust the viewfinder to allow for close-up shooting, though even here a preliminary test, as above, will give a clearer indication of the best place to position the subject within the viewfinder frame of your compact.

Above left: Parallax error means that a compact will never be able to show in the viewfinder *exactly* what the lens "sees." But it's more of a problem with close-up subjects than those at standard shooting distances.

Left: The standard 35mm focal length of a compact gives a wide-angle view, ideal for photographing people and places.

Below: Double exposure, a feature often found on mid-to-high priced compacts.

Architecture

Photographing architecture is easy and difficult at the same time. It's easy because buildings are solid and immoveable and can be photographed at any shutter speed. It's difficult because the photographer needs to take some time to choose the best viewpoint and lighting in order to make the most of the subject.

Procedures such as waiting for the right lighting, selecting a suitable viewpoint and using the right lens for the job, all require a disciplined approach to architectural photography. Overcoming the problems and producing a strong, impactful image is one of the challenges and rewards of architectural photography.

Lenses for architecture
A range of different focal lengths can be used to photograph architecture but the most useful is a wide-angle lens. A moderate (35mm) to wide (28mm or 24mm) wide-angle will give the best combination of encompassing views, with reasonable control of the barrel distortion that is a characteristic of this lens type. The grotesque barrel distortion of ultra wide-angle lenses can be used for effect but for general architectural photography will not be able to give a good impression of the vertical and horizontal lines that make up a building's shape. Wide-angle lenses can result in converging verticals unless this effect is corrected.

A simple 50mm standard lens can be an effective lens for use with buildings, giving minimal distortion. Note that it will also give a narrow angle of view that will not include as much of a building as a wide-angle would.

Telephoto lenses can be useful for concentrating on specific architectural details or for getting at difficult to reach parts of a building. Sometimes a very good detail shot will be able to convey as strong an impression of a building's architecture as a wide-angle.

Telephotos are also good for photographing a group of buildings, the stacking effect caused by the compressed perspective giving an impression of density and even lining up various architectural styles within one picture. To get frame-filling shots photograph from a distance.

Below: Early morning is a good time to photograph architecture. Lighting is angled and soft. It's also when traffic is at a minimum.

Left: Lenses for architecture are specialized and expensive, but have superb image control. They are known as perspective control or tilt-shift lenses, and are mostly wide-angle.

Below: This Provençal architecture was photographed with a Nikkor lens. Ektachrome 400 was uprated to ISO 800.

Filters

One of the few controls the photographer has over image appearance in architectural photography is filtration, so a set of filters will be a useful addition.

A polarizer is the most useful single filter, even if you don't buy any others, being capable of adding a lot of impact to architectural subjects. It can be used to intensify the blue of skies behind a building. It will help to cut down reflections on shiny surfaces and bring out inherent colors of stone or woodwork.

The depth of field requirements and therefore longer exposures will be extended further by the polarizer's 2X filter factor. Polarizers are most effective when used in bright lighting.

Special filtration will be needed to cope with mixed lighting if you intend using daylight-balanced film for photographing architectural interiors. There are a range of color correction filters that can be used to adjust the color casts from mixed artificial light sources. But there are several proce-

Other Accessories

You need to choose the smallest aperture possible for architecture, to get the greatest depth of field. As this will also result in slower shutter speeds, a tripod is a must. A tripod will also help in lining up a composition with extra care, ensuring that all the various elements of the scene are in the right place. At slow shutter speeds anything that will help in steadying the camera is worth having, such as a cable release which will enable remote operation of the shutter button. An alternative is to set the camera to self-timer mode and let it take the picture, as long as the lighting conditions remain consistent for the duration of the self-timer countdown.

Left: The interior and exterior lighting give a good impression of the building's shape and size. Panasonic C-900ZM zoom compact.

dures involved, such as taping the right color-balancing colored gels over light sources, replacing some lamps with color corrected ones, and not forgetting the various compensations involved for filter factors and Reciprocity Law Failure.

These and other procedures involved include getting special permission from the building's owners and photographing at a time when the building is least crowded or empty. It may also be necessary to use a powerful flash, especially for interiors, either directed at a specific area or bounced off a reflective surface. The complexities involved with using flash to light interiors, especially large ones, may require more than one flash burst. This aspect plus the other procedures mentioned here, all fall into the territory of the professional photographer. More detailed information on photographing architecture can be found in books specializing in the subject.

The simplest route for the beginner keen on photographing architecture but unwilling at this stage to get involved in more complicated procedures of color correction is to use an 80A blue filter when photographing tungsten lighting with daylight film, or a 30M filter or FL-D filter so as to neutralize the green cast that occurs when photographing most fluorescent lighting.

There are alternative ways around the problem of color casts caused by artificial lighting. Shooting on color print film will enable any color casts to be corrected at the darkroom stage. Or you could shoot with tungsten-balanced film to neutralize some of the casts. This film is also balanced for longer exposures than are possible with daylight film and is, within reasonable limits, less likely to need compensation for Reciprocity Law Failure.

Some fast color films cope admirably well with mixed lighting and if you don't

mind some visible grain – the quality varies from film to film – then this is yet another alternative.

Finally, some color casts can be tolerable. Tungsten lighting's warm orange glow can look very effective when set against, say, a blue night sky.

Film

Part of the impact of good architectural photography is the recording of building details and surfaces. This calls for slow, high-quality film but will also mean working with a tripod most of the time in order to maximize the depth of field. As slow films mean slow shutter speeds, there's a limit to the ISO speeds you can comfortably work with. The slowest film speed is ISO 25. Its high image quality is undeniable, as are results with ISO 50 and 64 films. However, these films deliver their best results in bright lighting, which isn't always available. A medium speed film of ISO 100 or 200 gives more exposure leeway and is usable in a wide range of lighting conditions yet can deliver good quality results. These films also give a few extra stops of exposure, vital to give a workable set of shutter speeds and apertures when using compensating filters.

While artificial light sources will always cause problematical color casts with daylight films, black-and-white film is obviously not affected by these color casts.

With black-and-white film, yellow, orange and red filters will give increasing degrees of contrast and can add some drama to photographs of architecture. They will also have increasingly higher filter factors and, like polarizers, will need to be compensated for when assessing exposure (see Chapter 4 – Filters). Fortunately, black-and-white medium and fast films offer smaller apertures which can be used with faster shutter speeds.

Left: Slow shutter speed with flash was used. The flash was just powerful enough to light the foreground pillar.

Below: This normally gray building's surface was transformed by light from the setting sun (135mm Nikkor).

Technique

Viewpoint

While one of the benefits of photographing buildings is that they are static subjects, they are rarely positioned in the most photogenic locations or with their best aspects easily accessible. And other objects like traffic, street furniture such as lamps, bollards and fences can mar certain viewing angles or cast unwanted shadows. But they shouldn't be ignored completely. They can also give a sense of scale, just as long as their relation to the building, either via size or color, isn't visually distracting. Plants and people also give a sense of scale and can help to soften the hard lines of modern architecture.

Shooting from ground level will cause the problem of converging verticals unless you can avoid this by using the appropriate equipment (see page 128).

If there are obstructions between you and a full view of the building when looked at head-on then photograph it from an angle. This may also show the building's form more effectively rather than the straight-on shot, which shows a slightly flatter perspective.

When seen from a high viewpoint, buildings take on a foreshortened appearance. Depending on how high you are this vantage point can dramatically alter the scale of a building that, seen from ground level, might have appeared dominating. This viewpoint will also give a better view of roof details and any ornamentation on or around it. A zoom lens will give you several framing options.

Ultimately, the viewpoint you choose will be decided by the available shooting positions and the available lighting, but it is well worth the additional care and patience required.

Above: This New York scene benefits from the vertical format. Make a note of the effects of light on architecture, even when you're without a camera.

Left: Strong angled lighting is ideal for picking out details (135mm Nikkor, Fujichrome 100).

Far left: The foreground pillars frame the scene, while the human figures give a sense of scale (135mm Nikkor).

Above, top left: A telephoto selected this pattern of mirror windows.

Above, left: The same subject photographed on a day with different lighting.

Converging verticals

As buildings are mostly viewed from the ground, they also tend to be photographed from ground level. But the result is often an image which shows the vertical lines of a building tapering toward a point at the top. These *converging verticals* can convey an impression of height but don't show the building as it is (ie with straight parallel sides).

There are four ways to solve the problem. The first is to position yourself above ground level so that the effect of converging verticals is lessened or, depending on how high you are, disappears completely.

You could also use a telephoto lens to photograph the building from a distance, which will maintain the parallel verticals. But this isn't always practical as the build-ing may be closely surrounded by others, with insufficient area between you and the subject for the telephoto lens to be used effectively.

Converging verticals can be corrected at the darkroom stage when making a print, by tilting the baseboard which holds the paper, until the sides of the building appear parallel. But it takes an experienced darkroom worker to get a successful result as the baseboard tilt can make part of the image out of focus.

The final method is to use a special lens called a perspective control lens. Part of the lens can be raised up and this has the effect of straightening out the sides of the build-ing so that there is no convergence. And you can still photograph from ground-level. These special lenses are wide-angle

Page 126: Building photographed with an ordinary lens tapers to a point at the top.

Page 127: A pc lens will lose the tapering effect.

Above: Late afternoon lighting picks out this collection of different architectural styles.

types, usually 35mm or 28mm, and, because they use special optical and mechanical systems they are expensive, sometimes costing as much as a high quality SLR! They are only worth getting if you can spare the money or if you intend taking up architectural photography as a serious career.

Lighting for architecture

Bright lighting shows a building's details in full with the hard shadows effectively emphasizing form. High-contrast lighting can also be difficult to control, especially with light subjects or white surfaces. Strong lighting also affects subtle coloring such as brick or stonework, although it does provide an ideal backdrop when photographing stained glass windows from a church interior. It also brightens up an interior by bouncing light off various reflective surfaces such as walls, ceilings or light-colored floors.

In situations like these start off with spot-meter readings, work out the average, then bracket.

Angled lighting will pick out the texture of stone and can emphasize form by casting shadows on window ledges, door lintels and other details.

If you have the time try and view the building at different times of day and under different lighting conditions before photographing it. Note where the shadows fall and how the building's colors are affected under different illumination, whether daylight or artificial. And don't forget night-time illuminations which can transform even the dullest building. Learn to carry a camera at all times, so you're ready to capture all lighting conditions. Even a compact can be used as a visual note pad, recording the subject for a future picture-taking session.

Action

The small size and high-quality images obtainable from 35mm equipment lend themselves to action photography, where a highly portable but versatile camera is required. A good action photograph can be difficult to achieve for the beginner although ultra-fast autofocus systems and rapid film winders are valuable assets. But even these cannot produce a winning shot without some prior knowledge and skill in knowing how to use them effectively, what to photograph, and how to achieve the best results. This chapter serves as a basic introduction to an area of photography that demands a great deal of technical skill and sometimes the reflexes to be able to effectively capture subjects that are moving at speed. Ninety percent of the images on the following pages illustrated this difficult area of photography superbly.

Right: A semi-fisheye lens, a close vantage point and fill-in flash were used for this shot — plus some pre-planning and a secure camera position!

Tele-converters

Tele-converters are small lenses that can increase the focal length of an existing lens by 1.4×, 2× or even 3×. They attach between the camera body and the lens.

If you use a 2× tele-converter with a lens, it will double the focal length, so a 300mm lens becomes, in effect, a 600mm lens. Yet the focusing distance is the same. As tele-converters are reasonably cheap they can save you from having to spend money on an expensive 600mm lens. Tele-converters are small and light and take up less space in a camera bag than a 600mm lens would.

But they have some drawbacks. The first is that they cut down the amount of light that passes through the lens on to the film. So, if you're using a 2× tele-converter with an f/5.6 300mm lens, it loses two stops of light and becomes a 600mm lens but with an f/11 maximum aperture. With bright lighting this may not be a serious problem but it will be with poor lighting, giving fewer working apertures and shutter speeds.

A compromise is to use a 1.4x tele-converter. When attached to a 300mm f/5.6 lens it offers a more modest though still useful focal length increase of 420mm yet the exposure adjustment that is required is only 1 stop (ie f/8).

Some cheap tele-converters dramatically decrease image quality, the extended focal length resulting in poor sharpness and an increase in your lens's minor optical defects. If you want high optical quality but don't want to invest in an expensive long lens the tele-converters produced by camera and lens manufacturers to use with their own optics are preferable. These tele-converters give the best results, and some are the same price as a conventional lens.

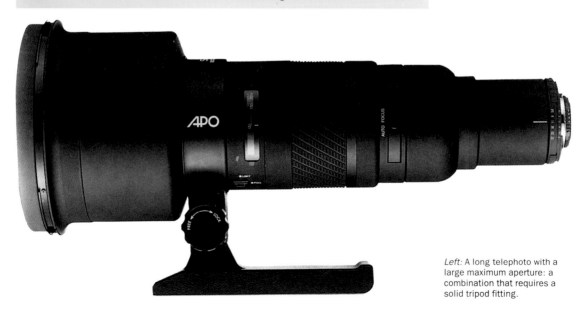

Left: A long telephoto with a large maximum aperture: a combination that requires a solid tripod fitting.

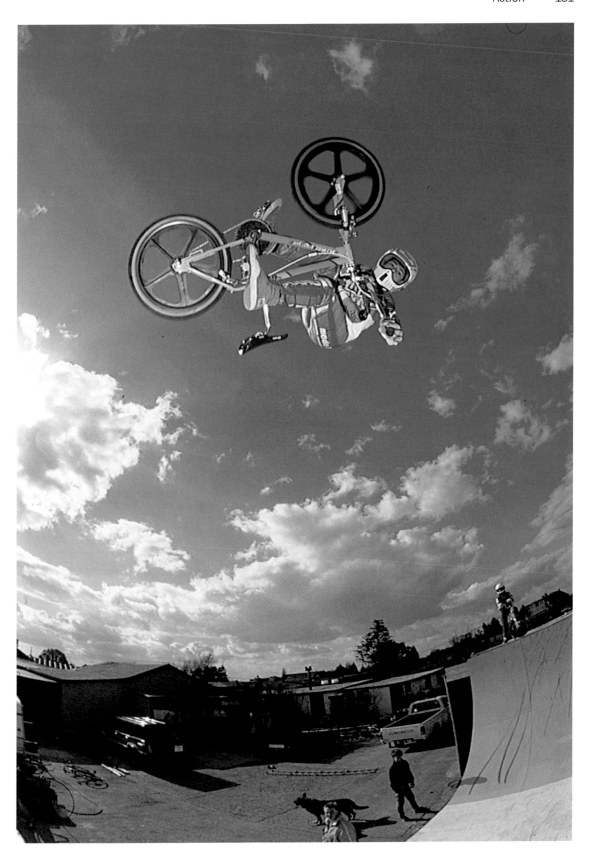

Getting equipped for action

A telephoto lens is a must but the focal length you select depends on the camera-to-subject distances that are usually encountered. The longest telephotos that are just about able to be used hand-held – depending on the make and the maximum aperture – are 300mm and then only in an emergency and at top shutter speeds.

Mirror lenses are lighter yet have longer focal lengths. A 500mm mirror lens, for instance, has a shorter body length than a 300mm telephoto lens and will balance easier in the hand. But these too are heavy and a support such as a tripod or even a monopod will give a reassurance of sharp, shake-free images.

What makes the result of camera shake easily visible with a telephoto lens is the narrow, magnified angle of view. With a wide-angle lens, because the details are smaller in the frame and will only reveal the results of camera shake when enlarged, slight blur may pass virtually unnoticed.

A long-range zoom, such as a 70-210mm, is an alternative choice though you may need to get a little bit closer to the action in order to fill the frame. The benefit of a comparatively smaller lens, such as a 70-210mm, is that it is lighter and the zooming facility gives a greater range of framing choices, even if you're shooting from just one position. Even better than this is a zoom with a longer reach, say a 75-300 or a 100-300mm

Shorter focal lengths have their uses but only if you can get close to the action and photograph it safely without risking yourself or your equipment. However, some stunning action shots have been taken on wide-angles with some careful pre-planning and positioning.

Camera supports

Telephoto lenses feature heavily in action photography and to get the most from these large optics they will need to be firmly supported when you shoot. A solid heavy tripod is the best kind of support, but the worst kind of accessory to have to carry around. If you're likely to be shooting from one or more locations that are within a short distance of each other then the weight of a heavy tripod can be bearable. Otherwise a lighter weight alternative is a monopod. This looks like a single leg from a tripod and also has a platform on the top on which to place the camera. Monopods are comparatively portable and, by using your stance to balance against, can form an effective support for heavy long lenses.

If even a monopod is restrictive, due to location or requirements of space, an alternative is a shoulder support. This consists of a brace which has a rifle-type butt that rests against the shoulder. There's also a small platform for securing the camera. The unit can be adjusted to suit the photographer and lens.

In the absence of any of these supports the photographer can use a wall, tree, or pole to rest against. Lowering the center of gravity, by sitting or lying down, can give added stability when using long telephotos.

Techniques for action

Most action photography, whether it's photographing sports, vehicles, or animals

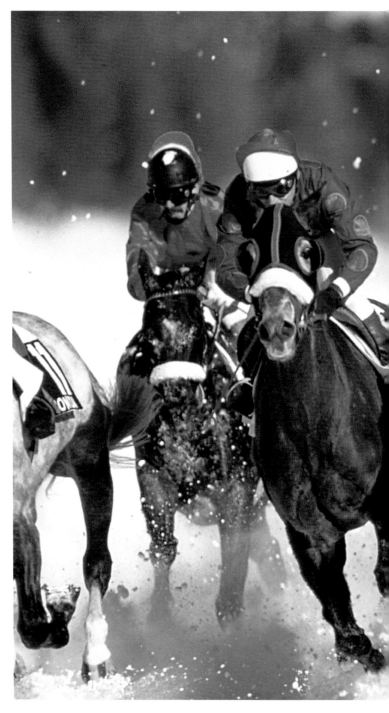

in motion, requires the fastest shutter speeds available. This can be a challenge as the lens in use, film quality requirements, lighting conditions, and camera stability (or lack of it) all play a part. Telephoto lenses, by their design, have shallow depth of field. Fortunately, most action shots benefit from shallow depth of field as this will make distracting background features become indistinct.

A general rule when using long lenses is to use a shutter speed that is near the equivalent of the lens focal length. So a 300mm telephoto would require a shutter speed of 1/250sec (the closest to 300), a 500mm mirror lens would need 1/500sec, and so on,

If you do need to maximize depth of field it will mean a reduction in the shutter speed. Yet, as a long telephoto lens needs

Below: The limited freedom of movement at some venues calls for crafty pre-positioning and clever lens work, as in this image photographed on St. Moritz Lake.

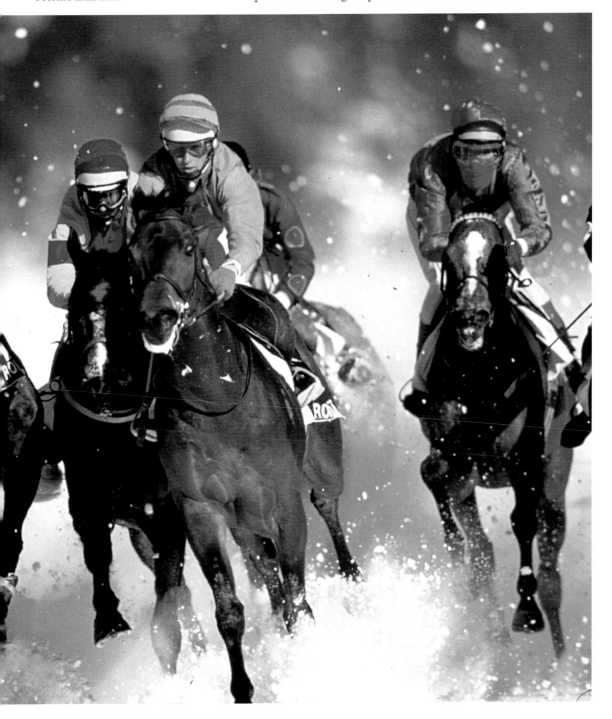

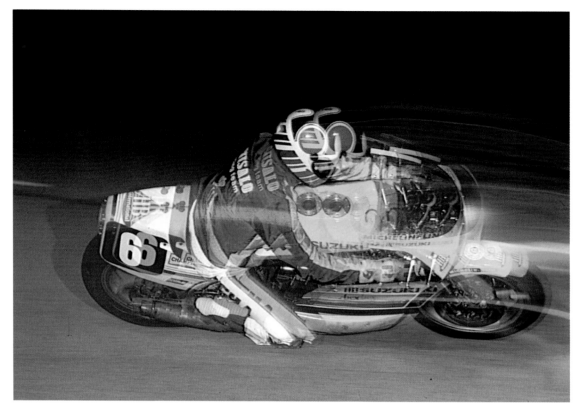

to be used at the fastest shutter speed possible, the alternative is to use a faster film. Choice of film is, as ever, dictated by the lighting conditions. In bright conditions you may get away with using a slow film and have a fast enough shutter speed to freeze the action.

Lighting conditions are rarely perfect for action photography. In poor lighting conditions you'll need to resort to a film which will give you quality plus a range of acceptably fast shutter speeds. Medium speed films of ISO 100 and, especially, fast films of ISO 400 will give exposures suitable for use with long lenses. The image quality of today's ISO 400 films, whether black-and-white, color print or color slide, is extremely high, with good overall sharpness, color rendition and well-controlled grain, considering its speed.

Photographing action indoors may require film speeds faster than ISO 400. These are available or you could also push your film so you can use it at a higher ISO rating, getting faster shutter speeds. Remember to make a note of how much the film has been pushed so that your film processor, or you, will remember to extend processing times accordingly.

Sports
Sports events are ideal venues for photographing action subjects. The fact that all the action takes place in a fixed area such as an arena or on a field makes it easy to

pre-arrange viewpoints and to monitor moving subjects. But it may not always be easy to get close enough to the action for frame-filling shots if there's a large crowd or if the sport is a high risk one, such as motor racing. In this situation a high viewpoint will increase your chances of getting good shots. For local sports events, where the crowds are perhaps not so plentiful, it will be easier to position yourself on the touchline or near the edge of a track.

If there is little chance of being able to move away from one location, then a zoom lens will help you to make the most of the situation by giving some variety to the framing of your shots. A zoom will also help at a venue that provides more freedom of movement. With most field sports, if you're photographing from the touchline a zoom range of 70-210mm should be sufficient. A 300mm will help you to get closer to the action, providing frame-filling shots but, as with a sport such as football, the action moves around the field. The variable focal lengths of a 70-210mm zoom make it a better option .

When photographing racing events find a viewpoint at a curve as the contestants will drop speed and so improve the chances of freezing the action. If you have a manual focus camera, pre-focus at a point on the curve where the racer will pass, then you'll only need to press the shutter when the subject reaches the spot on the curve that will allow for the best image.

Above: A flashgun with a rapid-fire strobe effect and a pan produced this highly effective movement shot.

If a curve in a track is inaccessible then a side-on viewing position will do. However as the subjects will be moving across the width of the frame it will be more difficult to keep them in constant sharp focus. You can either use the fastest shutter speed that is available, typically 1/1000sec or 1/2000sec with most SLRs. Or, if the lighting conditions make this difficult, you can use a *panning* action by swinging your camera to follow the movement of the racers. It's possible to use slower shutter speeds with panning yet still maintain a good deal of subject sharpness. First frame your subject, then press the shutter button. Move the camera to keep pace with the speed of the subject while the shutter speed lasts. A panned shot will show the main subject sharp with the background a streaked blur.

If the lighting conditions only allow slower shutter speeds, and if you can get into the right position, try photographing action subjects head-on. It's possible to use comparatively slow speeds to freeze action subjects moving towards the camera (see Shutter Speeds and Movement table).

Indoor venues invariably require use of fast film and the necessary filtration and adjustment for color casts will need to be considered. It's worth finding out before-hand what the type of artificial lighting is, so that you can prepare yourself with the appropriate films and filters. Flash is some-times frowned upon at indoor events and you may have to ask special permission from the event organizers. In some cases, flash is forbidden but once again it's worth finding out before you set out.

Also it's wise to ask the arena authorities and the team managers for permission to photograph. Refusals are rare but it helps if you can reassure those concerned that your photography will not interfere.

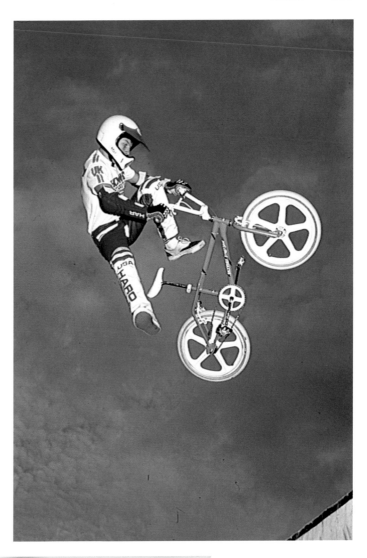

Above: Flash has frozen this rider in mid-air. If you don't have AF then try and pre-focus on an object that's in the same plane.

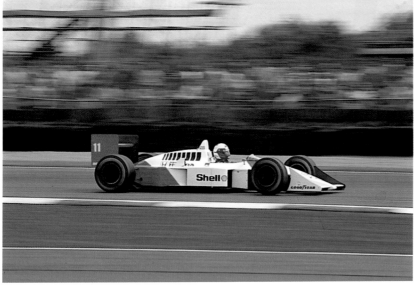

Left: Panning – moving the camera with the subject – will maintain a sharp image and blur unnecessary background detail.

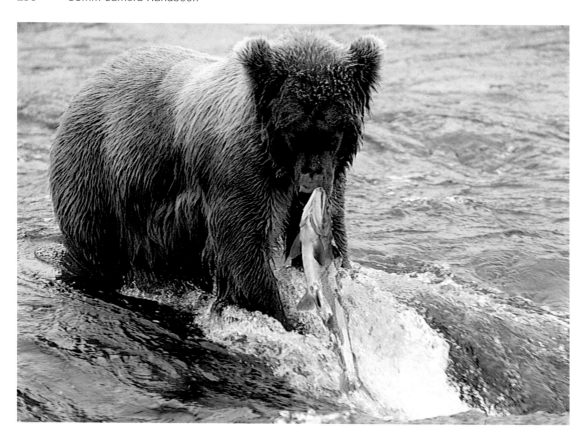

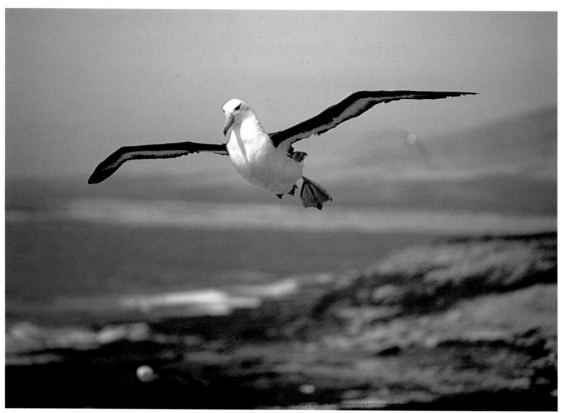

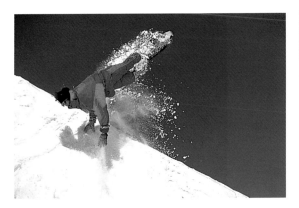

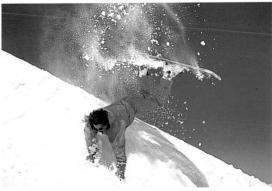

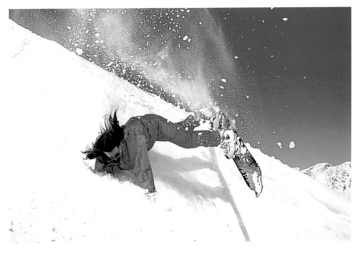

Animals

Getting action photographs of animals is much more difficult than sports photography but, because of this, is highly rewarding when you succeed. Birds in flight, for instance, can provide stunning images though, as with sports photography, pre-planning and positioning will dramatically increase your chances of success. A bird sanctuary is an obvious venue especially one that has prearranged viewing positions for bird-watchers. As with sports photography long lenses, fast shutter speeds and fast film will improve your chances of freezing the action, as will panning.

Domestic pets such as dogs are a great way to sharpen your skills in action photography techniques! Make sure you pick a location that has plenty of running space and an assistant to throw a ball or stick.

Horses and dogs at races are accessible action subjects, too, as are deer in a park. Wilder and shier animals, and nocturnal predators such as owls demand some additional technical expertise plus detailed pre-planning and use of flash. With shy animals like these remote firing of the camera is needed, and there are various methods available.

Sequences

A sequence of shots taken rapidly one after the other by a fast film winder can sometimes be more effective than a single image, as it will be able to show the action unfolding. Most autofocus SLRs have a wind-on speed of around 1fps but a few are capable of much faster rates, anything up to 5fps for top-of-the-range models. If even this isn't fast enough for your needs, or your SLR can't reach these speeds, there are separately attachable motordrives from the leading camera manufacturers that fit their models. A couple give higher wind-on rates than 5fps, though the batteries add bulk and weight.

Another factor worth considering with fast winders is that they use up film at a high rate. A 3fps auto film advance will use up a roll of 36-exposure film in 12 seconds on continuous shooting!

Remote control

If you're photographing shy animals or dangerous sports, remote camera operation is a safe way to get really close to the action. Special cable releases of up to several feet in length will enable you to trip the shutter from a distance away. When using one of these make sure that the camera has automatic film wind or a motordrive to wind the film on.

Wireless infrared remote control systems are available that have an even greater range than a long cable release, but these tend to be expensive and are aimed more at naturalists and professional photographers.

A simpler method for shorter range use is via your camera's self-timer, though it will be difficult to predict the peak of the action that will coincide with the end of the self-timer delay period of (usually) 10 to 12 seconds. A camera with a double self-timer will give two chances of getting a shot.

Some of the more expensive compacts have a facility to operate the zoom and fire the camera via an infrared remote system.

Above: A motordrive sequence, such as these three shots, can show an unfolding series of events, but it needs to be backed up with timing and anticipation.

Above, far left: Long telephoto (500mm) lens photography – the safest way to capture a brown bear!

Below, far left: A long lens is needed for sea birds, especially if you're shooting from a clifftop.

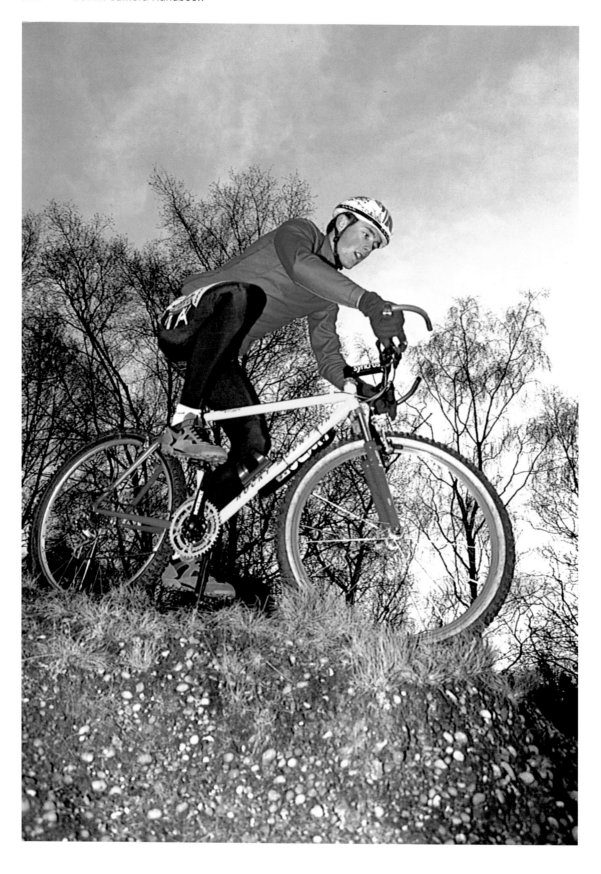

Fast winders are best suited for a specific sequence rather than all the time. As winders simply move film through the camera at a specified rate they're still no substitute for the anticipation and timing that go to make that special action shot.

Autofocus and action

The chances of capturing the peak of the action are more likely with a fast and highly sensitive autofocus system than a fast film winder. The average autofocus SLR, in continuous focus mode, is able to follow a moving subject. Some systems have focus prediction, that is, the auto-focus sensor is able to calculate where the subject will be and pre-focus at that position. The photographer simply needs to press the shutter button.

Another system, called trap focus, involves pre-focusing at a specific position where the subject is sure to pass. As soon as the subject reaches this point the camera will automatically fire. Once the

Above, left: The Canon power drive booster E1 has a rapid wind-on rate. Make sure you've got plenty of film!

Page 138 and sequence on this page: It's worth getting close for frame-filling shots. But first get permission, don't obstruct the race – and don't forget your own safety.

Overleaf: Some forethought can produce telephoto shots like this, taken at the Men's Downhill at Val d'Isère.

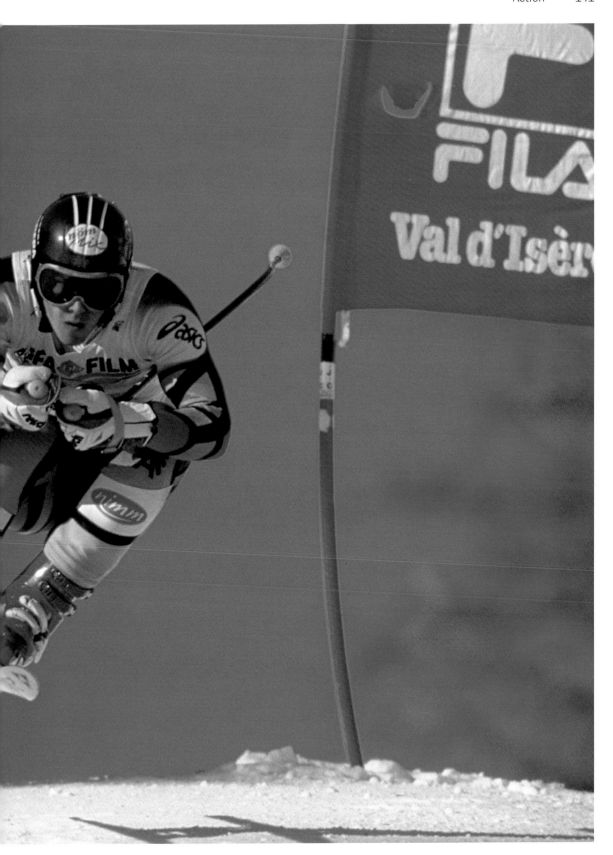

camera has been set there is no need for the photographer's presence. It's a sophisticated alternative to infrared remote control but requires the camera to be pointed toward a known position first. It's a safe way to grab action shots, though the location or viewing angle needs to be altered from time to time to avoid capturing a series of shots that could look virtually identical.

Shutter speeds for moving subjects

Once the focusing has carried out its task, the faster the shutter speed that is used, the sharper the subject will be. For a moving subject the shutter speed has to be fast, although the right speed to choose depends on the direction of subject move-

ment and the speed at which it is moving.

Subjects moving across the frame require the fastest shutter speed possible, the closer they are to the camera. If they are farther away, a slower shutter speed can be used (see table for suggested distances). These figures are for a static camera. If a camera is panned during the exposure then a slower shutter speed can be used, though shutter speeds of less than 1/30 second will give a high risk of blur.

If the subject is moving toward or away from the camera, a slow shutter speed can be used, as image blur is less evident in these situations.

As an alternative to sharp, frozen action shots try a few at slow shutter speeds. The right amount of blur will also convey a

Below: A dramatic effect like this — using flash, slow shutter speed and rule-breaking composition — can add variety and extra interest to motor-racing shots.

sense of movement and if the subject is colorful, all the better. The shutter speed range between 1/8sec and 1/30Psec depending on the speed of the subjects and the distance, should give just the right amount of blur yet still make them.

Flash is perfect for freezing the action although a very powerful unit will be needed to cover the instances involved and adequately illuminate the subject. Flash used with a slow shutter speed will give a striking sharp-blurred result.

Setting those shutter speeds

If you're using the manual exposure mode then setting the required shutter speed will be simple, whether you have a manual focus or an autofocus SLR.

Alternatively you could use an automatic exposure mode that has a bias in favor of shutter speeds, such as shutter-priority auto or high-speed program mode. An indication of the shutter speed set, either in the viewfinder or on the top plate LCD panel, will help you to monitor the right speed for your needs.

If you only have aperture-priority auto exposure mode the viewfinder display usually shows the shutter speed that's been selected by the camera.

Shutter Speeds and Movement table

Some suggested shutter speeds for photographing moving subjects (without panning): that are moving across the image frame.

Walker 13 feet (4m) 1/250 sec
Cyclist 13 feet (4m) 1/500 -1/1000 sec
Car 30mph (50km/h) 32 feet (10m) 1/1000 -1/2000 sec
Train 32 feet (10m) 1/2000sec*

*1/2000sec has become established as the average top shutter speed for an SLR.

Below: A static camera and fast shutter speed froze this speeding car.

Bottom: One of several shots at 1/15 or 1/30sec.

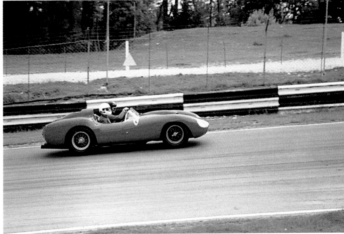

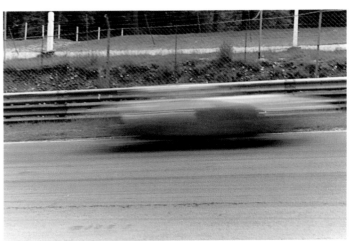

Image Processing

Getting your films processed and printed commercially is convenient and quick, but can become prohibitively expensive if you use a lot of film. The alternative is to process and print them yourself. Though it's expensive to begin with, this approach will ultimately save you a lot of money. Also, as the photographer, you can process and print the films to your personal preferences.

But even to an enthusiast beginner the idea of processing and printing your own work may seem daunting. It's certainly a whole new skill that needs to be learned. At its simplest level the principle of darkroom work is the same as that involved in photography – producing an image, and in much the same way. It would take at least another book to show the full capabilities of image creation in the darkroom. In this chapter we'll simply show you the basics of processing a black-and-white film (plus producing a contact sheet) and processing a color slide film. These first simple steps will form a basis on which you can build your future darkroom skills and experience.

What you'll need

The basic equipment required for processing and printing black-and-white film can, with certain additions, also be used for color print film. These are what you'll need:

Enlarger
Like a camera, a lens with apertures. Enlargements are carried out by moving the enlarger head up the length of the enlarger column. The negative or slide is positioned in a negative carrier, which is situated between the lens and the enlarger's built-in lighting system. The illuminated image is projected on to a sheet of paper positioned on a baseboard which is at the foot of the enlarger. Focusing is carried out by rotating a focusing knob.

The cheapest enlargers are those used for black-and-white printing. Some have an optional color head.

Enlarger lens
A 35mm format enlarger lens needs to enlarge a 35mm piece of film, be it a negative or a slide, up to 10×8in or more. So the lens – most often 50mm – has to be of the highest quality, producing sharp results right across the image frame. As with 35mm cameras the sharper the lens the more expensive it is. However, as enlarger lenses are much simpler than those used for cameras the price of a good quality enlarger lens is comparatively cheaper.

Chemicals
Different chemicals are used for processing black-and-white, color print and color slide film. There are also different chemicals for processing black-and-white and color prints made from these materials.

Within the range of black-and-white film processing chemicals, there are ones suitable for different film types and for different requirements. The film or print developer you choose will have varying results on the finished image and may specifically affect contrast, sharpness, tonality or grain. Add to this a large range of printing papers plus color toning and tinting capabilities, and the sheer range of effects and finishes that are possible gives infinite variety in the production of black-and-white images.

The chemicals you will need for processing a black-and-white film are a developer and a fix.

Chemicals for processing and printing color print (C41) and those for color slide

Below: The basic equipment required for darkroom work is simple and cheap.

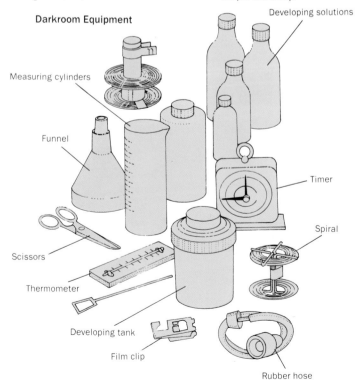

Darkroom Equipment

Developing solutions

Measuring cylinders

Funnel

Timer

Scissors

Spiral

Thermometer

Developing tank

Film clip

Rubber hose

films (E6) are standard, with very few variations. This is just as well, as color processing is a much more complex procedure than black-and-white processing. A standard universally accessible process therefore means a standard universal procedure. This also means that this type of processing is widely available commercially. So if you wanted you could cut out the first stage of processing the negative for a color print, or processing a color slide film, by getting it done in a lab. You could even get a set of prints to use as guide prints. This is a viable possibility as processing standards in commercial labs have improved considerably, while pricing is highly competitive. This would then leave you free to concentrate on the creative aspect back in your darkroom: making the final prints.

The darkroom

If you intend doing any complex and regular darkroom work, whether it's processing films or printing the results, it's best to have a room or space set aside for this purpose. Washrooms (and sometimes even kitchens!) have been used as temporary darkrooms, but the very nature of these areas makes them inconvenient for dedicated darkroom use.

While it would be ideal to have a room that can be turned into a darkroom, any reasonably large working space will do. It needs to have an adequate working area and ventilation. A water supply outlet in the room would be a useful extra though one that's nearby would be a feasible alternative.

It's important to make your darkroom safe, for you and members of your family. Chemicals should be labeled and stored in safe places. Electrical devices, such as enlargers and timers, should be kept in secure positions, their wires safely tucked away.

Processing a Black-and-White Film

Measuring cylinders
Four 300ml measuring cylinders each for black-and-white and color film processing.

Developing tank
This light-tight container contains the film, which has been wound on to a reel. Once it's been filled with chemicals and the lid put on it the rest of the developing procedure can be done in normal lighting.

Chemicals

Thermometer
Temperatures need to be accurately maintained for processing so a thermometer is a vital accessory.

Photographic Enlarger

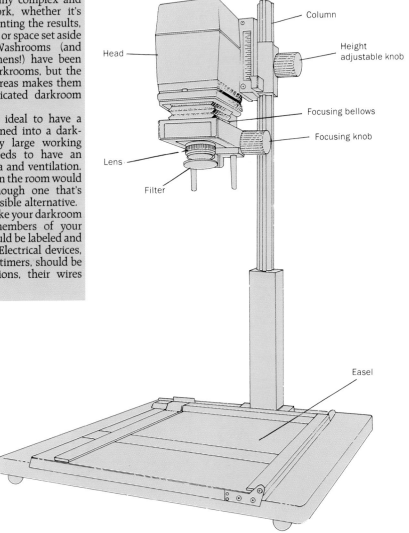

Column

Height adjustable knob

Head

Focusing bellows

Focusing knob

Lens

Filter

Easel

Processing a Black-and-White Film

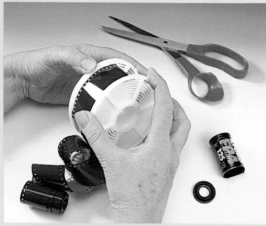

1) Open the film cassette using a bottle-opener. Square off the film tip, then insert into the reel, keeping the dull side of the film down. Rotate both wheels to wind on, then snip off.

2) Put 270ml of water into a 300ml measuring cylinder and add 30ml of Aculux (**developer**). Put 265ml of water into another cylinder and add 35ml of Acufix (**fix**).

3) Make sure that the temperature of the solutions is at or very near 20degC. Adjustments can be made by adding small amounts of hot or cold water.

4) Make sure the developer is poured into the tank quickly but smoothly. Fit the lid, then give a sharp knock to shake off any air bubbles from the film. Start timing immediately.

5) Agitate the tank for the first 30sec of the dev time, then twice each minute for the remainder of the dev time. (Dev time varies with different films — eg. Ilford FP4 will need 6½ minutes.)

6) Remove plastic cap from the dev tank about 15 seconds before the full dev time. Pour the dev steadily into its measuring cylinder so that it's all poured out by the end of the dev time.

7) Thoroughly wash the tank then pour the fix into it, replace the cap and agitate for about 30sec. After this agitate a couple of times for every 30sec, for a total time of 2 minutes.

8 Put the fix solution into a container, and make sure it's air-tight. You should be able to fix at least a dozen films with the 300ml solution that you've mixed.

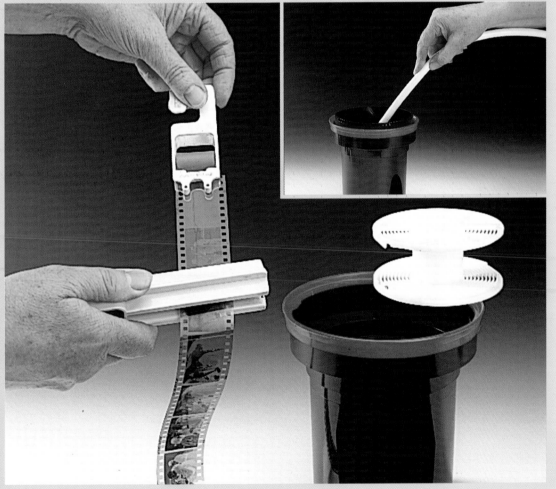

9 (inset) The film then needs to be washed in tepid running water for 30 minutes. A constant flow ensures that remaining chemicals are washed away.

10) Remove the lid from the dev tank, take out the reel and carefully unwind the film. Then attach a film clip and wipe off extra water, either by using wet fingers or a squeegee.

Film clips

These clips are used for hanging up film prior to drying it, and hold the film firmly without gripping part of the image frame too. A cheaper alternative is to use altered paper clips for hanging.

Timer

A watch with an illuminated dial or alarm may do as an alternative, though dedicated darkroom timers have bigger dials and figures plus a reset control.

Plastic container

The chemicals need to be heated to a specific temperature range and the most suitable way is to keep them in a plastic container such as a bowl filled with warm water. The thermometer can be used to check the temperature of the water and the chemicals. If needed the temperature can be increased by adding hot water to the bowl. A cheap thermostat can be used to maintain water temperature.

Making a Contact Sheet

Equipment for making a contact sheet (you may already have used some of this equipment for processing black-and-white).

Two developing trays

Developing trays that can take prints of up to 10×8in size are ideal. Try to get the trays in two different colors so that you can differentiate between the one that's used for the developer and the other that's used for the fix.

Print tongs

Tongs allow you to handle the prints without using your fingers. You need two pairs, one for the developer and one for the fix.

Piece of glass (approx A4 size) or a contact frame

The glass is used to keep the paper flat so that you can print on to the surface evenly. A contact frame has the same function.

Measuring cylinders

Chemicals

A print developer, unlike the one used for developing film, is needed for processing a contact sheet. You can, however, use the fix that you use for fixing film. Keep different dilutions for film and paper separate.

Printing paper

Generally speaking, two paper types are available: resin-coated and fiber-based. For contact sheets resin-coated paper is best as it has a coated layer which helps the paper to dry quicker.

Light source

If you don't have an enlarger a single light bulb will do, as exposure times needn't be super-critical for a contact sheet. Around five seconds should be sufficient.

Safelight

A safelight with an orange cover will be brighter than a red one. Note the recommended safelight for your film.

Processing a Color Slide Film

Timer
Squeegee
Developing tank
Thermometer
Storage bottles
Film washer
Film clips
Measuring cylinders
Changing bag
Chemicals
Plastic container

Presenting Your Images

Whether your finished image is a print or a slide you will want to display it or show it to other people. If your images are of a standard where you will want to sell them,

Below: A test-strip, given different exposures, will help you to get an idea of the nearest correct exposure time needed for your negatives. This one was at settings of 6, 12 and 24sec.

Bottom: A final exposure time of 8sec at f/8 was chosen.

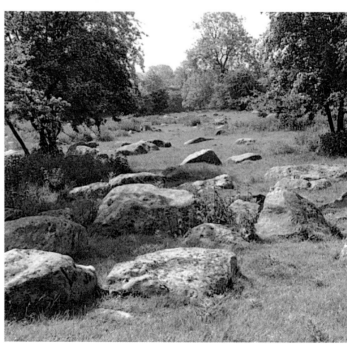

Making a contact sheet

1) Put 270ml of water into a 300ml container and add 30ml of Acuprint (**print developer**). Put 257ml of water into another container then add 42.5ml of Acufix (**fix**).

2) Ensure that the solutions are at 20degC and pour into separate, developing dishes. Make sure that these are easily distinguished from each other.

3) With safelight on, place your negatives carefully on a sheet of (glossy side up) 10×8in printing paper. Then place the glass cover over them. Switch main light on for about 6sec.

4) Tilt the dev dish and slip the paper into the solution, face-down. Then lay the dish flat to enable the solution to wash over the paper. Turn the paper over after 20sec.

5) Rock the dish backward and forward with a gentle motion for the first few seconds, so the dev washes across the paper surface. (Check the manufacturer's instruction for dev time.)

6) When development is finished, rinse the print in water. Then remove with print tongs, allow to drain and place in the dish of fix. Agitate for about one minute then lift and drain.

7) Place the contact sheet in running water and wash for about two minutes. Ensure that there's a continuous flow so that fresh water constantly washes over the surface of the contact sheet.

8) After washing, drain the print, then wipe off as much water as possible with your hand or a squeegee. You can then hang the contact sheet up to dry or use a hair-dryer.

Processing a Color Slide Film

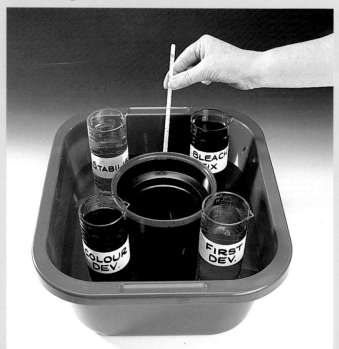

1) Prepare the solutions and place in a bowl of water at a temperature of 38degC, 1½ hours before processing. Adjust the temperature with hot or cold water as needed.

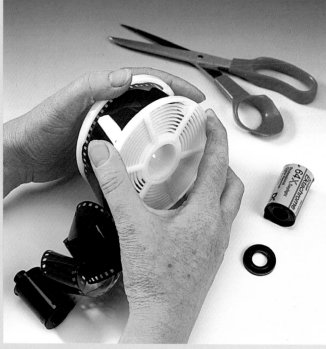

2) Open the cassette, snip off the film tip and carefully load into the spiral. Make sure that the glossy side (you should be able to feel this) faces up. Then load into the developing tank.

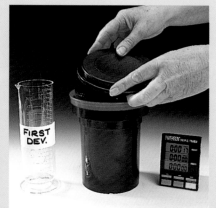

3) Put the **first developer** into the tank quickly, begin timing, and replace the lid. And don't forget to give the tank a sharp knock to shake off any air bubbles that may be on the film surface.

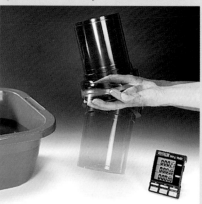

4) Agitate the developing tank for 15sec, turning it over several times. Then turn it over twice every 30sec — placing it in the water bath when not turning.

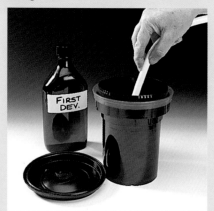

5) 15sec before the end of the dev time slowly empty the first dev from the tank into its bottle. Then wash the film thoroughly in four changes of fresh water, giving each change a 30sec shake.

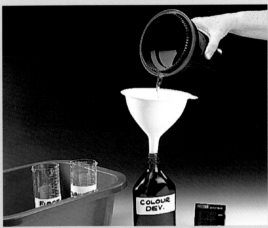

6) Empty the water completely and put in the color dev immediately. For the agitation procedure see Pic 4. Return the color dev to its container 15sec before the elapsed dev time.

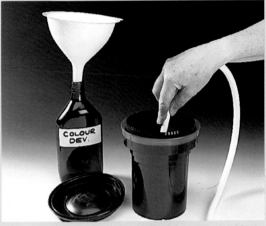

7) Once again, wash the film thoroughly in four changes of fresh water, giving each change a 30sec shake. Then empty the water thoroughly from the tank.

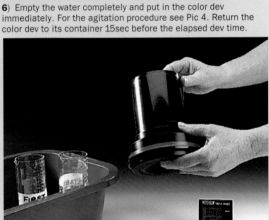

8) After putting the **bleach-fix** (blix) into the dev tank agitate it constantly for 15sec. Then turn it over twice every 30sec for the remainder of the blix time (usually 10min), and re-bottle the blix.

9) Give the film a *thorough* wash in six changes of fresh water. At each change agitate the tank for about 40sec. After the last wash make sure the tank is empty of water.

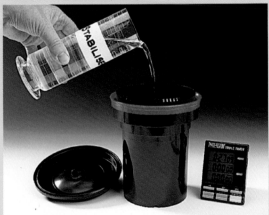

10) Pour the **stabilizer** into the dev tank and agitate for 7sec, turning it over about the same number of times. Leave the dev tank standing for 1 min then re-bottle the stabilizer.

11) Open the tank and carefully remove the film from the spiral. Squeegee off any excess liquid then hang the film up to dry. Try and put a weight on the other end, such as a second film clip.

you will need to show them at their best. There are several options.

Prints

The most popular way to show prints off is to mount them in a frame and hang them on a wall. There's a huge range of options in the framing market at varying prices. Try and choose a frame that will set off the colors or tones or theme of your image. And remember, all photographs fade in time. To make your image last as long as possible try and keep it away from a direct light source or sunlight as these will fade the colors or tones.

If you intend selling your images then a portfolio case or even a large box will keep them away from the light until such time as you want to show them. And displaying prints will ensure that your original slides or negatives remain safe.

Slides

Slides can be projected on to a screen although the intense light-source of a projector will, with repeated projection, eventually fade the colors. If you have a slide duplicator you can make a copy of your original and project the duplicate instead.

Negative and slide storage

Negatives can be put in plastic or paper filing sheets and kept in a ring-binder. Do not use a standard A4 ring-binder as the edges of the filing sheets and maybe the edges of your negative strips will jut out and be vulnerable to damage. Special binders for filing sheets have a larger area.

The filing sheets sometimes have a strip on which details – such as dates and other identifying information – can be written. With negatives from black-and-white film

Archival storage

Processed images stored at low temperatures (ie 20°C) and in dark, dry conditions will last for several years, though all films and prints will gradually fade. You can prolong the life of your images by, at the processing stage, altering developing procedures to get rid of traces of remaining chemicals. Images can then be stored archivally by placing them in archival filing sheets or boxes that are acid-free and do not have harmful vapors that will affect film. You can also print images on archivally permanent paper.

When filed away they should not be placed in wooden cabinets or drawers as these could give off harmful gases as a result of chemicals used in their manufacture. Best storage media are cardboard boxes that are acid-free, and metal cabinets.

you can also keep a contact sheet with the relevant batch of negatives, serving as an instant visual reminder of what's on the negatives.

The filing sheets are able to take six frames of cut film per slot. The transparent plastic sheets can be used to "contact down" on to printing paper to produce a contact sheet without removing them from the filing sheet.

There's an array of storage media for storing slides. Process-paid slides, if mounted at your request, are returned in the film manufacturer's plastic box. These give good protection against dust but slides are difficult to view.

Slide films, when commercially processed, can be returned in a filing sheet like negatives. Or they can be mounted by the processor at an additional cost. There are filing sheets with pockets for storing mounted slides. Some have punched holes in the side for keeping in a ring-binder, while others are able to take metal strips which fit into suspension files.

There are also slide magazines, plastic trays with rows of slots in them, which can be used for storing the slides but can also be transferred directly to a slide projector for viewing. Some are straight while others are round, to suit different projector types. They can hold 36 slides or 100, or 120, depending on the type of magazine.

Whichever storage system you choose it's important to label each batch of slides. Some film manufacturers return process-paid slides numbered and with the date of processing stamped on them. But you will need to include other identifying information for retrieving them at a future date, as slides can accummulate at a rapid rate if you're a regular user of slide film.

Electronic Imaging

Photo CD makes it possible to transfer conventional 35mm images, from negative or slide on to a compact disc. The images can be viewed on TV via a CD player, many of which can play normal CDs. The audio facility also means that your 35mm images can be combined with sound so that your family snapshots can have sound too.

Photo CD images can also be transferred to computer where, with the aid of relevant software, they can be manipulated, cropped, re-sized, combined with other images or lettering, color-corrected or color-altered.

A Photo CD can hold up to approximately 100 35mm images. A single-session Photo CD can store images all at one session but will not be able to store additional images after this. Multi-session Photo CDs are able to have images stored in them more than once though are more expensive than single session discs. There are several commercial labs and bureaux that will transfer your 35mm film to CD.

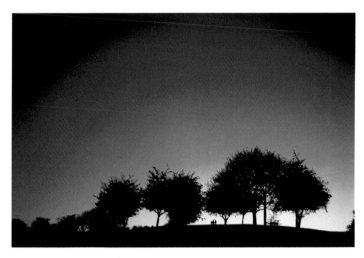

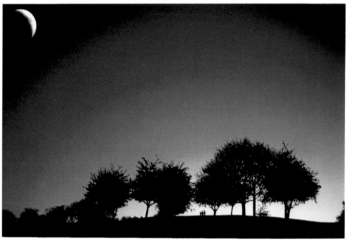

Digital Cameras

There are cameras available that can take pictures without the aid of conventional film. The images are stored digitally on a floppy or hard disk from where they can be transferred to a computer. Many are, photographically, the equivalent of high-quality fixed focus models. But the images produced by them are still a long way from photographic image quality. The cameras' storage and power capabilities are also lacking when compared to a conventional SLR. Finally, the prices of digital cameras are currently high, at least twice that of a conventional SLR. But Apple and others are addressing this aspect.

The idea of digital cameras is attractive: capturing images in a digital form and then enabling them to be endlessly manipulated, with a "film" medium (the disk) that can be used over and over again. The image quality of digital cameras is gradually improving. But it may be some time yet before it can at least match the image quality, the price *and* the hands-on versatility of a conventional 35mm SLR.

Top: Digital imaging is capable of subtle changes to images as well as more way-out effects. The original slide was transferred into a digital image on an Apple Mac Workstation.

Above: The moon image was selected from a clip art library, modified slightly, then positioned.

Above left: Transfer your 35mm images to Photo CD to show them on TV. Or manipulate them using a computer.

Far left: Kodak's digital camera (a Nikon AF SLR) is a perfect combination of 35mm camera design and digital imaging technology. Instead of film it records images onto a built-in computer hard disk.

Accessories

This is a selection of accessories which may, photographically speaking, help to make life a little easier. Most of these items can be found in, or ordered via, a well-stocked camera shop. Also, photographic magazines are excellent sources of information about new and existing items of equipment.

Lens

Manual -to-autofocus converters are available from some SLR manufacturers and independents. These will enable manual focus lenses from the same marque to be used on autofocus SLRs within the range. All involve a slight increase in focal length with the converters attached.

A special adaptor fits over the rear part of a lens so that the lens can be used as a telescope. Works best with telephoto lenses.

Filter

Cokin markets a filter with a ready-made rainbow on it, if you need one in a hurry!

A Monovue filter gives a mono-chrome effect when looked through with the naked eye, useful when you want to see how color subjects will appear in black and white.

Camera

If your camera doesn't have a self-timer, there's a device that has one built-in. It screws into the cable release socket of a manual focus SLR and has a settable clockwork mechanism that fires the shutter button after a selected delay time.

Nickel Cadmium batteries (NiCads) are re-usable batteries that will help you save money on battery power. Some cameras may not be able to use NiCads due to voltage differences. It's best to check your instruction book first.

There are special handgrips with triggers which make it easier to fire the shutter button when holding the camera in different positions. They screw on to the base of the SLR and are connected to the shutter button via a cable release. The set-up is especially useful with long lenses.

Special rubber eyecups, available for most makes, can be fitted over the SLR eyepiece for more comfortable viewing.

Magnifiers that fit over the eyepiece will increase the size of the image in the viewfinder, making it easy to

focus and assess composition.

Right-angle finders also fit over the viewfinder eyepiece and enable through-the-lens viewing of subjects with the camera positioned at ground-level.

A 30 percent gray card can be used to take average light readings, either via a handheld light meter or the camera's built-in light meter.

Spirit levels help to keep horizons straight and verticals vertical. Special ones are available for use on cameras and have a hotshoe fitting for this purpose.

A framing guide consists of two pieces of L-shaped card which can be moved to find the best image shape

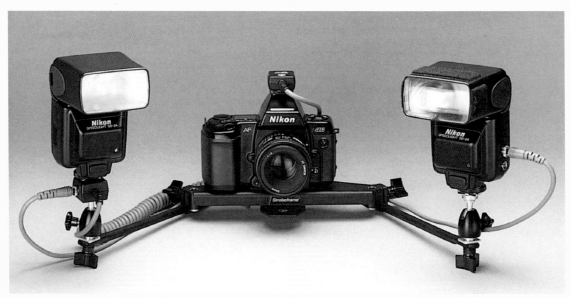

for composition or cropping.

Flash

Special diffusers are available for use with flashguns. These range from flexible fold-down "cards" with white or silvered reflectors, to balloon type diffusers and even a mini brolly.

A slave cell is a low-cost yet versatile tool for remote flash use. It's handy for filling in dark areas in indoor photography when more than one flash unit is being used.

A flash bracket, an arm that attaches to the base of the camera, can be used to support heavy units such as hammerhead flashguns.

Film

A film retriever is the perfect device for rescuing film that has accidentally been wound back into the cassette before being completely used.

If you use a lot of film on a regular basis a bulk film loader may help to cut down costs.

A lightbox is a must if you're a regular user of slide film. You can use it to judge processed film and mounted slides and, in an emergency, even as a light source.

Slide-mounting jigs make it easier to mount slides than doing it by hand. Some also have an integral mini lightbox for assessing the slide.

There are alternatives to conventional slide mounts that crop the slide in half, or just a narrow central strip, or four separate frames like a window. They are also available as circles and other shapes and will add a bit of variety to your slide shows.

Tripod

Quick-release tripod adaptors, screwed on to the base of the camera, enable quick attaching and removal from a tripod head.

Tripod clamps are for use in locations and situations where use of a conventional tripod is limited. These devices contain a tripod screw on a small platform attached to a clamp which can fit around a tree branch or a pole. Variations of these are fixed to large spikes which can be pushed into wood or, for low-level stability, into the ground.

Darkroom

A changing bag is a light-tight bag that can be used to transfer film into a developing tank in daylight. It's also useful for emergencies such as open-

ing the camera back to check whether the film is properly wound on, with manual cameras.

Print trimmers make it easier to cut prints and paper for printing and are more accurate than using a pair of scissors or a scalpel.

Left: A slave cell provides versatile off-camera flash without connecting cables.

Below left: Extension brackets offer flexible positioning of flash units.

Above right: This handheld light meter has a digital display for easy reference.

Right: Tripod manufacturers supply a wide range of optional tripod heads.

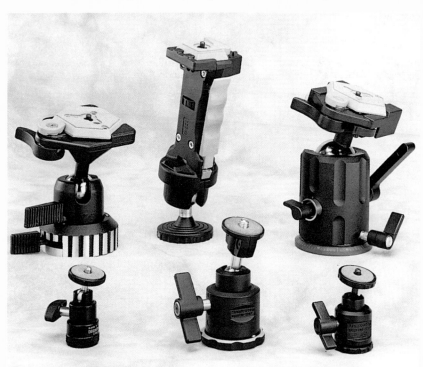

Glossary

This is a glossary of the most commonly used terms and phrases in 35mm photography and processing.

Aerial photography Photographing down on to land or buildings from the air, either from aircraft such as aeroplanes or helicopters, balloons, airships, or even high towers. 35mm camera equipment is ideally suited to aerial photography because it is small and light.

Ambient lighting Another word for available lighting, indoors as well as out of doors.

Apochromatic A special lens type which enables the three primary colors – red, green and blue – to come to a focus more accurately than in ordinary lens glass. Apochromatic lenses have superior sharpness and control of distortion. They are also more expensive than lenses made with conventional glass elements.

Archival paper/processing This system uses special chemicals, procedures, papers and storage containers to ensure that films and prints last way beyond their normal expected lifespan.

ASA/DIN Old names for ISO (International Standards Organization). Still seen on early camera equipment and photographic literature. Ignore DIN numbers. ASA film speed numbers are the same as ISO film speeds.

CdS Cadmium sulphide light-metering cell.

Charge coupled device (CCD) The heart of an autofocus system, the CCD assesses focus and transmits focusing commands to the lens.

Cold Refers to cold colors on the color temperature chart (ie blue, green, gray). Can be used in conjunction with black-and-white paper characteristics, ie a particular printing paper may have a cold black tonal reproduction (*see* Warm).

Depth of focus This refers to the area of sharpness of an image focused on to a film or printing paper. Not to be confused with depth of field.

Diffused lighting Lighting which has been softened and spread wider by passing through a filter or other translucent material.

Dodging This technique, also known as burning-in, is used to give additional exposure to a small part of a print. You can use your hands to form a mask or make special masks that can be used over the areas you want to have dodged (*see* shading).

Double weight Refers to thick photographic paper. There are thinner, also single weight papers.

Drying marks These are streaks found on film, caused by water impurities or insufficient or no wetting agent used in the final film rinse. They can be removed by rewashing or cleaning with special solutions.

E4 process A special slide process used for Kodak Ektachrome infrared film and Kodak Photomicrography film.

Element This is a single glass lens, several of which comprise a photographic lens.

Fiber-based paper One of two kinds of photographic paper used in black-and-white printing. Fiber-based papers give good image stability and are easy for retouching. They take longer to dry than RC (resin-coated) papers.

Film plane The plane along which the film lies, and at which the rays of light from the lens focus on to form the image. Manual focus SLRs, especially older types, have a film plane symbol on the camera top plate. This is to help when precise film-to-subject distances need to be known, as in macro photography.

Flashing Giving a minute burst of brief illumination to a photographic paper or film before use to lower contrast. Slide film can be flashed in order to lower contrast.

Fog Caused by a print or film being accidentally exposed to light or a chemical processing error. Appears as an area of darkness on negatives or extreme over-exposure on slides.

Glossy A surface that is shiny. Glossy photographic papers can enhance certain subjects.

IF (Internal Focusing) An IF lens has elements that move during focusing without the lens altering its length during this operation.

Independent A manufacturer that only produces lenses, rarely SLRs. An independent lens manufacturer produces lenses that fit a range of manual focus and autofocus SLRs.

Iris The blades within a lens which close down to form the different apertures. Also known as the diaphragm.

K-mount A lens mount that was originally made for Pentax SLRs, it is now also found on several other SLR brands. Pentax has a variation of the K-mount fitting for its autofocus SLRs.

Lens coating See-through layer on the front and rear elements of a lens to cut down on flare and improve contrast. Vulnerable to traces of acid deposited by finger marks.

Light-box An illuminated box on which slides and negatives can be viewed. Most of those commercially available are color-corrected.

Lustre Midway between a glossy and a matt finish. Also referred to as a pearl finish.

M42 Lens mount fitting that has a 42mm screw-thread fitting instead of the widely used bayonet fittings of various types. For use with older models of manual focus SLR.

Matt A surface that is not shiny, as with matt photographic paper.

Monochrome An alternative term for black-and-white.

Newton's rings A pattern caused by

air trapped between two layers of glass, as in an enlarger's film holder. If not corrected will transfer the pattern on to the projected image from an enlarger. Anti-Newton glass mounts for slides are available.

Normal lens Another term for a 50mm standard lens.

Open flash A technique that, with the shutter speed set to B, enables more than one flash burst to be recorded on one image.

Paper grades In black-and-white printing there are different paper grades that give different degrees of contrast. These range from 1 (low contrast) to 4 or 5 (high contrast). Can sometimes be used to rescue images from over or under-exposed negatives.

Photoflood A tungsten light bulb with a color temperature of 3400K which can be used for lighting portrait subjects.

Photogram A photograph made without using a camera. A photogram is made by placing an object, preferably flat, on to a piece of photographic paper or film and then exposing it to light. Enlargers can easily be used to make photograms.

Positive Opposite to negative. Slide film produces a positive image.

Rangefinder A focusing system consisting of two images which, when brought together by focusing the lens, produce a single, focused, sharp image. Also a type of older camera that uses this focusing system.

Resin-coated (RC) paper Plastic-coated photographic paper, it can be washed and dried quicker than fiber-based paper.

Shading This is a technique used to hold back exposure in part of a print. It can be used to hold back exposure in one part of a print while the rest of the image gets the full exposure. Hands or home-made masks can be used to shade the print during exposure.

SPC or SPD Silicon photo cell or Silicon photo diode, both light-metering cells.

Stop-down metering Stopping down (ie mechanically closing the iris diaphragm to the taking aperture so that a meter reading can be taken. Now only found on early model second-hand manual focus SLRs.

Strobe A special lighting unit which emits bursts of bright light at regular intervals. Because these pulses are very rapid and bright they can be used to take several photographs on one frame.

Supermarket films These films, also available in non-food chain stores, are branded films actually produced by film manufacturers such as Fuji, Konica, Agfa and Scotch.

Synchro sun Another term for fill-in flash used for backlit outdoor subjects.

T setting Similar to the B setting except that the shutter remains open after the button is pressed and the finger removed. To close the shutter simply press again, after the required exposure. Useful if you know how long you want your timed exposure to be,

T2 adaptor A special lens adaptor that enables lenses from one SLR to fit on to another SLR that uses a different lens mount fitting.

Thick Refers to under-exposed slide or negative.

Thin Refers to over-exposed slide or negative.

Variable contrast paper A special black-and-white paper that uses filters to give it different grades of contrast. Cheaper and more convenient than buying several different paper grades.

Warm Refers to a hue of a warm color temperature (ie red, yellow and brown). Can also refer to paper toning and tinting, as well as particular black-and-white paper characteristics (ie a paper with a warm black tone).

Zone system A method of pre-visualizing the tonal range of a resulting black-and-white image by taking readings off a range of tonal zones in the scene or subject.

Right: Some of the accessories for Olympus's macro system.

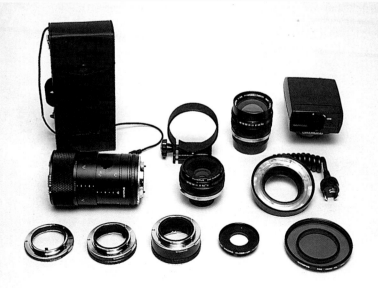

Index